REMEMBRANCE NOW

Michèle: For my grandparents

Tszwai: For Shuk Chun Chan (mom)

REMEMBRANCE NOW

21st-CENTURY MEMORIAL ARCHITECTURE

MICHÈLE WOODGER and TSZWAI SO

First published in 2023 by Lund Humphries

Lund Humphries
Huckletree Shoreditch
Alphabeta Building
18 Finsbury Square
London, EC2A 1AH
UK

www.lundhumphries.com

ISBN: 978–1–84822–456–8

A Cataloguing-in-Publication record for this
book is available from the British Library

Cover: Staircase at the Katyń Memorial and
Museum at the Warsaw Citadel by BBGK
Architekci

Credit: Julius Sokolowski photographer
(courtesy of the architects)

Copyedited by Pamela Bertram
Designed by Jacqui Cornish
Proofread by Patrick Cole
Cover designed by Mark Thomson
Set in Avenir

Printed in Bosnia and Herzegovina

Contents

Acknowledgements

We both owe huge thanks to former *RIBA Journal* editor Hugh Pearman for his encouragement, and to Val Rose, commissioning editor at Lund Humphries, for her support. Likewise, to the wider publishing team: Sarah Thorowgood, Rebeccah Williams, Jacqui Cornish, Pamela Bertram and Patrick Cole. Also, to Isabelle Priest, *RIBA Journal* managing editor, for writing such an encouraging Foreword.

We are very grateful to the architects who gave up their time and expertise in interviews (some of which can be read in full): Andy Groarke of Carmody Groarke, Brienne Nueslein formerly of MASS Design Group, Cai Yongjie of Tongjie University, Claudio Vekstein of Opera Publica, Daan Roosegaarde of Studio Roosegaarde, Katy MacDonald and Kyle Schumann of After Architecture, Jan Michael Antoni of Willy Yang Architects and Planners, Lee Eunseok + Atelier KOMA, Mahmoud Keldi of Keldi Architectes, Martín Gómez Platero of Gómez Platero Architecture and Urbanism, Moshe Safdie of Safdie Architects, Michael Arad of Handel Architects LLP, Mirosław Nizio of Nizio Design International, Philippe Prost of Atelier d'Architecture Philippe Prost, Sook Hee Chun of WISE Architecture and Yogesh Chandrahasan of WeBe Design Lab.

Thanks also to the following practices and individuals who provided information and material: Adjaye Associates, Agence Rudy Ricciotti, BBGK Architekci, DNA_Design and Architecture, Erlend Blakstad Haffner architect, Federico Cairoli photographer, Gómez Platero Architecture and Urbanism, Gustavo Penna Architects (Diana Penna), Kimmel Eshkolot Architects (Etan Kimmel), Libeskind Architects, M3 Architecture, Manuel Herz Architect, Safdie Architects (Robyn Payne), MASS Design Group (Amber Lacroix and Regina Chen), Mindspace Architects (Swetha A), Nizio Design International (Karolina Szmytko), Oving Architekten BV, Paul Lukez Architecture, Public City Architecture (Taylor LaRocque), the University of Pennsylvania Stuart Weitzman School of Design (Randall Mason), the Singapore National Heritage Board (Elizabeth Tang), Spheron Architects and photographer Joaquim Boren, and WISE Architecture (Young Jang and Sook Hee Chun).

Michèle would like to say thank you Tszwai for sharing your fascinating views, knowledge and experience. Merci to the following for their translation, editorial and general assistance: Ali Negyal, Babak Farrahi, Daniel Cariello, Eleanor Coen, Gurj Kang and Xavier Delpierre. Special thank you to memorial artist Mark Frith of City and Guilds London Art School for sharing his thoughts on private and public memorial design, Wilfrid Pisani for information on Notre Dame de Lorette, and Yumi Hyun, managing editor of *C3 Magazine*, for Korean language help. Finally, thank you Patricia, Brian and Christina Woodger for your support and practical assistance. And thank you Edward and Leo Taylor for your fantastic help, encouragement and inspiration.

Tszwai would like to thank Michèle for all her hard work, dedication and above all her original idea of writing about memorial architecture, without which the completion of the book would not be possible. Thank you, Alaksandra Dynko, Ales Cajcyc, Brenda Hu for your Chinese translation and research, Christiane Burklein, Edman Ma, Herbert Wright, Dr Ian Pan, Inna Pilevich, Janne Kantee, Justin Kwok, Linda Wu, Margaret Greeves, Natasha Reid, Phyllis Yung, Ray Chu and Susanna Lui for your invaluable feedback and support.

About the Authors

Michèle Woodger is an architecture and design writer based in London. She is contributing editor of the Korean architecture journal *C3 Magazine* and regularly contributes to *RIBA Journal* and *Products in Practice*. She has also written for *Pulp*, *Eye Magazine* online, *Forum Magazine* and the Lettering and Commemorative Arts Trust book *How Do You Want to be Remembered?* During her career at RIBA she was the recipient of the Gordon Ricketts Memorial Grant for her research into environmental graphic design in London's built environment.

Tszwai So is an award-winning artist and architect from London. He is the founder of Spheron Architects, and a visiting lecturer at the University of Westminster. His notable memorial projects include the Belarusian Memorial Chapel in London and the Pan-European Memorial for Victims of Totalitarianism in Brussels. So's artworks are in the collections of the V&A Museum and Wolfson College, University of Cambridge, and his art film *E-motion-AI City*, premiered at the Venice Biennale 2021.

Foreword

Isabelle Priest
Writer and journalist on architecture, and managing editor at *RIBA Journal*

At the time of the Grenfell fire in 2017 I was living in west London. My sitting room had a view of the tower. I saw and passed it every day. Still relatively new to the area, I didn't know the tower's name. I wasn't at home the night of the fire, as I was on an overseas press trip. That I wasn't, and that its refurbishment had taken place before my unaware eyes, stays with me. But in the days after the fire, I witnessed the outpouring of emotion that flowed onto the streets. Roads couldn't function. There were impromptu speeches, donations piled up, free hot food was on offer, but even at that early stage a great deal was memorial – messages, tributes, flowers, photographs, mascots for those that were missing.

Those days and weeks, which cemented into monthly memorial walks, demonstrated the modern purpose and need for memorials; for people at the very least to make tangible their feelings. It showed an urgent and immediate need for spaces of remembrance and contemplation for those directly and loosely connected to the tragedy. People also came from all over London, the UK and beyond to use the site and the surrounding streets as a place to absorb the enormity of what had happened. Different focal points of memorial emerged with different meanings and characters. The question of how to make permanent those sites and expressions has been a challenge for the people, groups and organisations that first helped in the aftermath of the fire. Some have channelled them into gardens, new buildings, public installations, or local initiatives and ideas.

This book deals with the transition from immediate outpouring to permanence – the commissioning of artists and architects whose work is chosen to defy language and metaphorically speak to all. In some ways it is an atlas, with examples of other contemporary memorials drawn from across the world. In other ways, it's an in-depth intellectual rationalisation – designed to be discursive – of the meaning and art of memorials and how they are almost living, breathing objects whose identities change over time. We saw that during the events that followed the fall of the Berlin Wall in 1989. We saw it more recently during Black Lives Matter protests in 2020 and 2021.

My awareness of these discussions started with Madge Dresser's 2007 essay, 'Set in Stone? Statues and Slavery in London', in the *History Workshop Journal* which I first read in 2009. It brought to life the urgency of addressing what memorials are. This book guides you through those complexities further into the 21st century – the purpose, ownership, changes of interpretation and representation of memorials. It does so, all while exhibiting their material richness in case studies, including their similarities and differences, no matter where in the world.

A note on the book's authors: I'm lucky to have worked with both Tszwai So and Michèle Woodger through *RIBA Journal*. It's an honour that their working relationship flourished out of their work for the magazine. I know them and their work well, and that in navigating the space of memorial and memorials, readers of this book could not be in safer hands.

Words and Music

Michèle Woodger

Remembrance is an ongoing conversation, a continuing dialogue between our past, present and future selves.

Tszwai So and I have been talking about memorial architecture for a long time. His perspective is that of a practising architect and mine is that of an architecture writer whose academic interests lie in the history of visual and material culture. Together we have collaborated on several projects, leading to many enlightening discussions about what remembrance looks like now.

This book crystallises our thoughts. Through a selection of architecturally interesting and culturally engaging memorials taken from a global context, we reflect on ways to interpret and approach this typology.

Memorials are rigorously studied by academics of all species, but there are few books which showcase contemporary memorials side by side. Yet there is increasing public demand for such structures. Events such as Historic England's 'Immortalised' competition (2018), David Adjaye's 'Making Memory' exhibition (Design Museum, London, 2019) and Spencer Bailey's book *In Memory Of* (Phaidon, 2020) acknowledge this growing interest.

Beyond architecture, controversies surrounding contested monuments – such as the acquittal of Bristol's Colston Four – demonstrate the intensity of public feeling, and the need to renegotiate what is publicly memorialised and how.[1] Such stirrings are happening around the world: civil unrest and protests following the death of George Floyd in Minneapolis urgently

questioned the legacy of US confederate monuments;[2] Belgium has faced calls to remove statues of King Léopold II; in France, contested monuments garnered increased media attention following the Black Lives Matter (BLM) protests and prompted the campaign #JeVeuxUneStatueDe, in response;[3] in Mexico City, Christopher Columbus' statue will, imminently, be replaced by the Young Woman of Amajac, a recently excavated pre-Columbian Huastec carving.[4] Times are changing, citizens no longer wish to identify with what they perceive as toxic legacies, and reshaping the memorial landscape forms part of the conversation.

We chose 2000 as a nicely rounded date to narrow down an enormous selection of memorials. Seismic social changes have taken place within these two decades: 9/11, the global recession, the acceleration of digital technologies and social media, the #MeToo and BLM movements, the climate crisis and the COVID-19 pandemic. These have all formed the backdrop to architects' memorial endeavours.

In the same way that our collaboration as co-authors has involved an exchange of ideas, our book is structured around a series of conversations. We begin with an introductory dialogue capturing our different approaches, recalling various references and inspirations which shape our ideas.

We follow our introduction with a series of case studies, which we chose together to illustrate a breadth of memorial responses, and which I put into words with Tszwai's architectural expertise. The memorials are drawn

from international contexts, and are mostly completed and architect-designed, with a few notable exceptions (grassroots installations, sculptures, unbuilt proposals) chosen due to their social relevance and relationship to the built environment. We situate the projects within their wider contexts, and suggest ways the monuments can be read. It becomes clear that each memorial project is in fact allowing a great many otherwise silent voices to speak.

Interspersed are architect interviews. We both talked to a large number of professionals, but it was not possible to include all of their words. Many insights find their way directly into the project descriptions. Our interviews offer a glimpse into the research practices and design processes undertaken by architects, and also reveal how their own memories, and understanding of memory, influence their practice. When we interviewed architect Philippe Prost for this book, he described memory as a precious resource, one that enables individuals to create imaginative works, and to 'ensure that the music stays original'.[5]

I was struck by his reference to music, as I also use music as an analogy to describe the challenges I face when writing about architecture. Both require words and sentences to do the job of expressing sensorial, auditory, spatial experiences; the systems and structures differ and the mechanisms are not always compatible.

Tszwai's illustrations, which he produced specifically for this book, are his means of responding to memorial architecture in a way that bypasses language, enabling him to explore the realms of emotion and feeling.

I have two further personal observations on writing this book. First, learning about the human tragedies behind so many memorial projects was emotionally taxing, especially during the lonely coronavirus pandemic when I began writing. With the 24-hour news cycle constantly reminding me of the suffering going on in the world, like many people, I found it hard to disengage.

As Susan Sontag observes in *Regarding the Pain of Others*, 'being a spectator of calamities taking place in other countries is a quintessentially modern experience'. It is easy to become despondent faced with suffering and no apparent means to act. But, she goes on to say, 'Remembering is an ethical act, has ethical value in and of itself.'[6]

Seeing how architects produce works of sincerity and meaning offers solace, and, for me, writing this book was an antidote to moral resignation. I hope that this book not only sparks interest in architectural interpretation but actively helps commemorate all those 'who have died believing that we all were on their side'.[7]

The second observation is that many contemporary memorial designs explore a relationship with the written word: sealed-off libraries, reading pavilions, buildings that resemble books. This recurrent theme speaks of an ineffable relationship between paper, ink, bricks and mortar – a complex interaction, that goes beyond metaphor, between the assimilation of experiences using language, the recording of memories in written form, and the translation of these into spatial forms. Books are paper memorials, which house, shape and create memories all at once.

And, as with books, our readings of memorial architecture are subjective and will shift and evolve independently of their designers' intent. As Margaret Atwood writes in *Negotiating with the Dead*:

> . . . works of literature are recreated by each generation of readers, who make them new by finding fresh meanings in them. The printed text of a book is thus like a musical score, which is not itself music, but becomes music when played by musicians, or 'interpreted' by them, as we say. The act of reading a text is like playing music and listening to it at the same time, and the reader becomes its own interpreter.[8]

Reflections

Tszwai So

Our idea of writing a book about 21st-century memorials evolved from Michèle's 2017 article 'Ways to Remember' in *RIBA Journal*, to which I contributed. The article tried to decode what makes a successful memorial and how to approach and understand such monuments. Afterwards, we both agreed that there was still much scope to expand on this topic.

I have long been fascinated by the subjective connection between human emotions and the built environment – I always want to understand why and how some structures touch certain people's hearts. My career thus far has been preoccupied by this question and I have been involved in a number of memorial projects revolving around the commemoration of tragedies. For example, since 2018 I have been working with a group of Jewish volunteers who have ties with Slonim in Belarus, in an attempt to save a derelict 17th-century synagogue. Slonim was a vibrant Jewish town until, in 1941, the Nazis exterminated the entire Yiddish-speaking population of 22,000; the magnificent synagogue bears witness to this atrocity. As a team we have had heated debates about how to restore the synagogue – should we simply do a replica of a distant glorious past prior to the atrocities of the Holocaust? Or should we leave the scars of history alone, allowing future generations to draw their own conclusions?

Irrespective of our cultural backgrounds, we cast our own identity in one narrative or another, and remembrance is more about serving the needs of those living in the present rather than the past: our memories are interwoven with

curated narratives to help us navigate through life. Public memorials, in particular high-profile ones, are nevertheless physical manifestations of state-endorsed narratives, and remembrance, by default, cannot escape curation.

The irony is that memorials are built for posterity, yet history is constantly subject to revision. For instance, societal values and sometimes even the so-called historic facts, seen as unambiguous in a patriarchal society in the past, could soon become obsolete within one generation: erecting a statue for a male slave trader was once perfectly acceptable, but this is no longer the case. In the same way, what we consider self-evident nowadays might be called into question in the future.

Architectural education worldwide has become increasingly homogenous since the days of the empires and therefore western, modernist values as well as aesthetics have left their marks in most architects' training around the globe. It is no surprise to identify as many similarities as differences in their approach to memorial designs; to some degree we can see critical regionalism at play wherever we go, which at its core, is still fundamentally modernist.

One exercise that Michèle and I organised was a memorials walk around London's parks for my undergraduate students at the University of Westminster, taking in notable landmarks from Edwin Lutyens' Cenotaph (1920) to Carmody Groarke's 7 July Memorial (2009), designed almost a century apart but sharing similar qualities of simplicity and restraint. A surprising outcome of this event was my students' change

in opinion between assessing the memorials at face value and again after critically examining their context and their design processes. In their original approximation, classical references were 'appropriate'; this reading changed on closer reflection. One aim in this book is to prompt similar processes within the reader, provoking reassessment of thought when considering memorial structures.

Whether we personally believe one to have more architectural 'merit' than the other is to some degree immaterial – it is ultimately for the reader or visitor to decide, once acquainted with the context. Moreover, as our memorial walk demonstrated, challenging preconceptions about what constitutes 'memorial architecture', or indeed 'architecture' can be a healthy exercise.

Two memorials which I have designed are the Belarusian Memorial Chapel in London and the Pan-European Memorial for the Victims of Totalitarianism in Brussels. The former was a direct commission where time was not an issue, enabling me to immerse myself in Belarusian culture. The Belarusian diaspora community emerged soon after the Second World War, during which Belarus lost a quarter of its population. Still haunted by the memory of the atrocities back home, they converted one of the rooms in a large house into a makeshift Eastern Catholic church. It was their collective hope to one day have their own purpose-built place of worship. Forty years later, Belarus was devastated by fallout from the Chernobyl nuclear disaster.

My research took me to the country on an extensive field trip, passing through rural Belarus as if I were a documentary filmmaker, but instead of a camera I used pencils and a sketchbook to record my visits to buildings, as well as people's testimonies.

The Pan-European Memorial in Brussels, on the other hand, was an open international competition with attendant deadlines. The site, Jean Rey Square, was chosen due to its close proximity to the key EU institutes in the European quarter of Brussels, and my challenge was to create a memorial that could connect at an emotional level with the many, unrelated passers-by.

At that time, I was also becoming increasingly doubtful of the relevance of authorship in memorial design. Rather than seeing myself as the creator of the memorial, I considered myself as a messenger, carrying a suitcase full of letters written by the victims to their loved ones to scatter them over the square.

My team reached out to victims' families and archives, soliciting permission to use their letters. In the process we were buoyed by an outpouring of support and garnered permissions to use almost 40,000 letters to form the basis of this memorial. No abstraction, no symbolism, just letters enlarged and reprinted on the ground.

Immersion in the subject would give designers the best chance to instil their memorials with human resonance. It is almost impossible to define or quantify the success of any memorial, but for me, one can only do justice to any memorial project if one approaches it with total dedication and humility.

Drawing by hand is an integral part of my research and design process; I prefer sketching ephemeral moments to taking photographs when I visit sites or people – as I did in Belarus, for instance – as drawing on location is the prism through which I see the world.

Drawing can take us to a place beyond the reach of our languages, and drawing by hand, in particular, is the most direct and 'innocent' way of liaising between one's vision in mind and the outside world.

No two people experience a memorial through the same lens, let alone two cultures. Language in no small part shapes a culture, and yet it has its limits in understanding the world, as asserted by Ludwig Wittgenstein: 'What we cannot speak about we must pass over in silence', or in this case, through drawing.[1]

1 *The Messenger* – concept drawing for the proposed Pan-European Memorial for all Victims of Totalitarianism in Brussels (charcoal on paper) the RIBA collections, Victoria & Albert Museum, London

Remembrance Now
Memory and Design in Dialogue

INTRODUCTION

MW: In Greek mythology, the goddess Mnemosyne was the mother of the Muses. Without Memory, there can be no art, music or history, no poetic expressions of love or tragedy.

Memorials are physical mnemonic devices. They are structures which attempt to materialise the insubstantial and ineffable construct that is memory, and as such they inhabit a world of complexity, nuance and paradox. Their origins lie in human suffering, yet their forms evidence creativity and inspire wonder. Their association with tragedy and mourning is incongruously juxtaposed with their cheerful and life-filled settings in urban centres and parks. And, while their ostensible purpose is the remembrance of people or events which have passed, it is the living whose needs they fulfil.

Memorials are also liminal structures in that they manifest a threshold between the physical temporal world and the ethereal realms of past recollections. They mediate between states – such as loss and mourning, and acceptance and healing – as if facilitating a rite of passage. They are places of communion between the living and the dead, twilight zones between here and wherever souls reside, one-way portals to the River Lethe. Like tabernacles or shrines, memorial sites are numinous places, borderline sacred ground.

Of course, memorials sit within a wider social framework, which allocates to them a range of additional duties: education, encouraging civic participation, establishing group identities. They play an active role in a complex network of relationships, from the personal, where they provide consolation and hope to individuals, to the international, where they link global populations. Memorials are multifaceted and heavily loaded items of material culture.

Such structures are also a product of, or response to, their political context. Oftentimes subject to manipulation by parties seeking to propagandise, cement a legacy, revise history or control a narrative, memorials are also vehicles for speaking truth to power. The most powerful memorial architecture surmounts unavoidable politics with sensitivity and meaning.

But at the centre of it all is that alchemic element called memory.

MEMORIES INDIVIDUAL AND COLLECTIVE

TS: There is a quote from Nobel Prize-winning author Gabriel García Márquez which really speaks to me: 'What matters in life is not what happens to you, but what you remember and how you remember it.'[1] The facts are of secondary importance; what counts is how they are remembered and applied. Memory cannot escape curation. It is always processed and edited.

This reconstructive account of memory is largely accepted by memory scientists.[2] Autobiographical memories are not possessions that we have or do

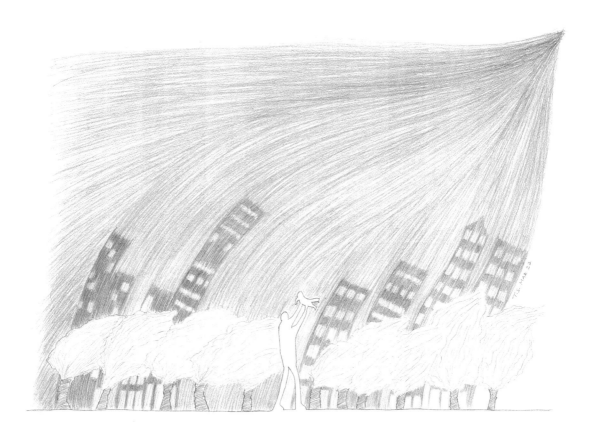

2 *Ancestors* (pencil on paper, 420 × 594 mm)

not have; they are mental constructions, built in the present moment, fulfilling the demands of the present.

Remembering is like unfolding and refolding an item of clothing kept within a drawer – each time its creases fall in slightly different places. When we access a memory, it presents itself in narrative form. We subtly mould the memory, tailoring the story.

Márquez's quote sums up the reason for having any memorial at all; the memorial is a method for curating narratives of the past, placing memory at the service of the present.

MW: Susan Sontag observes that 'What is called collective memory is not a remembering but a stipulating: that this is important, and this is the story about how it happened, with the pictures that lock the story in our minds.'[3] The term

'collective memory' is used a lot, but is it truly memory? Is it an agglomeration of synchronised memories, where individual recollections are subsumed into an entity with a life energy of its own – a subjective history?

TS: For me, 'collective memories' are neither collective nor memories, they are myths. Be it family folklore or state narratives, they are versions of events arrived at by general consensus. You can have individual memories, or collective tales. Of course, there is a huge amount of academic debate about it; I am likewise sceptical of the term.

I experienced exactly this communal narrative building while working on the memorial chapel with the Belarusian diaspora community in London (p.54). The project was about reliving a constructed memory of their history by common consent, passed down to them by first-generation Belarusians with a strong sense of national identity who arrived after the Second World War. Their narrative is significantly different to the one endorsed by the ruling regime in Belarus.

'BEFORE MEMORY, TRUTH'[4]

MW: Philosopher Jean-Paul Curnier – writing about Rudy Ricciotti's Rivesaltes Camp Memorial (p.84) – suggests that 'collective memory' is akin to a confiscation of individual memories. Because we are bidden to remember things outside of our own sphere of existence, we colour, simplify and appropriate the memories of others.[5]

Memorial architecture is often tasked with recasting unspeakable memories in a format fit for public consumption. The architecture of the Rivesaltes Camp Memorial attempts to provide closer access to the truth preceding the memories through its inscrutability and muteness.[6]

TS: Soviet filmmaker Andrei Tarkovsky said that he was fascinated by the impossibility of transferring experiences. 'We must live our own experience, we cannot inherit', he said. 'We cannot impose our experience on other people, or force them to feel suggested emotions. Only through personal experience we understand life.'[7]

A father can share painful experiences verbally with his child, but he cannot fully communicate the pain to prevent his child from making the same mistake as himself. This is why memories cannot be collective, and why memorials can only ever go so far in preventing future tragedy. The memorial proclaims 'never again', yet terrible things happen again and again, because of this impossibility of transferring experiences.

MW: An example that illustrates this for me is the memorial synagogue in Babyn Yar, Ukraine (p.51). It was inaugurated in 2021 and almost bombed in 2022, to the bewilderment of its architect Manuel Herz, who found himself asking: 'What is the point of commemorating history, if the lessons to be learned are forgotten and ignored so easily?'[8]

TS: Indeed, what is the point? 'It might sound so obvious to say, but the memorial's only purpose is to stop people forgetting. If it doesn't stop people forgetting, then it has no purpose', said Andy Groarke in his interview (pp 34–7). In a memorial's purest sense he is right; if a memorial loses its mnemonic function, it is redundant.

A memorial is part of a package of remembrance, but not the full package. In some cases, it's only through the collective rituals undertaken at the memorial that memories get revived. The memorial gets activated if there is an audience, and people react to what is presented, and start remembering.

MW: In some ways, anniversary rituals allow society to stow traumatic memories away; we can spend most of the year untroubled, during which time the memorial is dormant, only to revive the memory as often as is deemed necessary. If society was continually faced with remembrance

obligations, it would become burdensome. Scheduled, permissible amnesia is liberating in a way.

IDENTITY AND NARRATIVES

TS: Memorials have a lot to do with identity. Which is why memory loss is destabilising – it entails an erasure of identity. When we erect memorials to ancestors or loved ones we are also doing it for ourselves, for our sense of identity. A gravestone is memorial architecture in its most basic form, and the identifiers on there – 'our beloved grandmother', etc – are really important. We want to remember our family members because the personal relationship we had is important to us, sure, but also because our past shapes our identity as the son of someone, the grandson of someone . . .

For public memorials this is scaled up, which is what political scientist Benedict Anderson was getting at in his work on imagined communities. From him we have learned that a community starts as a household, it becomes a village, then a nation; in order to establish and cultivate an identity, so that the collective can work as a unit, you need a narrative. We see an example of this in practice in the Wang Jing Memorial Hall, China (p.146) where a historic narrative was revived to reinject some life back into the community, and in Barcaldine, Australia (p.142) where a memorial replaces a lost historic landmark.

The whole question of narrative building is therefore crucial to nation building. The Chinese author Bo Yang once opined that, although some historians were reluctant to give weight to national myths or narratives, myth was the soul of a nation. 'If the history of a nation does not include myths, this nation is nothing more than a group of puppets', he said.[9] Without stories and tales, you cannot have a nation or national identity. Memorials help to fill that space. Memorials bring people together and centres this sense of identity and belonging.

MW: It's interesting to see these complexities explored in such different ways among the memorials we have studied: Kengo Kuma's Singapore Founders' Memorial (p.128 – due for completion in 2027) uses landscaped pathways to allude to the fact that Singaporean identity stems from many different directions. Its proposed location at Bay East Garden was chosen for its greenery, presenting Singapore as a 'Garden City', which also overlooks the iconic Marina Bay skyline, so it is likewise celebrating Singapore's path to economic success.[10]

The Emirati war memorial complex, Wahat Al Karama, by bureau^proberts and sculptor Idris Khan (p.144), integrates memorialisation with politics, culture and religion. Its monumental leaning forms communicate Emirati solidarity and interweave the poetry of past and present rulers with Qur'anic inscriptions.[11]

The National War Memorial, New Delhi – which formed part of Prime Minister Narendra Modi's election pledge (p.118) – derives inspiration from Hindu concepts of rebirth and chakras. While fulfilling the desire to step away from a colonial past, it grounds sacrifices of soldiers with Hindu belief systems, inserting the origin myths of the Mahabharata into India's national narrative – a country which is in fact a secular democracy.

So yes, national memorials are equally concerned with creating and elaborating a national identity as they are with commemoration. They are about creating national heroes, tying them into a belief system and solidifying them within architecture. Memorials physically root memories into the soil of a nation.

POLITICAL NARRATIVES

TS: In the early 20th century, many memorials cemented the officially endorsed narrative of the 'might and glory of empire for the children of empire' in a top-down approach. Now politicians

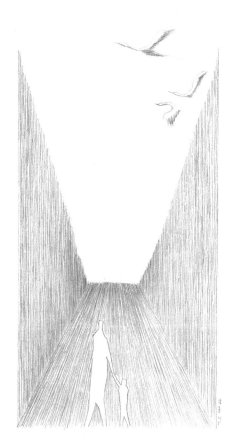

3 *The Cranes* (pencil on paper, 420 × 594 mm)

try to use memorials to do many things in one go: they want to be seen to create memorials in response to popular desire, and they seek to own or steer a narrative as well.

While memorial design has largely moved on from these imperialist memorials, which dictate to the viewer what to believe – such as a bronze statue or a cannon on a marble plinth; those sort of memorials are like a one-liner – contemporary national memorials still present a very controlled, rehearsed narrative. Even if the design is more abstract and invites interpretation, the narrative is still very scripted.

With any memorial, much hinges on how they are initiated, commissioned, designed, constructed and funded. To understand them fully, these socio-political factors need to be examined and questioned.

MW: There is an enormous irony to war memorials given that the same authorities erecting monuments to past conflicts continue to engage in new ones. These kind of cynical actors 'do nothing but build to destroy' (as Bob Dylan puts it in 'Masters of War' – a song I frequently find myself coming back to). 'Politics' can sound like a dirty word when juxtaposed with a quasi-sacred notion like 'remembrance'; realistically, politics are omnipresent but not pathological by default. Even the selection of memorials in this book is, in a sense, political.

Many memorials exist to hold politicians to account. The Thunderhead 2SLGBTQI+ National Memorial (p.138), destined for downtown Ottawa, is the result of a class action lawsuit against the Canadian government for decades of institutional discrimination.

The National Memorial for Peace and Justice, in Montgomery, Alabama (p.112), appeals to the conscience of leaders in counties where historic lynching occurred, inviting them to install columns from the memorial in their community. Yet it will eventually become apparent who has accepted or refused to participate – implying a denial of culpability.

And due to my own political interests, I am particularly drawn to l'Anneau de la Mémoire (p.40) by Atelier d'Architecture Philippe Prost (AAPP), which makes a strong statement about European solidarity, all the more relevant today. Prost's studio has said, 'Responding to the ambition to make a strong political statement we conceived of this unique work . . . to constantly remind us of the importance of peace, and to offer to Europe a peaceful vision of the future.'[12]

Such political memorials can have a positive outcome to improve representation, educate, redress past political wrongs and deliver justice.

TS: There can never be a 'perfectly' apolitical public memorial. Political agendas manifest to a greater or lesser degree depending on circumstances. National memorials involve government authorities and large committees of stakeholders who commission an architect or an artist to design a prominent structure that has to be relevant on a population level. Local special interest groups or private benefactors sponsoring smaller-scale memorials also have their own agendas.

It's easy to be cynical. But, as you say, they have the potential to be positive, however political they are. Memorials could play a pivotal part in a much wider awakening moment in humanity.

AN AWAKENING MOMENT

MW: 'The monument is no longer a representation, it is an experience of time and place that is available to everyone', David Adjaye has said, '. . . whether it's for a nation, a race, a community, or a person, it is really used as a device to talk about the many things facing people across the planet.'[13]

He is acknowledging the memorial as part of a wider dialogue, about how nations, groups

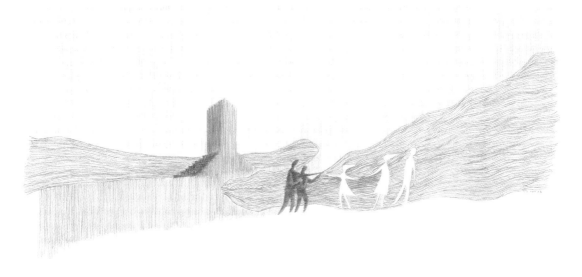

4 *The Departed* (pencil on paper, 420 × 594 mm)

and individuals shape a narrative and define an identity fit for this century. Societies across the world are questioning commonly held narratives, with a consequent shift in how and what we commemorate.

I hope and believe that the average person has a better understanding of diversity and equality than they ever did. It's my observation that this diversity is reflected in architecture – 21st-century memorials apply a broad range of forms, materials, scale, subject matters, sites, contexts and architectural approaches. Some are counter-monumental, in that they react against established tropes and belief systems.

There is also more focus on experiencing the space, an effort to speak directly to people's emotions, an awareness of nuance and subtlety, an attempt to provoke introspection, raise questions and encourage a breadth of responses. Didactic elements, although still there, are often less heavy-handed or more oblique.

TS: Inevitably memorial design is involved in the relationship between architecture and the art world. In the 19th century it may have been about statues and classical references, but modernism changed that – whatever is relevant at the time in creative circles finds itself in the designs – so there is a fluid and circular exchange between art movements, memorial architecture and societal circumstances.

Memorials have always been a typology, but one that has changed radically in recent decades. Our 21st-century designation is of course a little arbitrary – it simplifies our selection here, but significant change didn't start suddenly in the year 2000. There have been shifts in sentiments and design thinking throughout the 20th century. 9/11 was an emotional watershed moment, particularly in the west, but it was a catalyst event that manifested all these changes in humanity, not the cause.

The internet also impacted memorial culture by changing the way we consume and process information. People have more access to information (but not always the tools to discern or digest it). We have more access to harmful fake news, propaganda and sophisticated – some might even say corrupted – social media algorithms, which ultimately lead to polarised viewpoints and culture wars. Where extremist viewpoints arise, we must counteract them urgently.

Today, things are more intensified, events happen much quicker and their implications span out in multiple directions, given that people are connected globally. And it is easier for people with particular interests to identify each other and connect; 'Hashtags don't start movements. People do', said Alicia Garza, the cofounder of Black Lives Matter.[14] Issues come to light, victims get together, communities join forces and push for change – this can take the form of a memorial.

MW: In his interview Andy Groarke expressed a similar view on warfare in the information age (p.34): 'A lot of modern conflict has more nuance, so it's not necessarily fought in physical ways and therefore physical imagery can't be brought about to form those figurative reminders and points of reconciliation.' Warfare today is complex; 'straightforward' approaches are no longer always suitable, which calls for a different visual language. The memorial design process demands more complex thinking, resulting in a multiplicity of approaches.

YESTERDAY'S MEMORIALS

MW: Let's detour, then, via a small selection of 20th-century memorials, which lead us to this point. Charles Sargeant Jagger's work adopts the figurative approach of his era but in radical ways; the Royal Artillery Memorial, London (1925) borrows the language and materials of traditional monuments, but, rather shockingly, depicts

a dead soldier underneath a full-size stone howitzer.[15] I see parallels between this vulnerable portrayal of soldiers and Frank Gaylord's Korean War Veterans Memorial in Washington, DC (1995), which is also a city saturated with celebratory monuments. The soldiers trudge wearily through the scrub, alongside the inscription 'Freedom is not free'. It is haunting and eerie.

Edwin Lutyens' monumental memorial architecture – such as India Gate (1931), Thiepval (1932) and Villers Bretonneux (1938) – define their landscapes. The Cenotaph, London (1920) embodies Lutyens' elegantly sparing approach and is now the centre of state remembrance rituals, and replicated the world over (despite the original structure intended to be temporary).

Kenzo Tange's masterplan of the Hiroshima Peace Centre and Memorial Park (1955), including the iconic arch and raised museum, was a radical attempt to weave a scene of destruction – the skeletal Genbaku Dome ruins – into a new, urgent, narrative of peace and modernity.[16] Another modernist example, Georges-Henri Pingusson's Mémorial des Martyrs de la Déportation, Paris (1962), has influenced countless others with its bunker-like appearance, its descent via a narrow stairway into what resembles a prison or crypt, its orchestrated route and its emotive power.

Daniel Libeskind's deconstructivist Between the Lines design for the Jewish Museum Berlin (2001) – although not a memorial per se – makes use of dramatic verticality, physical emptiness and experiential sequences in ways that have informed his subsequent memorial architecture.

The museum's zigzagging floor plan creates voids at points of intersection with an invisible straight line running through it; in the Memory Void, visitors to Menashe Kadishman's installation Shalekhet (Fallen Leaves) walked among 10,000

metal faces on the ground, experiencing unsettling sensations and sounds. This building opened Libeskind's career as a leading memorial architect.

In northern France, fields of identical white First World War-era headstones defy belief with their number. A pile of 5,000 human skulls – victims of the brutal Khmer Rouge – housed in the Choeung Ek Buddhist stupa in Phnom Penh (1988) is equally breath-taking in its tragedy and horror, with friendship bracelets tied to killing trees adding further poignancy with their bright colours and makeshift nature. Both honour the dead in radically different ways; both are an exhortation and an appeasement of souls.

TS: Above all, Maya Lin's Vietnam Veterans Memorial in Washington, DC (1982) was a fundamental turning point in the way that architects conceive of public memorials; she challenged a lot of preconceived notions about the function and appropriate aesthetics of memorials.

We could have started the timeline of our book with her memorial, rather than at the turn of this century, as Lin set the tone for the next few decades, and even defined an era. Her monument lists the victims in chronological order rather than rank, and the polished granite surface allows visitors to see their own reflections behind the names they are reading – it is a highly personal experience.

Lin's memorial was one of the first major memorials in the west to make a deliberate departure from the orthodox figurative and symbolic form. Instead, it adopted an anti-monumental approach, making a cut in the ground (albeit a figurative statue was later installed at the site, to counterbalance the negative sentiment from veterans and critics towards Lin's unapologetic, abstract language).[17] Lin's influence looms large in subsequent major memorial commissions worldwide.

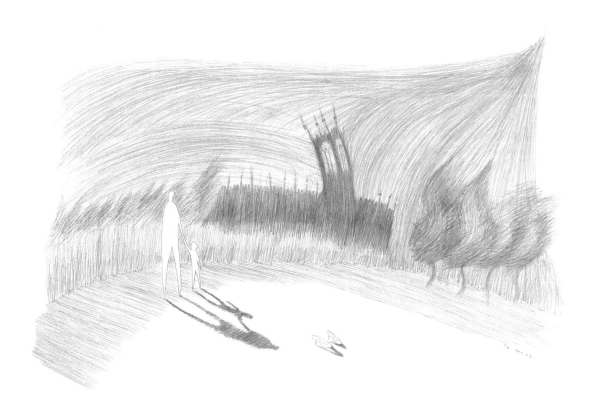

5 *Mama's High Heels* (pencil on paper, 420 × 594 mm)

I question whether she would have won the competition had it not been judged blind – that is, had the jury known she was a 21-year-old Chinese American female undergraduate at Yale.[18, 19]

MAKESHIFT MEMORIALS

MW: Satisfying critics and stakeholders is an almost impossible challenge within memorial design, which grassroots memorials that emerge spontaneously at certain sites initially escape due to their immediacy. Most people find these very affecting and are compelled to contribute.[20]

TS: When people construct makeshift memorials in the immediate aftermath of an event, you could say that is a memorial in its most 'pure and innocent' form. Seeing these genuine responses moves people's hearts, because the constructions are, by and large, immediate and unmediated (although even these could be steered politically). This begs the question about who is responsible for driving the memorial when you start to immortalise a memory. There is the risk of introducing a singular voice, or one which only represents a small minority of decision makers. Memorials have the biggest positive impact when they are not curated top-down, when they are fortuitous, when they do not say more than necessary.

MW: It's as Erica Doss (who wrote the definitive scholarly work on America's memorials) describes: 'the mundane, familiar things of which they are made, trigger personal associations'.[21] Artist Peter Majendie's installation 185 Empty White Chairs, Christchurch (2012) (p.38) harnesses the emotional potential of familiar household items to trigger memory. Although it began life spontaneously, it resonated with the public far more than anybody anticipated.

One online comment deems it 'the only really meaningful memorial'.[22]

A wholly different engagement with 'spontaneity' is the Nyamata Church Genocide Memorial Centre, Rwanda (p.122). The architects were tasked with halting 25 years of decay to preserve the memorial as it was during the Rwandan genocide. It attempts to present an authentic, un-curated space to the visitor – although that approach in itself is a type of narrative curation.[23]

TS: The American pragmatists from Harvard of the late 19th and early 20th centuries, such as William James, challenged the long-held notion of knowledge as impersonal fact, arguing that in reality we acquire our knowledge as participants, not as spectators. The same paradox also applies to memory. It is fluid rather than static, depending on our lived experiences. The idea of permanence therefore contradicts this fluidity and turns everything into something incorrigible. In effect, this means our interaction with history and with tragedy is an ongoing daily construct of the present; therefore the idea of having a permanent memorial arguably contradicts that notion.

REMEMBRANCE NOW AND THEN

MW: Does an individual wish to be remembered forever, in ways they have no say in? The so-called permanence of a memorial, and its associated rituals, could become unhealthy – hindering social cohesion, prolonging enmity, overemphasising gratitude to the point of resentment . . . the memorial could be a millstone.

It's not a new consideration; the American writer Carl Sandburg's 1918 poem 'Grass' expresses the sentiment of needing to forget and heal, with the line, 'Two years, ten years, and passengers ask the conductor: What place is this? Where are we now? I am the grass. Let me work.'[24]

And a permanent reminder of a trauma could exacerbate that trauma, as was the case with artist Jonas Dahlberg's Memory Wound. In June 2017, the Norwegian government controversially cancelled his competition-winning entry for a memorial to the victims of the Utøya massacre, after local disapproval. His landscape intervention proposed an irreversible 3.5-metre slice through the Sørbråten peninsula, which ultimately proved to be a too literal manifestation of the scars and social rupture of extremist violence.[25]

HEALING THROUGH NATURE

MW: Conversely, The Clearing by 3RW (p.136), also on Utøya – which takes the form of a ring suspended among pine trees from which forest, sea and coast can be viewed – seems to have satisfied the community's needs more aptly. Embracing nature and harnessing community spirit were overt strategies to assist the healing process. 'We [proposed] a landscape-friendly memorial, built through volunteer work and community – the true spirit of the Norwegian society', said the architects. 'The memorial at Utøya should show [how] nature slowly changes time and the memories.'[26]

Many memorials connect nature with healing (the 9/11 Memorial Glade for instance) or derive inspiration from nature's cycles of birth and rejuvenation. Although, sometimes it has to do with offsetting carbon emissions of the project.

One unusual case was a memorial for a melted glacier in Iceland, 2014; 700 mourners attended the ceremony. 'We struggled with how to process the loss of Okjökull. What could we do?', wrote anthropologists Cymene Howe and Dominic Boyer. 'We decided on a memorial plaque for little Okjökull because memorials are monuments of mourning, recognizing lost lives or historical events; very often memorials materialize pride in human accomplishment . . . we wanted to recall that climatological collapse is also a human

accomplishment, though one we would be foolish to take pride in.'[27]

TS: Well, construction projects are one of the main contributors to global carbon emissions so we have to justify any building project, because we are mortgaging our futures in carbon.

We could even go so far as to question the relevance of physical memorials at all. Digital memorial projects already exist – the US-based National AIDS Memorial Quilt, for instance, can be experienced online. We could design digital memorials using AI, and members of the public could experience them in VR. Maybe that is what will happen in future.

We are balancing two different moral imperatives: remembrance of the past versus thinking about the future.

THE PHYSICALITY OF GRIEF

MW: We've talked about the social aspects of public memorials. Let's now consider personal responses to them.

Everyone encounters loss in their lifetime, but it is endured alone. On the death of his wife, Joy Davidman, C.S. Lewis wrote: 'Grief is like a long valley, a winding valley where any bend may reveal a totally new landscape.'[28] The emotional pilgrimage begins as a series of cul-de-sacs – truncated conversations – yet wends over time towards something more spiritual.

A memorial is like a physical marker on this journey towards acceptance. Commemorative artists frequently observe that the process of commissioning a headstone is cathartic for bereaved family members, bringing a certain comfort in the achievement of the memorial art-piece that aspires beyond tragedy.[29]

While memorials provide a locus for mourning, they are, naturally, not the only place where loss is felt; but simply knowing they are there can also bring relief.[30]

Grief is a bleak state with no apparent prospects; seeking stability, we reach for something tangible. In wars, natural disasters and terror events, loss occurs abruptly, unfairly, arbitrarily, to a large number of people. This shakes us existentially and raises metaphysical doubts on a grand scale, about nihilism, fate and the existence of justice.[31] A public memorial becomes a focal point where open expressions of mourning are acceptable, and stands as a public recognition of an incomprehensible event.

It's as Max Porter's narrator says in *Grief Is the Thing With Feathers*: 'I missed her so much that I wanted to build a hundred foot memorial to her with my bare hands. . . . Everybody passing could comprehend how much I miss her. How physical my missing is.'[32] Loss itself can be felt physically, hence the importance of physicality in remembrance.

In her memoir *Notes on Grief*, Nigerian writer Chimamanda Ngozi Adichie observes: 'Grief is a cruel kind of education. You learn how ungentle mourning can be, how full of anger. You learn how glib condolences can feel. You learn how much grief is about language and the grasping for language.'[33] (Adichie's book *Half of a Yellow Sun* was included in David Adjaye's Gwangju River Reading Room, p.65).

Her comment on language, and its limitations, is very pertinent to me, as a writer. Communicating the extremity of emotions associated with loss is arguably impossible using words alone.

In terms of memorials, some actively rely on language for their meanings to be understood, for their memorial function to be activated. The Memorial to Victims of Violence in Mexico (p.92), for instance, relies on members of the public to write their own messages on the walls; heart-rending missives in chalk – such as 'Where

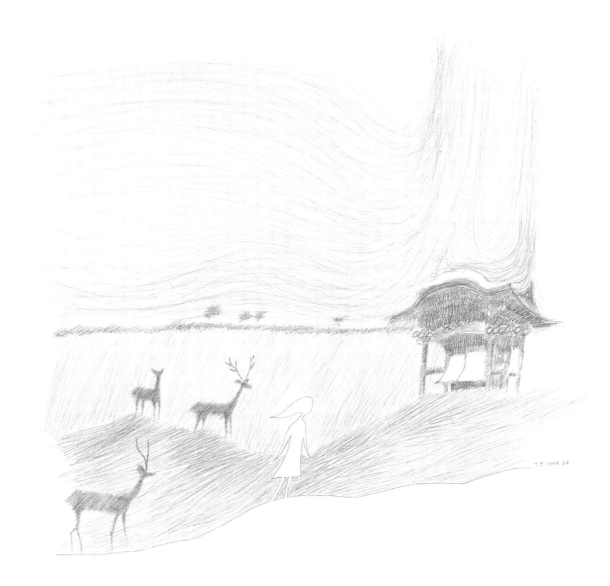

6 *Deer Share My Grief* (pencil on paper, 420 × 594 mm)

is my son?' – make a direct appeal to the viewer's conscience. Other memorials integrate words into their architecture, such as Daniel Libeskind's recent Dutch Holocaust Memorial of Names (2022) which spells out the Hebrew words 'In Memory Of' through its structure.

Yet in many other cases, memorial architecture eschews language and opens a direct channel to the emotions of its viewer. It is capable of communicating something further, beyond the limitations of words.

THE LANGUAGE OF MEMORY

TS: Actually, the link between language and the construction of memory is fundamental. When we think, we shape our thoughts using language; the language system in which we grow up gives us a certain perspective, which then shapes our understanding. 'Memories are recalled in the language we had available to us at the time of encoding', says psychologist Catriona Morrison.[34] As soon as we acquire our mother tongue, we begin to have an entirely new way of encoding,

organising and retrieving information about the past – a new way of remembering.[35]

The way that one thinks in Chinese, for instance, is very different from in English. It has to do with vocabulary, grammar, adjectives and so on. The language is a lens; you see the world through that lens. As Wittgenstein already said for us: 'The limits of my language are the limits of my world.'

CONSTRUCTING EMOTIONS

TS: I have long been interested in the relationship between emotions and architecture. To some extent I think architecture can transcend language barriers, but on the other hand language also shapes our emotional response to things, including buildings.

You mentioned earlier that grief is part of the human condition. But Tahitians, for instance, have no direct translation for the word 'sadness'. Professor Lisa Feldman Barrett, an authority on this subject, observes therefore that Tahitians do not share the same concept of 'sadness' in the western sense.[36]

Neuroscientists have confirmed this long-held understanding of human nature – that we are subjective animals, and our emotions are cognitive constructs heavily linked to our cultural upbringings and personal memories. Feldman Barrett argues that the human brain is a cultural artefact, that emotional concepts are learned, that they cannot be universal, and that emotions vary from culture to culture because words represent concepts, and concepts are tools of culture.

I believe that there is a lack of awareness amongst architects of how emotions are constructed in the brain. As designers we would do well to look at some empirical studies, or read the works of neuroscientists and psychologists on memory, emotion, complicated grief, trauma and neurodiversity, so that there is less of a

disconnect between the disciplines.[37] There is already a mounting interest in the application of neuroscience to architectural design (in terms of materials, spatial organisation and so on) and how this contributes to mental wellbeing. The field of neuroaesthetics is growing in importance.[38]

A similar approach should be taken to address how emotions and memories are linked and affected by architectural spaces. Architects continue to allow their subjective biases to guide/misguide them, but perhaps, rather than asking what moves people, they should ask why and how people are moved.

UNIVERSAL APPEAL AND 'RECEIVED WISDOM'

MW: Many memorials from across the world use homogenous symbols and tropes such as eternal flames, running water, confined spaces or views of the sky. Are these symbols really as universal as they seem?

TS: If you sit inside a confined cell with a tiny window, yes – compared to sitting in an open grassy field, you will feel different, and that experience will probably be negative. But that is an obvious and simple example. When it comes to activating memories, the responses are much more complex. I do question how universal memorials can be. You will not be able to fully experience a space in the same way as someone who speaks a totally different language brought up in a totally different culture. Nuances are there; we can't ignore the lens of language, and feelings or emotional responses (such as expressions of sadness), which seem universal at first, maybe aren't. All of us remember, but the way we remember (what sparks our memories, and what dictates the emotions that arise) could be very different depending on our cultural background.

It seems that there are some memorials which are engaging despite one's background, and my

argument for that is that western culture is really dominant wherever you go around the world. Many architects are trained in a western fashion, but translating that sensitivity to a different context may not always work.

Due to globalisation, a lot of memorials seem homogenous – they follow certain universal patterns that you couldn't necessarily say are definitively from one place or another. A skyscraper in Dubai or London or Shanghai could be anywhere. This is an uneasy observation. Is it good or bad? We don't know.

Also, the more international architectural competition juries are, the more likely they are to select a response that is more global and less culturally specific. The 'best' responses marry these influences with a contextual and sensitive response.

'Received wisdom' teaches us that certain aesthetics – such as austere minimalist interior spaces or exterior facades – are 'emotionally charged', a notion echoed by teachers or journalists who are the disciples of this kind of aesthetic, without appreciating that what might be appealing to one particular group of people, for another group might be meaningless. But I also don't think there is a contradiction, because I don't think any structure can be universally appealing; if you believe that, you are setting yourself up for failure.

EMPATHY, CONTEXT

MW: Indeed, and often what appeals to architects' design sensibilities does not necessarily gel with popular opinion, for better or worse. There is a risk that, in following a relativistic argument to its logical end, we could conclude that it's impossible to produce memorials of meaning, which isn't something I believe. The fact that Maya Lin's memorial, for instance, has subsequently been so well received, despite the initial clamour, is

testimony to the fact that it is possible and legitimate for a person, of a given ethnicity, gender or age, to create a meaningful memorial on behalf of others who are different.

'We, as architects, can understand other people's experience or empathise to a degree that we can offer something that will address their needs, even if we cannot ever truly experience what other people are experiencing', said Michael Arad in his interview (pp 105–7).

Even if experiences cannot be transferred – to borrow Tarkovsky's expression – thankfully we do have the capacity for empathy.

TS: In the monument's interpretation we are limited; we are bound by our worldviews. But as designers we are not powerless. One of the biggest challenges for architects and artists is to create memorials in physical forms that strike a chord with members of the public from all sorts of backgrounds unknown to the designer. Full, dedicated immersion into researching everything surrounding the event is essential.

It is generally easier for the architecture to connect with the visitor if the memorial happens to be erected on the spot the tragedy took place, as context plays a huge part in priming people's responses. But when a memorial is destined for a site unrelated contextually, it poses an inherent challenge for the designer which needs to be carefully adressed. A memorial could end up becoming a monument to anything if it isn't contextual.

MW: WISE Architecture's War and Women's Human Rights Museum (p.149) demonstrates an interesting approach to dealing with a lack of context, as architect Sook Hee Chun explains in her interview (p.152). The site was a residential house with no connection to the museum at all. The architects created context by focusing on perceived notions of 'home', turning the domestic residence into an uncomfortable, literally *unheimlich*, setting, to emphasise the

trauma of the 'comfort women'. Most people understand the home as a place of security and comfort – or at least should have the right to.

In extreme cases a lack of contextuality leads to unwelcome responses, as has happened to Peter Eisenman's 2005 Berlin Memorial to the Murdered Jews of Europe (p.89) where a lack of contextuality and abstraction – a strategy of deliberate non-interference with the way the memorial is used – has given tourists a licence to behave inappropriately. Is it the tourists or the architecture that is to blame? Another uneasy question.[39]

AUTHENTICITY, EGO AND THE ARCHITECT

MW: So, what in your view enables an architect to capture or convey sincerity within a memorial's design?

TS: It is an interesting one. How can we make a memorial 'authentic' to that particular tragedy or event?

There will always be limiting factors: obviously, there will be a budget constraint, obviously there will be a political element, obviously the architect has a vested interest as he or she has a business and a professional reputation and a career.

If the memorial is to be 'honest' or 'faithful' in the way it commemorates, even in the context or framework of being commissioned by parties with their own agenda, the way to bypass or cut through any cynical elements is to understand emotion. If an architect or artist is serious and really cares about how other people feel in relation to the event being commemorated, they will need to understand how emotions are made.

Being authentic doesn't mean being original – trying to be original for the sake of it is very inauthentic. Authenticity is a quality fast disappearing from capitalist societies where almost every human quality has been commodified.

When designing the Belarusian Memorial Chapel and the Brussels memorial, An Echo in Time, it felt important to me that I, as the architect, should be more muted. That the designer should not intentionally try to propagate a particular narrative. One of the judges of the Brussels memorial (which incorporates letters written by those incarcerated by totalitarian regimes) said he liked the fact that the memorial presents something rather factual – it is what it is – but allows the viewers to draw their own conclusions. I think if a memorial is either overly symbolic or too abstract, if an architect starts to play these kind of architectural tricks, that is more harmful than helpful.

Art and architecture have both got the potential to be a selfish business, where egos reign supreme. As architects we are creating public spaces that people have to live with. The architect has to understand the limitations of self-expression and to reconcile that with the public and the clients, really.

'If you are obsessed with self-expression or with the ego', Moshe Safdie beautifully expressed in his interview (pp 165–7) 'then your priorities change. So, I think it's a given that a serious architect . . . will achieve a kind of self-expression because their being is in it, but it's a by-product rather than an objective'. For an 'authentic' memorial, the architect has to understand the needs of the client, and the public, and those being commemorated, and the context, and put those needs above those of creative self-expression.

ENDINGS AND REFLECTIONS

MW: I invoked Mnemosyne at the start, but I could also have summoned Janus, Roman god of thresholds, transitions, beginnings and endings. This conversation reflects how

meandering, forwards-and-backwards-looking and transformative the topic of memorials has been to research and write, and I have really enjoyed doing so.

The examples we talk about in this book make up such a small selection of today's memorial architecture – there are so many more, especially from a non-European setting which we would have liked to cover – but our choices have been deliberately varied. As we've said before, this book is not a 'best of' list which evaluates memorials' merits against one another, it is an attempt to demonstrate the wide array of creative responses to commemoration.

Architects are taking commemoration in new directions, exploring its possibilities and particularities in ways that earlier styles of memorial architecture didn't give adequate scope to do. They are expanding the conversation by contributing to a more representative understanding of history, and providing dynamic and active spaces, fitting for something as fluid and changeable as memory itself.

We've talked about how unique and individual memories are, and how memory itself is conceived of differently from person to person. So, it follows that, for architects, this theme can open up so many unexpected avenues of exploration leading to such diverse outcomes.

As Philippe Prost said rather poetically, 'The memory . . . within each architect is a resource. It enables us to transmit emotions, to create imaginative works, to ensure that the music stays original.'[40]

TS: Memorial architecture, as a typology, occupies a unique place within both visual art and architecture. Unlike 'straightforward' buildings, memorials have one primary imperative – remembrance. This lack of other functionality frees up the designer to conceive of far more creative and unpredictable responses.

The nature of memorials, so often associated with tragedy, forces the architect to think about existential philosophies, which aren't usually a preoccupation of day-to-day practice.

Those memorials that have come into being through a rigorous, empathetic, sensitive and intellectual architectural process certainly merit closer consideration and appreciation.

Adolf Loos wrote that 'Only a very small part of architecture belongs to art: the tomb and the monument. Everything else that fulfils a function is to be excluded from the domain of art.'[41] Memorials are a rare typology that blurs the distinction between the disciplines of architecture and art, and like art, memorial architecture can mediate between the sayable and unsayable, the knowable and unknowable.

1

7 July Memorial

Architect: Carmody Groarke
Location: London, UK
Year: 2009

Made up of 52 stainless steel beams, one for each of the victims of the 7 July bombings which shook London in 2005, Carmody Groarke's elegant and sparse memorial stands like a company of silent sentinels on the border of Hyde Park, shielded from the bustle of Park Lane by a grassy bank.

Minimal information is included on each stele: a date, a time and a location. Names are listed to the side. This anonymity is deliberate, to emphasise the random, impersonal and indiscriminate nature of terror.

The architecture of this sparing and thoughtful memorial explores, in multiple ways, different concepts of presence, selfhood and scale, and questions the nature of individual and community. Each beam weighs 850 kilograms, and at 3.5 metres tall, are at double human height, a relatable scale. This attention to the importance of scale takes a cue from the

7 The victims' names are listed separately to the monument. Typography designed by Phil Baines makes subtle reference to Edward Johnston's London Transport typeface

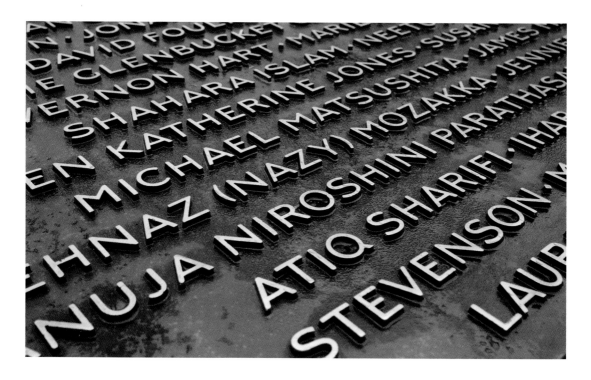

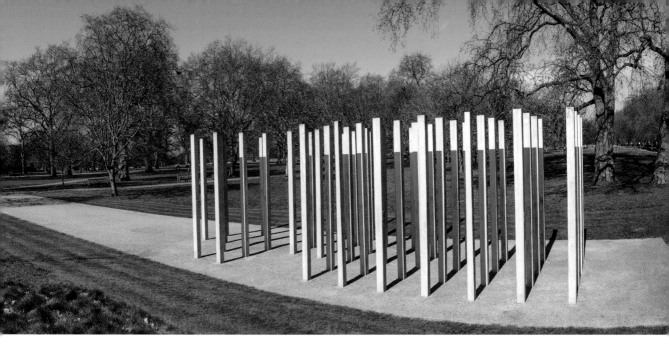

8 The 52 beams are grouped in four clusters according to the scenes of the tragedies, but together they make a cohesive whole. Their surface texture is unique

sculptures of Antony Gormley, who acted in a consultative role on the project, and whose artistic practice often explores how the human body is situated in space.

The stelae are grouped in four clusters, according to the four different locations that the bombings occurred: Tavistock Square and Edgware Road, King's Cross and Aldgate East tube stations. Each beam is oriented, within its matrix, to face a different direction. This requires the visitor to weave through the assembled stelae in search of written information.

'We wanted very much to capture the notion of the singular and the collective loss', said the architects. 'The memorial has a very complex message it needs to convey, that there are 52 individual lives being remembered and that there is also the sense of radiating collective loss across London and beyond.'[1]

The beams are all cast from the same mould, but their surface texture is unique due to an open casting process: while the victims shared the same humanity, they were individuals with unique and unreplicable qualities. Perceived

from a distance, the beams form a group, resembling petrified trees or ancient megaliths. But as one approaches, the solitary presence of each individual beam makes itself felt, as does the adamantine quality of steel, a material choice that is rooted within the context of London's architecture.

The architects worked hard to integrate victims' families within the construction process, inviting them to the Sheffield steel foundry where the stelae were cast. 'We proposed an architectural process of listening to the client, spending time with the client, and understanding these needs ourselves', said Andy Groarke (p.34).[2] This participation became part of the commemoration process.

Carmody Groarke's deceptively simple memorial belies a rigorous intellectual process, which successfully resolves competing and complex challenges, including: generating context in an unconnected site; using abstraction to derive meaning when sculptural representation is inappropriate; and equitably serving a disparate group of people, celebrating their diversity and uniqueness as well as their commonality.

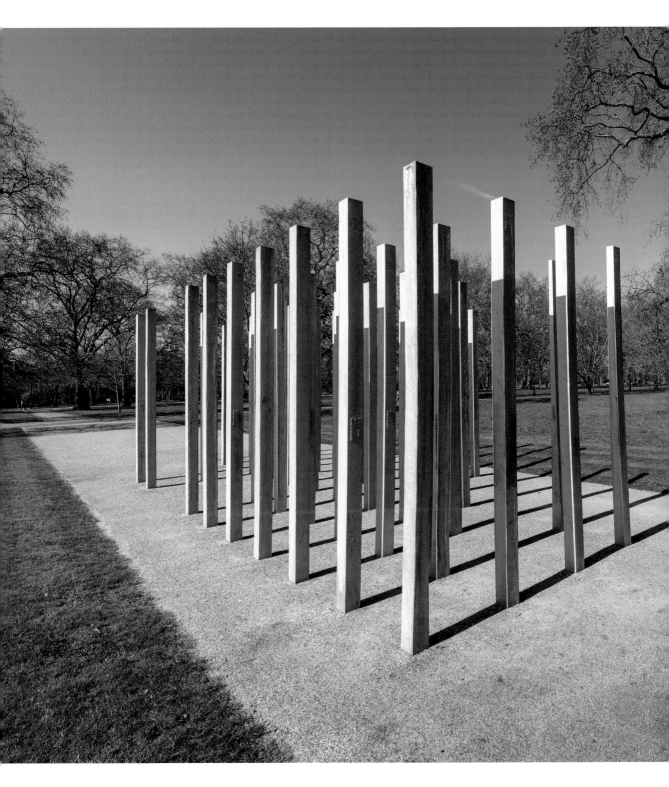

9 Carmody Groarke conducted substantial research
to find a suitable location within Hyde Park that would
create a sense of relative quiet

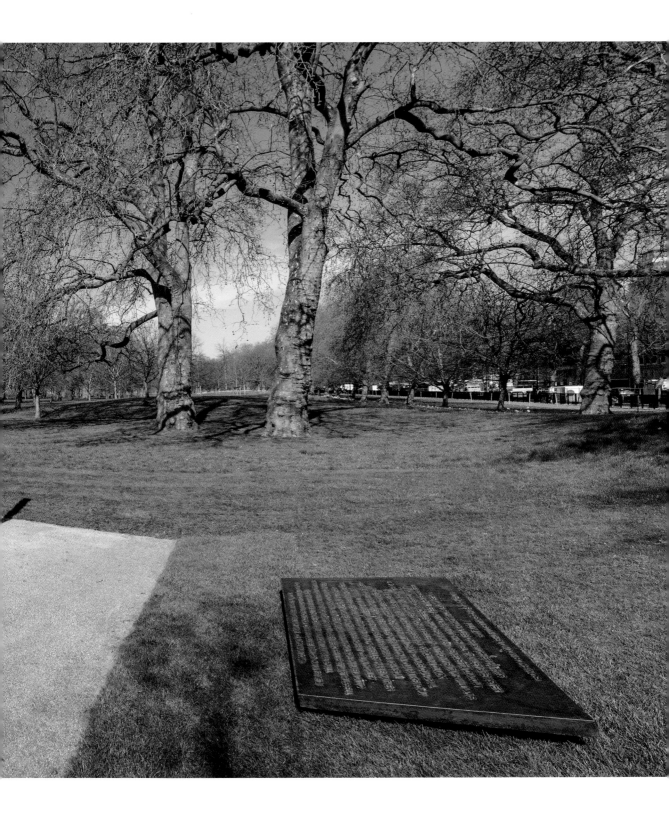

INTERVIEW WITH ANDY GROARKE, CARMODY GROARKE

Could you tell us how the monument's architectural identity evolved?

We pitched for the competition about 18 months into our practice. We were the only architects to be shortlisted – the other eight were artists – so we brought an architectural process to that presentation. Not an artistic idea that, in some figural form, could sum up the complex emotions of the client – the consortium of bereaved families. We felt it wasn't right to attempt to sum up their thoughts in our words.

As architects, we always try to reconcile what the users need and what the place seems to need. We proposed an architectural process of listening to the client, spending time with the client, and understanding these needs ourselves.

Architects are well trained in being detectives, in discovering a sense of place, and we located the memorial through researching the history of Hyde Park, and how its edges had been shifted and re-sculpted over time. One path, formalised sometime around the English Civil War, had been severed, and didn't reach the park's perimeter. We extended that path and re-sculpted the terrain, creating a sense of relative quiet.

How to depict the identity of the memorial was a thornier subject. We presented lots of precedent studies and looked at the modern history of memorials, and discovered that actually the civilian disaster memorial is a recent phenomenon. The British are particularly good at war memorials of the First and Second World Wars, and some of the symbols of such warfare can be figuratively transcribed into sculpture very well – imagery of soldiers bayonetting other soldiers, or of cannons, etc. These depict the horror of war, the pathos, the heroic acts of bravery, and also can be symbols of reconciliation.

Yet, when you think about some of the imagery that was conjured up from the events of 7 July, three of the four bombings took place underground, so there was no imagery to recall. One of the prominent media images was the photograph of the bus in Tavistock Square, and it wasn't appropriate to reconstruct that figuratively.

We presented our research on the modern history of memorials, to get a common ground and common glossary of terms to the client: what do we mean when we say a figurative or an abstract memorial? We would talk about Charles Sargeant Jagger's memorials and Maya Lin's memorial – which sets the bar. But that's a war memorial, and as we said, actually we're in unfamiliar territory here, because there aren't many precedents for civilian disaster memorials.

In a world where we're so displaced through technology, it's still relevant to come together, have shared experiences, and make sense of our times.

There is a difficulty with modern memorials, about what they depict and how they depict it. War memorials, several centuries ago, were easy to depict, because those wars were physical wars. Now modern conflict isn't necessarily physical. It has more nuance, and physical imagery can't be brought about to form those figurative reminders and points of reconciliation.

We looked to other ways that memorials have been depicted. There was a tipping point in the work of architects like Sir Edwin Lutyens that in

the Cenotaph created this figurative and abstract form that was a nexus for people coming together and making sense of their times.

We started to discuss this idea of the singular and the collective, and the imagery of an element representing a life lost and those elements being in a matrix that somehow, through their arrangement across four events, could be blended together.

In the memorial, 52 stelae are arranged in four clusters, and each element, representing a life lost, was spaced apart so the living could walk amongst those things that represented the dead. That keeps the message of the memorial alive.

It is an abstract piece of architecture that is simultaneously figurative – a column represents a figure standing tall but not a humanistic figure – and these are arranged in an abstract mathematical pattern that comes in and out of focus at different proximities to the park. It's very dynamic as a visual composition and has no front or back. Yet we used the park path to create a sense of preparation and ceremony to approach the memorial.

Tell us about the collaboration with sculptor Antony Gormley and his influence.

Kevin Carmody and I have worked with Antony Gormley since we met at David Chipperfield's office. One project we collaborated on was 'Blind Light' at the Hayward Gallery,[1] and although we don't claim any artistic authorship there, what was interesting about that as a piece of critical research was Antony's ideas about the body in space. It was almost an anthropological observation about individuals trying to make sense of their own bodies in a collective space – and making sense of other people making sense of their own condition.

This notion of the singular and the collective was very present when we were first imagining the 7 July Memorial.

We did a lot of scale testing on the size, proportion, height. The plane tree canopy, in its full summer leaf, is roughly double human height. There's this nice symmetry of the dark tree canopy and the light, bright stainless steel with its diffuse surface. There's a picturesque composition of light and dark, modern and ancient.

The memorial design process involved the bereaved families to a large extent. Would you say that in so doing it potentially helped them on their personal journeys?

We tried to involve the families in every step. Some of the bereaved families thought that stone would be most honorific. But we thought the material should resonate with the city of London, the commercial buildings. Stainless steel is a material of modern mercantile London, but we wanted to use it in a way that was part of an archaic process. Stone had traditional references but even stone isn't indestructible.

Through every stage we took the concept of the one and the many, the singular and the collective, as well as in the figurative, spatial, organisational concept. We made one wooden former which equated to one metric tonne of stainless steel, and in one face of the rectangular volume, we had some lettering – designed by typographer Phil Baines – based on Edward Johnston's London Transport font.

Stainless steel works at a very high temperature – 1,600°C, twice bronze's working temperature. And it only has a working temperature range of 6 or 7°C: as soon as it goes out of that range, it starts to solidify. We made this casting mould, we pressed the letters into one face, and we pressed those moulds into sand 52 times. The same wooden mould, one tonne of molten stainless steel, and it solidified in a few seconds. It took its form in one explosive instant.

The memorial embeds into the surfaces of that form all the turbulences of the casting

moment. Even though you've got 52 individual things making one collective message, you have all the individualistic characteristics of the volatile casting process, of this medieval casting technique, that turns this contemporary, hard-wearing material of the city into something archaeological, instantaneously freezing its identity and creating 52 individualistic characters, even though the forms are consistent.

There's something rather violent about the image of that 'one explosive moment'. Was anyone disturbed by that metaphor?

As you can imagine, this process brought to the surface all sorts of emotions, because the bereaved families were trying to make sense of these confusing events.

We were going on this journey with them. We'd never done anything like this before as architects. It had none of the comfort, for us, of a functional building to rely on. Equally it had none of the conventional features of architecture, that of shelter and comfort. It pushed us into unfamiliar territory.

Some of the conversations about materials caught us unawares, and we had to reflect on that. Some of the bereaved families reacted incredibly emotively about molten metal to begin with.

The foundrymen that cast the stelae were equally confused about the technique that we wanted to use, because their engineering reputation was to do with making manifolds for industrial food mixers, and valves for the petrochemical industry and such. They rely on engineering precision, and we were saying: no, we want these things to look deliberately imperfect, deliberately disfigured at close proximity.

The foundrymen were completely perplexed and even apprehensive about releasing these pieces, because it reflected on their reputation as engineers. It has an otherworldly presence up close. Some have said it looks like moon rock.

It does have an elemental quality.

It's got a very elemental quality, but a quality of something that you've never quite seen or touched before. And what fascinated us is the ability of the material and the surface to attract people to touch, and physically engage. The living physically engage with those things that are representing the dead, in a way that a shiny, slippery stainless steel surface never does. We would never go and touch such a building.

Why do you think that it's important for us to engage with the memorial physically like that, to have those kind of sensory experiences?

Well, there are two experiences in the memorial. There's this field of elements that, rather like 'Blind Light', you become physically part of the space, and also part of the narrative message in real time. It becomes an interpretive act of discovery. You go there and you ponder the meaning of these vertical tags of information.

One thing that we realised, as part of the process – and it might sound so obvious to say now – was that the memorial's only purpose is to stop people forgetting. If it doesn't stop people forgetting, then it has no purpose.

Someone might go there and ponder its meaning in two or three generations' time, and act as a detective, activating that process of interpretation.

At the end of this procession through the field of elements, we hit a gently rising berm of earth, onto which the plaque with the names is laid out, objectively, categorically, in alphabetical order. There is a certain objective anonymity to the memorial. We could interpret that this could have been any one of us. This idea of chance, and order within chaos, and chaos within order, is one of the fundamental ideas of the whole project.

Has what you learnt on this project influenced your subsequent architecture?

I don't think there's a more humbling job that you can do. We were thrilled at the time to win the opportunity to work on what we called our first public building. Even though it doesn't have a roof or doors or plumbing or stairs or windows, it was a piece of civic architecture.

And we were making architecture for the city. There's a sense that we push those difficult things, like life and death, to the edges of the city now, and this was a project that made us confront ourselves in the middle of the city as Londoners.

We also learned a lot about how to listen and how to consult with people's need for making architecture, and also who architecture is ultimately for. There is so much architecture today that is just in the service of market forces, whereas this is truly a piece of civic architecture.

We realised eventually through this whole process that the client that was sat before us, with whom we were consulting, was not our ultimate client. Because actually the purpose of the memorial, as I said, is to stop people forgetting. These stelae are not surrogate gravestones. They're not for that family member to enshrine as their own. It's a place for others to come and make sense for generations to come, to stop people forgetting. The families will never forget, so in a sense, this actually isn't our client; our client is those passers-by, in generations to come.

It's for the commissioning client, the government, the treasury who put in the money. It's for the bereaved families, at the time, the end user; but also it's for society at large in perpetuity, and in a sense that is what all good buildings do – they make up the foreground and background of our cities.

The stainless steel, the height of the plane trees, the typography . . . this monument is more rooted within its London context than immediately appears.

Also, the wrinkles in the landscape of the park, that berm that we manipulated to form a little cove of acoustic buffering, this long history of Hyde Park – we're just adding to the continuity of those.

Adding an archaeological layer.

Yes, and setting new, picturesque relationships.

Carmody Groarke is a London-based architectural practice founded in 2006 by Kevin Carmody and Andy Groarke. The practice has developed a reputation for working internationally on a wide range of arts, cultural, heritage and residential projects. The practice's work has been recognised through several prestigious architectural awards, including being shortlisted for the EU Mies van der Rohe Award, a nomination for the 2021 RIBA Stirling Prize, the Civic Trust National Panel Special Award 2020, the Architects' Journal Building of the Year 2019 and Building Design Architect of the Year 2018.

185 Empty White Chairs

Artist: Peter Majendie
Location: Christchurch, New Zealand
Year: 2012

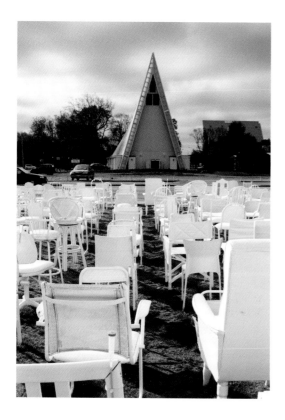

10 The installation originally appeared near Shigeru Ban's cardboard cathedral, another construction responding to the earthquake's devastation with intentional impermanency

With minimal fanfare, on the night of 22 February 2012, New Zealand-based artist Peter Majendie installed his unofficial memorial, 185 Empty White Chairs, in the grounds of the demolished Oxford Terrace Baptist Church. The date was the

anniversary of the 2011 Christchurch earthquake in which 185 people lost their lives.

Taking cues from Van Gogh's surrogate self-portrait 'Chair' (1888), as well as from the Oklahoma City National Memorial, Field of Empty Chairs (inaugurated 2000 following the 1995 bombings), this installation also uses the metaphor of a seat left vacant by the departed.[1]

Originally intended as a three-week-long, temporary installation, this assemblage of household furniture was rapidly embraced by locals and tourists, such that it became one of the city's most visited landmarks.[2] And despite not being 'designed', in an architectural sense, its story is intrinsically linked to that of its city and explores the role of permanent and temporary structures in defining a sense of place. 'No towering obelisk is needed', writes one online commenter. 'Only a humble reminder of the seats standing tragically empty at dinner tables, work stations and bar rooms across a nation.'[3] The chairs also illustrate the reciprocity of memorial design, demonstrating how memorial architecture in one city can be adopted and adapted for a wholly new context on the opposite side of the world.

This unusual memorial has, however, been drawn into its own game of musical chairs, forced to relocate across Christchurch multiple times. Yet in each case it has formed new relationships with its surroundings, responding to different built environments, and creating new contexts. By 2013 it had been moved to a site across the

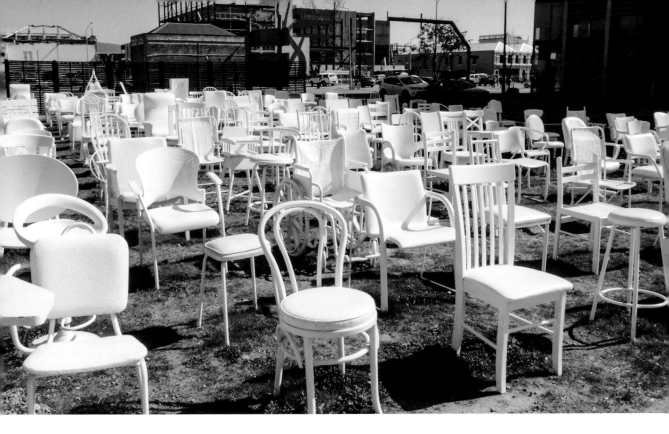

11 Following the earthquake, Christchurch had to be rebuilt. The memorial's makeshift
nature responds to a city under construction, resonating with the public

road from another temporary structure, architect Shigeru Ban's cardboard Transitional Cathedral, where together they formed a sort of memorial landscape in flux.

That location likewise proved transient; from February 2021, the memorial was re-installed on the grounds of the demolished St Luke's Church. The arrangement was now no longer a grid – assembled to mirror rows of pews in the demolished church – but a circular formation, oriented around St Luke's surviving wooden belltower.[4]

Funded by The Side Door Arts Trust and maintained by a group of local volunteers, who periodically repair and repaint the chairs, a campaign exists to make the memorial permanent[5, 6] – although Majendie also favours the idea of natural deterioration: 'Let it run riot for five years', he has said. 'The beauty of flowers and gardens would take over.'[7]

Each chair varies in style, material and size (albeit painted uniformly), pointing to the victims' individuality without necessarily representing them. Several were donated by victims' families, colleagues and friends, thereby directly standing in for them.[8] That the memorial is modest, relatable, egalitarian and even untidy is a large part of its appeal. It was also erected years earlier than the official Oi Manawa Canterbury Earthquake National Memorial, arguably capturing people's hearts simply because it was there when they needed it to be.

The memorial also occupies a unique position between the sacred and secular, where some contemplate loss in silence and others convivially remember loved ones over a beer. The chairs have become 'the spiritual oasis of the city', says St Luke's vicar Jenny Drury, and a place where people can 'sit without people breathing down their neck'.[9]

Anneau de la Mémoire International Memorial of Notre Dame de Lorette

Architect: Atelier d'Architecture Philippe Prost (AAPP)
Location: Ablain St Nazaire, France
Year: 2014

With its cemetery, basilica, interpretation centre and new memorial monument, inaugurated on 11 November 2014, the memorial complex on the hill of Notre Dame de Lorette, near Arras, Pas de Calais, is one of the most significant in France. The necropolis of Notre Dame de Lorette is one of the country's largest military cemeteries, where over 42,000 French soldiers who died on the front at Artois and Flanders in the First World War are laid to rest.

The Ring of Remembrance was designed by Philippe Prost (interview pp 43–6) for the 100th anniversary of the conflict. It honours those of all nationalities who died in that territory – 600,000 people – irrespective of country of origin, religion or rank.

The 328-metre elliptical memorial is made of 122 high-performance, fibre-reinforced concrete segments. From the outside, this forms a sombre ribbon balancing on the hill. On the inside of the ring are 500 full height, gilded steel panels. Their golden glow contrasts dramatically with the darkness of the ring's outer surface and are presented like pages in an open book.

The enormous ring is rooted to the ground for two thirds of its diameter; the remaining third cantilevers 60 metres over the hill's apex.

Here the earth falls dramatically away from the structure, a reminder of the fragility of peace.

Bespoke typography was designed by Pierre di Sciullo. 'Lorette' is a timeless typeface with the flexibility to accommodate names of widely differing lengths within the appropriate spaces. A light installation by Yann Toma illuminates the memorial at night; entitled 'La grande veilleuse' (nightlight), it bathes the structure in a warming, comforting glow.

The circular formation was partly inspired by children's games played in the round, a symbol of friendship suitable to the premise of the memorial which is to reunite former enemies in the same commemorative space. 'Through our project, we wanted to give form to fraternity, an expression to peace, to combine art and nature to put them at the service of memory', said Prost.[1] The ring makes a clear statement about European solidarity by drawing attention to the sheer number of lives sacrificed to achieve peace in this continent. That unity seems particularly precarious today.

The ring honours those who came from all over the world to fight in northern France between 1914 and 1918. The names are listed in strict alphabetical order and the rhythmic visual effect of this display of text is dizzying. One visitor recounted that despite being aware of historical

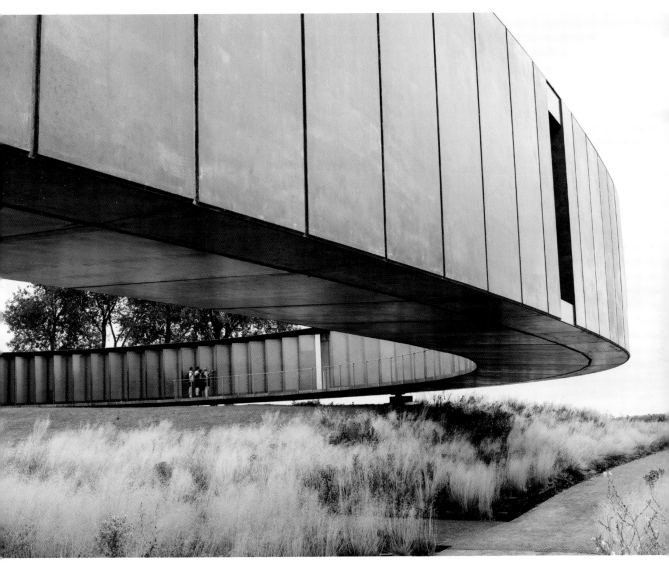

12 The ring cantilevers over a dip in the landscape; the sudden void is a reminder of the precarity of peace in Europe.

statistics, seeing the names listed at such scale brought home the extent of the loss.

The first name – A Tet – was a Nepalese member of the merchant navy. The last name – Zywitz, Rudolf – was an eastern European soldier whose name has been Germanised.

Among the casualties listed are John Kipling, son of Rudyard Kipling, and Joseph Standing Buffalo, grandson of Lakota Chief Sitting Bull, as well as the youngest German soldier to die in the conflict, 14-year-old Paul Mauk. Wilhelm Winter and Paul Winter are listed side by side: were they enemies or cousins?

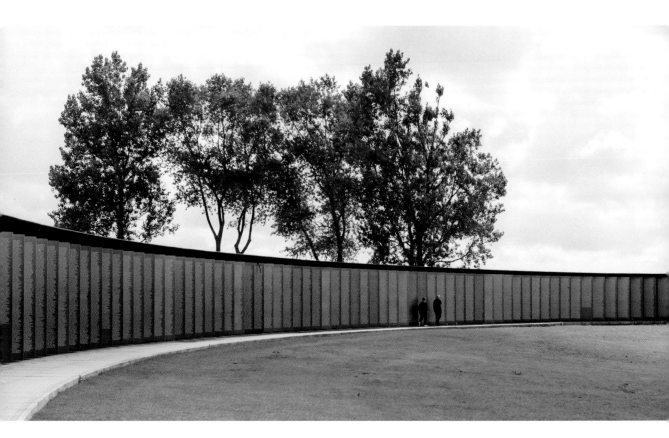

13 People of all nationalities are listed side by side, their names forming a rhythmic pattern

14 Gilded sheets of stainless steel line the interior of the ring, concertinaed like the pages of a book

INTERVIEW WITH PHILIPPE PROST,
ATELIER D'ARCHITECTURE PHILIPPE PROST[1]

What is the context behind L'Anneau de la Mémoire? What was the inspiration for its elliptical form?

The site was that of an extremely important First World War battle which resulted in over 100,000 deaths. There is a hugely important national necropolis there, which has a very strong presence, with crosses and stelae occupying a large horizontal plain.

There was a requirement from the Nord Pas de Calais region, which launched the competition for the project, which was very particular: it consisted of creating a monument reuniting all the names of those who died, irrespective of nationality or whether they were enemies or allies. They must be brought together in alphabetical order – independent of rank, race, religion or date of death – according to official recorded lists.

Daniel Percheron, president of the region, launched this project and defined these criteria. It is his belief that western Europeans do not realise that the peace we have enjoyed since 1945 is the longest stretch of peacetime that we have ever seen. He wanted to raise awareness, in particular amongst the young, of this notion of peace. This is a monument to peace and not a monument to death. It commemorates those who died at the beginning of the 20th century, on whose sacrifices peace is founded, to say 'we are turning a page' now that there are no longer any survivors of the First World War, and this monument seeks to reunite all nationalities.

Certain identical surnames sitting side by side could just as easily have been enemies or related . . .

Exactly. There are names which could be Anglo-Saxon or German. The aim was to group together the combatants in a way that surpasses and rises above the conflict that pitched them against each other.

Many names from the German army are eastern European names Germanised. We took the names as they appeared on the official list. Some have first names or initials. The first name is Asian, the final one is from eastern Europe. The first name is A Tet – a Nepalese name – who came here because of the Commonwealth. Not everyone was a combatant either – there are also female names, some were associated with hospitals, etc.

We had to find a form for this monument. My idea, that won the competition, was that the public, by looking at the monument, would also reunite the names. This is how I came up with the ring formation. If I stand at the centre, I can embrace – with one look around – all the names in one go.

The names are listed exactly as they are on the official lists, including multiple examples of the same name – there could be 15 Tom Parkers, for instance; there is no amalgamating surnames together, because behind each name there is a person. And that is actually quite striking – the repetition of text constitutes a kind of graphic motif. When it is always the same first name and surname repeated over and over, it finishes by creating a visual pattern.

Next, given that there were almost 600,000 names, evidently it was a work which would have large, imposing dimensions. When you discover these names, you don't come across them as single names one at a time, you

encounter them all in one go. The ellipse is 325 metres in perimeter. When you arrive, you experience a shock as you realise that it necessitated such a huge monument to accommodate such a large number of names, and this work is extremely big.

I wanted this effect of astonishment, this very strong sensation which seizes us, then leads us to search for a name. At that point we pass from the monumental to the intimate, because this idea of engraving the names on panels arranged like pages of a book means that people can stand close to the panels and search for a name, at a more intimate scale.

There is a double scale in the monument: the scale of astonishment, of the big site, the 600,000 names; and the intimate scale, where I search for a name, where I look at one name in between two pages.

And how was this linked to the topography and the existing architecture on the site?

Once that ring formation had been decided on, I wanted the visitor to set form into motion. I have to move myself along a route, and at a given moment I am going to find myself in front of the void, where the ground drops away, and I am going to feel the fragility of balance, the equilibrium of the structure. My peace is disturbed by this, hence experiencing the fragility of peace.

Two small windows are also important. One looks out over the nearby coal mining basins with their heaps and headframes, all their mining equipment, towards the direction of Lens – because that was the historical reason for the violence on that specific site, the control of coal mines. We understand even today the importance of oil and gas. The German and French armies clashed on that site, with so many deaths, trying to conquer or maintain possession of coal mines – that is what fuelled the war.

On the other side, the window looks out over a gothic church, the only building that survived the battle. After the First World War it was decided to maintain it in a state of ruin, so that it would forever be a reminder of the immense destruction that happened. After the war, you see in photographs, it looks like a moonscape. Not a single tree or house standing. The choice they made to preserve it was to retain some sense of memory there. The approach is almost John Ruskin-like. A precious ruin that witnesses something and we are not looking to reconstruct.

The site was so important, and the topography enabled us to use this cantilever for the ring over the void. With the necropolis behind it, the monument was conceived as horizontal, which would not cut the view away from the plain of Artois in the distance and lets the gaze pass uninterrupted. It also doesn't exceed the summit of the crosses and the stelae of the necropolis. There is also a lantern tower, constructed in the 1920s and whose beams travel over 70 kilometres as far as Lille, to remind of the presence of this necropolis. To this verticality, I responded with horizontality.

The ring is intended to be minimal, discreet, with a strong but silent presence. Outside there is nothing written, not even signage. The words are on the interior.

Could you explain your choice of materials – for instance, the innovative use of fibre-reinforced concrete, stainless steel and so on?

We couldn't construct the memorial with the same elegance and finesse without using fibre-reinforced concrete. In traditional concrete, the cantilever which extends 60 metres above the void would not have been achievable. So, we combined this high-performance material with the post-tensioned cables, which was a very careful and difficult task involving some complex engineering to make it structurally feasible. In engineering terms, it was a first. A technical feat.

The fibre-reinforced concrete is also a sombre material, resembling ominous clouds, like the colour of war. This was a response to the white concrete of the necropolis, which is so white that it resembles stone – it isn't. At the time it was built, the quarries had been destroyed, the woods had been stripped of timber for the trenches, there was an extreme paucity of materials. So, they used very basic concrete poured in situ. I wanted to create an interplay between dark and light.

The other material in the monument is stainless steel. The construction of this memorial was in fact a pan-European effort as the steel was manufactured in eastern Europe, cut in Belgium, taken to the UK for treatment to give it a coppery, gilded surface and then back to France to have the typography inscribed, beneath which is the natural colour of the steel.

When we enter into the interior of the ring, there is something far brighter, something far more luminous, than the exterior. We feel we are in a cloister between the earth and the sky. We have the earth beneath our feet and the sky above our heads and at some point the lighthouse and the basilica in the middle distance. We are in the middle of the ellipsoidal form in a floating state.

So, the material choice was practical and aesthetic, and it led to this alliance between the concrete and the metal, the sombre and the bright, and this contrast brings the names to life. The panels light up, when the sunlight catches them, and the ring appears to move – it seems that the form is turning and when you displace yourself with the monument it appears to rotate around you.

When we won the competition, the president of the region told us that the building must have a 100-year, not 10-year, warranty. We couldn't use steel-reinforced concrete; it could oxidise and leach through. The memorial must be perennial, it must stand the test of time, and – other than

maybe testing the tension of the cables – it shouldn't need much maintenance. So that guided all our material choices.

There are numerous references to European solidarity in this monument. Do you think that historic commemoration has a role to play in promoting cohesion within current society?

The president of the region sadly had a presentiment about peace in Europe. From 1916, the northern French front was divided into two: one front was predominantly fought by the French army, the other by the Commonwealth army. At the beginning the armies fought side by side, but in 1916 they divided the zones of combat. For the French the final 'battle of battles' was Verdun (eastern France) which involved the French and the Germans. Although Flanders and the Somme are strongly commemorated in the UK, there was a sense within France of this north region being forgotten. We speak of *l'enfer du nord* because of the destruction and violence that happened in France and Belgium, but it is often overshadowed in history by Verdun.

Many people from Canada, New Zealand and Australia visit this monument because of the Commonwealth links. So, yes, I think that commemoration has an important role in bringing people together today, and in our current situation right now.

There is an equilibrium to maintain, relationships need to be developed if we don't want to find ourselves at war again. Commemoration has that force – it makes us remember that war can always return, and we must exercise vigilance.

Standing in the middle of the monument is a very moving experience; has it impacted people's emotions differently to how you anticipated it might?

There is a sense of amazement standing in the middle of the monument. And when you

walk around the inside at a certain pace, you accelerate and then slow down – a bit like calligraphy, when you draw a shape like this there is a moment when you slow down and then pick up speed to complete the circle. That action puts the monument into motion, it creates a certain momentum. You are coming back to your origins in some way. Like an orbit.

The steel panels with names are around three metres high, and because we had to keep within the boundaries of the allocated plot, their positioning like book pages, with inscriptions on both sides, helped to maximise space. So, that was reasonably technical, but there was something I learned, which was that the origins of the names impacted how long they were; for instance, Anglo-Saxon names are shorter than German and French ones. So, on some panels the names seem to contract and on the other side to expand, so the ring seems to expand and contract, expand and contract, because of the way that the typography is dispersed, like a heart that is beating.

Also sound plays an important role. This is something I didn't anticipate. When we are walking around, sound encircles us in the monument, and when people talk, or when we hear birds singing, there is an effect within the circle. So the space is put into movement by our pace, and the light, and the sound, and the sway of nearby tree branches – altogether it is very powerful. Sadly, we see that the *prise de conscience* that prompted this monument was not enough to ensure peace in Europe in 2022.

Do you have anything to add on the subject of memory?

Memory is central to my architecture. We are all unique and each individual has a memory which is made up of impressions, sensations and events, which are recorded. And this life and story, which each one of us has, gives us as individuals the capacity to do unique things.

Today, when we talk about globalisation and commodification, it seems that we must hang onto our memories, and our ways of absorbing life and forming relationships, to keep our humanity and unity.

There are things that come to us naturally, we don't know where from, but when we interrogate the thought, we realise that this idea came from this other idea, that we saw this, that we put this into this perspective, or we experienced this sensation, or this thing happened to us as children . . . these things come back to our memories. Yes, there is a memory of events, there are historic memories, but there is also the memory of each individual, and within each architect that is a resource. It enables us to transmit emotions, to create imaginative works, to ensure that the music stays original, not artificially created – architecture is the same thing.

Philippe Prost is a French architect and urbanist, a professor at l'École nationale supérieure d'architecture de Paris-Belleville, a member of l'Académie d'Architecture and president of l'Association Avenir et Patrimoine. He is the founder of Atelier d'Architecture Philippe Prost (AAPP) based in Paris. L'Anneau de la Mémoire has won numerous French and international prizes, including L'Equerre d'Argent (culture category), the RIBA International Award for Excellence (UK) and the Dédalo Minosse International Prize (Italy).

Arch for Arch: A Monument for Archbishop Desmond Tutu

Architects: Snøhetta and Local Studio
Location: Cape Town, South Africa
Year: 2017

Nobel Peace Prize Laureate Archbishop Desmond Tutu (1931–2021) – priest, theologian and human rights advocate – was affectionately known as 'Arch' by fellow South Africans. Initiated at the Design Indaba Festival of Creativity 2017, a literal interpretation of this nickname found its way into Cape Town's cityscape with Arch for Arch, a nine-metre monument designed by Snøhetta in collaboration with Johannesburg-based Local Studio. This towering, yet gentle, structure stands as a tribute to the man himself and to the peace and democracy he helped forge.

The permanent wooden arch marks the site where Tutu began many of his anti-apartheid protests and is situated between the Houses of Parliament in Cape Town and St George's Cathedral, the Archbishop's seat. Here, it creates a new public space in the downtown area, reminding lawmakers, from its visible position, of the values Tutu stood for.

At around three storeys high, the arch frames the public entrance to Company's Garden, South Africa's oldest park. This is a popular route for pedestrians arriving at the city's cultural heart, and the open formation of this large-scale structure welcomes them in.

Fourteen intertwined strands of bent larch wood – one per chapter of the South African constitution – were moulded into shape by Croatian boat builder Dario Farcic. 'In a country like ours, a

landmark of this nature – you'd imagine – would be built from something like stone or concrete or possibly steel. But I think the use of wood is an interesting contrast to popular opinions in terms of public commemorative structures. It has an element of surprise', said Local Studio's Thomas Chapman.[1] Timber has a warm and intimate quality and larch is highly durable and resistant, and weathers gracefully over time.

The structure's domed formation alludes to a globe, a celebration of Archbishop Tutu's role as a unifying figure for peace around the world; it appears to encircle those who pass through it in a warm embrace. It also alludes to the 'Rainbow Nation', a moniker that Tutu himself came up with.

Arch for Arch is intended as more than a simple monument for one man, but rather builds on the legacy of Tutu's campaign for democracy and his commitment to the South African constitution. The arch stands as a permanent architectural tribute to what was sacrificed in the pursuit of democracy and the abolition of apartheid, and the need to continue to protect these rights in the future.

Arch for Arch was unveiled on Archbishop Desmond Tutu's 86th birthday on 7 October 2017. A second, smaller arch was unveiled on 20 December 2017 on Constitution Hill in Johannesburg, near the Constitutional Court. The arch, like its namesake, exhibits strength with lightness of touch.

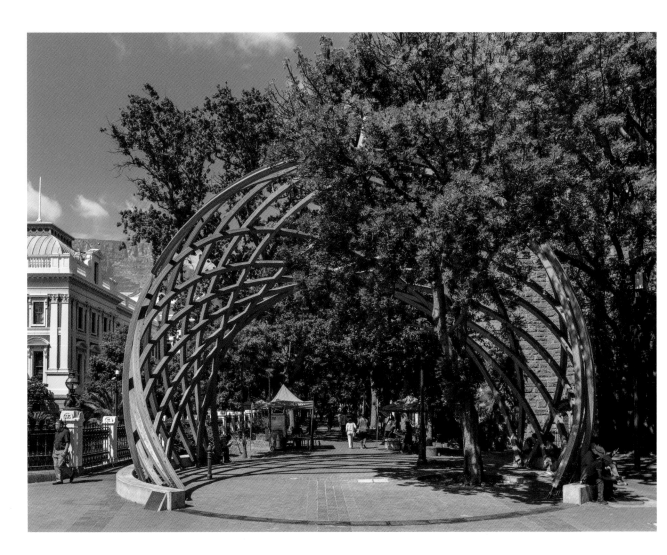

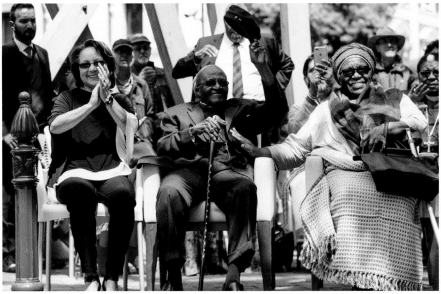

Atocha Station Memorial

Architect: FAM Arquitectura y Urbanismo
Location: Madrid, Spain
Year: 2007

In the middle of a busy road outside Madrid's main rail station is a translucent, tubular structure. Its appearance, from a distance, is strangely luminous and with a metallic quality that blends in with its infrastructural surroundings. This is the above-ground exterior of the Atocha Station Memorial, which commemorates the victims of a terrorist attack by Al-Qaeda on 11 March 2004, in which 191 people died on four commuter trains.

Atocha's original wrought-iron, glass and brick concourse, designed by Alberto de Palacio

Elissagne and Gustave Eiffel in 1892, now houses a tropical garden. Substantial new additions were introduced between 1984–92 and 2007–12, designed by Rafael Moneo, and it is outside Moneo's distinctive, circular extension that this memorial stands.

The memorial has two parts: the 11-metre-tall oval glass cylinder and a chamber within the

17 The cylinder of glass blocks emerges into the light

18 The quiet blue chamber contrasts with the busy station concourse

subterranean part of the station. The sombre, dark-blue interior of the chamber offers a welcome contrast to the bright and noisy station concourse, offering an introspective and peaceful environment. Through its interior design and location, nestled between escalators and platforms, it dialogues with the visual language of the station. This room sits below the luminous tube-structure, which turns the centre of the chamber into a spot-lit shrine.

The cylinder is formed of 15,000 solid glass blocks, bonded together with acrylic resin to create a permeable, ephemeral lighting effect. The interior of the cylinder is lined with a lightweight polymer membrane inscribed with 20,000 printed messages of commemoration in different languages – words left at the site of the tragedy which the architects faithfully reproduced.[1] Victims' names are included

at the entrance foyer at their families' request, on the doors of the blue chamber.

During the day, the cylindrical tower is illuminated naturally. By night, internal lighting projects the messages outwards into the city.[2] The light-filled vertical shaft is an enlivening contrast to the subdued chamber below. Compared to the introspective nature of this darkened space, it is more outwardly focused, and external noises are more easily discerned from within.[3]

'Light was the material which built the structure', says architect Pedro Colón.[4] The translucency of the materials allows this elusive substance to take on an agency and fabric of its own. Varying hues and shadows create an ever-changing interplay of light both inside and outside the memorial, lending the interior scene a poetic quality in prosaic surroundings.

6

Babyn Yar Synagogue

Architect: Manuel Herz
Location: Kyiv, Ukraine
Year: 2021

'What is the point of saying "never again" for 80 years, if the world stays silent when a bomb drops on the same site of Babyn Yar?' tweeted Ukrainian President Volodymyr Zelensky on 2 March 2022, when Russian bombs were thought to have destroyed the Holocaust Memorial site outside of Kyiv.[1]

Although it later materialised that the target had been the nearby Kyiv TV tower, the depth of feeling stirred by the site's potential destruction indicates its importance for Ukrainians and Jews worldwide. It was also keenly felt by architect Manuel Herz, whose memorial synagogue was inaugurated there mere months before. 'What is the point of

commemorating history, if the lessons to be learned are forgotten and ignored so easily?' he asked. 'It leaves me speechless, numb and powerless.'[2]

Babyn Yar is a ravine situated at the northern edge of the city of Kyiv. Between 29 and 30 September 1941 it became the site of one of the worst massacres of the Second World War, when around 34,000 people were killed by Nazi death squads. In the following two years, several thousand additional victims were added to this number, their murderers making use of the site's geography to avoid burying the dead.[3] The Babyn Yar Synagogue is a new memorial on the site.

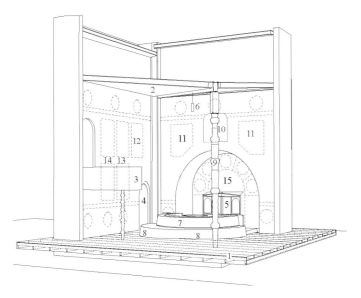

1	Platform
2	Ceiling with star constellation
3	Women's balcony
4	Stairs to women's balcony
5	Aron ha qodesh
6	Ner tamid – Eternal light
7	Bima
8	Seats
9	Zitzit – column
10	Window
11	Dream blessing
12	Sh'ma Yisrael
13	Morning blessing
14	Kaddish
15	Ten Commandments

19 Axonometric drawing of the synagogue which opens and closes like a book

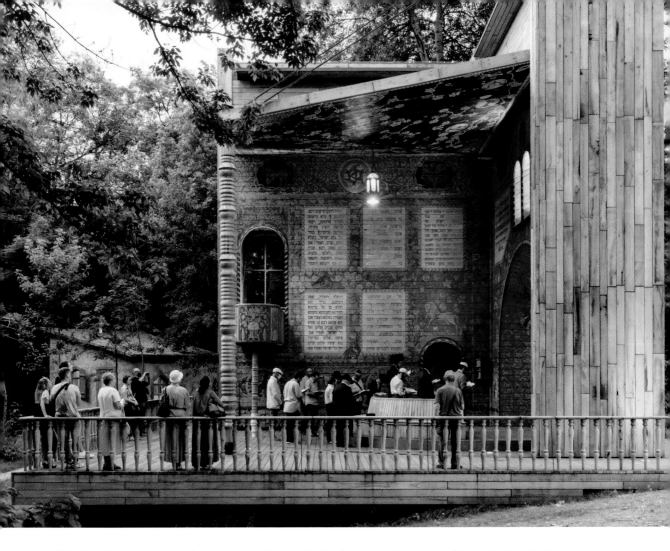

20 Worshippers gather at the synagogue. Opening the book structure forms part of the collective ritual

'If we conceptualize the synagogue as a building typology in its purest essence, we can consider it as a book', writes Herz.[4] During religious services, Jewish congregations gather to read from the Torah, or Siddur, a book of prayer. This concept informs the design of the building, which itself opens and closes like a book.

'Pop-up books can be magic books that unfold into three dimensions . . . when we open them, new worlds unfold, that we could not imagine before', Herz elaborates. Likewise, a synagogue is a 'cabinet of wonders', a place of fascination. The building – timber with a steel frame – sits on

a wooden platform hovering slightly above the ground, not disturbing the soil. When closed, the synagogue is a flat, 8 × 11 × 2-metre volume, and its manual opening process is something of a collective ritual. It unfolds to reveal the bima, or reading platform, in the centre, surrounded by benches and a balcony.

The oak used in construction was over 100 years old, sourced from all parts of Ukraine, a gesture which connects the modern building to a time before the massacre. Timber likewise gives the synagogue a certain fragility: 'This continual care and tenderness is exactly what remembrance is about', says Herz.[5]

The interior and ceiling are painted with symbols and iconography referencing historic Ukrainian synagogues from the 17th and 18th centuries. On the ceiling is a constellation from Kyiv's night sky on the night of the historic tragedy; on the walls are prayers and blessings, including the Shema Israel and the Kaddish. One unusual blessing, from the historic synagogue of Gwoździec, takes on an added poignancy today – it is a prayer for turning a nightmare into a good dream.

21 Detail of the ceiling, with its constellation of stars

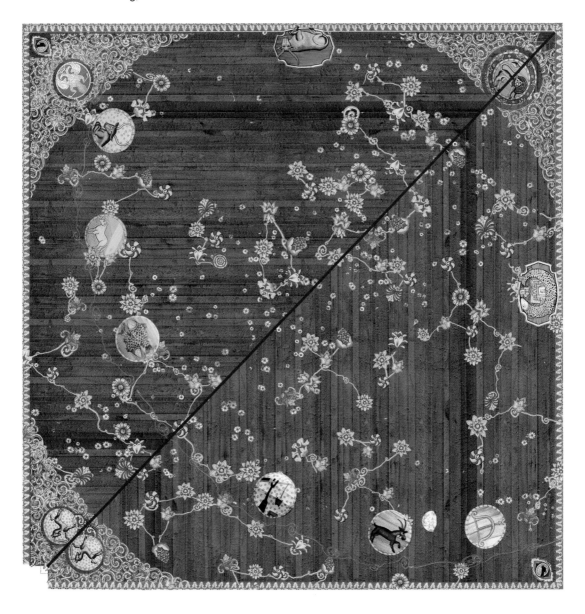

7

Belarusian Memorial Chapel

Architect: Spheron Architects
Location: London, UK
Year: 2017

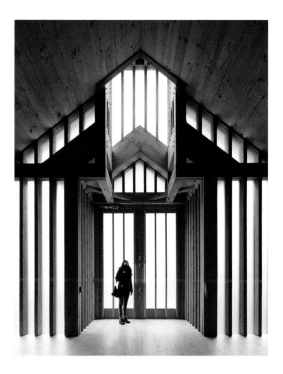

22 The memorial reinterprets Belarusian vernacular architecture and materials with contemporary detailing

This diminutive wooden chapel, of only 70 square metres, was commissioned by the Holy See of Rome for the long-established Belarusian diaspora community of London, many of whom arrived in the UK after the Second World War. As well as commemorating the victims of persecution, it also memorialises those affected by the Chernobyl disaster. On 26 April 1986, two powerful explosions destroyed Reactor No 4 of

this notorious nuclear power plant. Although it is located in modern-day Ukraine, 70 per cent of the radioactive fallout fell upon Belarus, causing the loss of a large number of rural settlements in the country.

The Belarusians were once predominantly Greek Catholics. Their history was one of persecution at the hands of the Tsarist regime, which, in the 19th century, banned their form of religious worship. During the Second World War, Belarus lost around one third of its population – the largest percentage of any country – during which time countless wooden churches and synagogues were set alight by Nazi troops, often, horribly, with worshippers trapped inside. The first generation of Belarusians in Britain were still haunted by such traumatic memories. They were soon joined by demobilised Belarusian soldiers from the Polish divisions, reluctant to return to their homeland due to the onset of the Cold War and the creation of the Iron Curtain. The diaspora's first church was established in 1948, within a house in north London, but it had always been the community's collective desire to build a dedicated church.

The design of the memorial chapel recognises the importance of familiarity, comfort and shared memories within the Belarusian community. Its design draws inspiration from architect (and co-author of this book) Tszwai So's first-hand recording of churches within rural Belarus. Motifs associated with Belarusian identity and memories, such as the Baroque

54

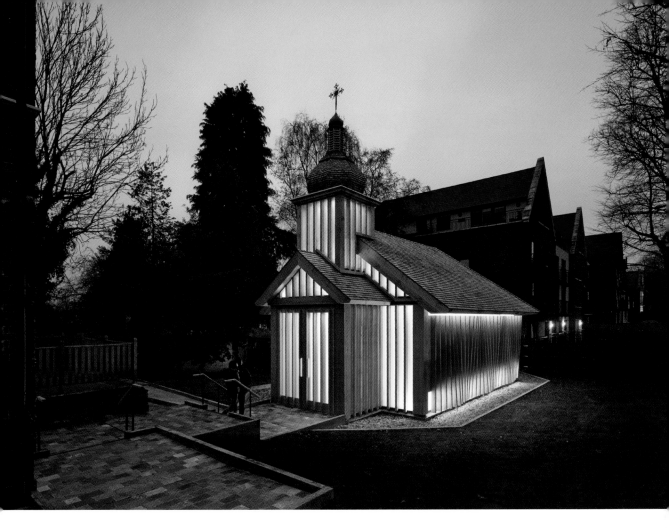

23 At night the chapel glows softly from the inside, subtly referencing historic tragedies while offering hope

cupola, reappear as a sign of the community's Greek Catholic faith; in Belarus these historic cupolas had all been replaced with Russian Orthodox onion domes after the official banning of the Greek Catholic Church in 1839.

This reinterpretation aims to transcend architectural ideologies by marrying a vernacular typology with contemporary detailing, exemplified by the undulating exterior fins that form an unobtrusive yet dynamic facade. The chapel interior is enhanced by natural lighting due to the positioning of clerestory windows, giving the impression that the structure is floating. This illusion amplifies the spiritual presence of the building, yet contrasts with its

structural solidity. Natural ventilation flows via the bell tower, bringing with it the scent of fresh timber. Air-sourced heating concealed beneath the altar, alongside the extensive use of certified off-site timber construction, helped to reduce the carbon footprint.

This structure commemorates the victims of tragedies not only through the architecture itself, but through the communal participation in the rituals within its four walls, for generations to come. At night, the chapel glows softly from the inside – a subtle reminder of those distant tragedies – while inside, in prayer, new, happier memories are made in the light-filled chapel.

Camp Barker Memorial

Architect: After Architecture
Location: Washington, DC, USA
Year: 2019

This small-scale memorial forms the entrance to an elementary school, which occupies the site of an American Civil War-era contraband camp. Such camps offered refugee accommodation, albeit under harsh conditions, to those escaping slavery in the South; Camp Barker is considered formative to the history of the well-established African American community within north-east Washington, DC.

The memorial gateways sit on three sides of the school's perimeter fencing, whose grounds take up an entire urban block, and also function as a public park. The thresholds are created from a continuous folded plane that forms the walls, floor and roof of the portals, which measure 3.2 metres in height and between 2 and 5 metres wide.

The memorial gateways' external surfaces are clad in charred wood, a material that recalls that of the former camp, creating a material memory.

24 Children enter the school via the memorial gates, reminding them of the history of the site

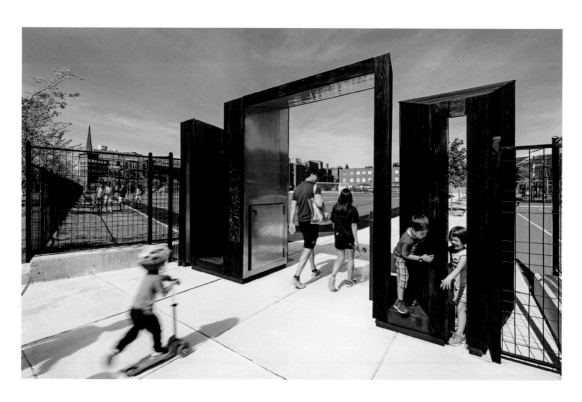

25 Bas relief sculptures by Vinnie Bagwell narrate key figures and moments in African American history

The internal planes are lined with brass, literally inviting reflection in the shiny metallic surfaces. According to the architects, this creates 'a kind of visible ghost that removes personal identity in favour of a shared human condition'.[1] Bas relief sculptures by artist Vinnie Bagwell are integrated into the portals, their darkened bronze materiality blending in with the charred wood palette. These have a narrative function, illustrating key figures and moments in African American history such as abolitionists Sojourner Truth and William Lloyd Garrison, social reformer Frederick Douglass, and 1862, the year of the DC Emancipation Act.

A fundamental premise of the design was to engage children, it is rare for memorial architecture to place children at its heart. Camp Barker Memorial's elementary school setting required a memorial design that could become 'a part of the everyday landscape of school

children', architect Kyle Schumann told us. 'By removing the memorial from its pedestal and encouraging people to walk through it and inhabit it, the memorial becomes a space of reflection and understanding, but also a site of imagination. The project tensions past and present – daydreams of the future take form with the past in clear view.'[2]

The role of educating the children was particularly important: 'Memorials make tangible the abstract conceptions of history, resituating the stories of textbooks and museums within the physical, public realm', says architect Katie MacDonald. 'It follows then that memorials might help children in particular connect the lessons of the classroom to their everyday lived experience. Ambiguity of scale, material, or function in a memorial's design may help it spark childlike wonder or curiosity.'[3]

In contrast to so many of Washington, DC's landmarks – of momentous scale and imposing materials – this modest memorial draws attention to a parallel history and engages with a different audience. 'The Camp Barker Memorial responds to the landscape of American monuments which valorise performance in battle, instead taking the form of a series of spatial markers which convey a complicated history', the architects explain. At a time when many contested Civil War-era monuments are being renegotiated, this monument instead encourages us to consider important counternarratives.[4]

26 Elevation demonstrating the scale of the archway in relation to a child

9

Clamor de Paz

Architect: Paul Lukez Architecture
Location: Guaimaca, Honduras
Year: 2015

In the hills above the small town of Guaimaca, Honduras, is a modest chapel and meeting place which looks out, through a shuttered window, over the verdant hillside below. The chapel is a place of pilgrimage for locals as it is the memorial of two children – Jennie Lopez, aged 12, and her brother, Karlin Adali Valdez, aged ten – who were killed in June 2008 when intruders broke into their home.

Although three of the four criminals were caught, tried and sentenced (an unusually successful outcome here), it would take more to fully heal the community. The brutal crime was yet one more example of lives ruined by violence and injustice in Honduras, a country with one of the highest rates of homicide, violence and wealth inequality in the western hemisphere, and where around half of the population lives below the poverty line.[1]

'We wanted to build a humble space with a small garden where no one could walk on top of where the bodies were found', the children's mother Marta Lopez said at the time.[2] The family approached the Dominican Sisters of the Presentation – who ran the school that Jennie attended – to see if a memorial could be made. She had been a promising and bright student, and was well known and liked.

The Sisters in turn approached a group of US missionaries who had worked in the town, and $30,000 was raised in donations. With the assistance of 65 local volunteers, architects Paul Lukez, Alex Hogrefe and Josh Canez voluntarily designed and implemented 'Jennie's Place', which now stands on the footprint of the former mud-brick home. The project's other name is Clamor de Paz (Cry for Peace).

'The idea was to convert the existing house into a space that honoured the children's memory while also serving the local town as a gathering area, community centre and place of worship', said Lukez. It comprises three rooms – chapel, meeting room and washroom – with additional

left

27 The small, shuttered window looks out over a verdant Honduran hillside; the memorial chapel was once a domestic home

above

28 At certain times of day, beams of light illuminate the bronze name medallions on the floor

exterior spaces including an entry court, bridge and terraced courtyard. The stepped terraces overlook the valley.

The building is concrete with a stucco finish, steel frame and aluminium roof. Inside, two small bronze medallions commemorate the children, fixed to the floor with black polished concrete. These are illuminated in the afternoon by light entering the chamber through slits in the wall. When closed, the wooden doors and shutters, which were made by local craftsmen, form the silhouette of three crosses, recalling the hill of Calvary.

The effect on the family, and on locals, has been profound, with the children's grandfather commenting, 'This memorial has been a gift . . . a new way to find God and peace.' And, for Lukez, 'This project – both the process of designing it and getting it built – has been one of the most rewarding experiences I have had in my career.'[3]

10

Dr Kallam Anji Reddy Memorial

Architect: Mindspace Architects (Sanjay Mohe)
Location: Hyderabad, India
Year: 2016

left

29 Visitors learn about the company's formation and the pioneering achievements of its founder

above

30 A linear body of water reflects the sky in its granite surface, denoting absence

Dr Kallam Anji Reddy – scientist, entrepreneur and philanthropist – was the founder of the multinational pharmaceutical company Dr Reddy's. At the time of his death, in 2013, this well-respected pioneer of the Indian pharmaceutical industry had amassed an estimated personal wealth of $1.5 billion, but his origins were humble, as the son of a farmer.[1] Reddy's father was known in his community for distributing free herbal medicines to those unable to pay for them, and this early experience of goodwill would influence Reddy's decision to pursue a career in generic pharmaceutical manufacture. It was Reddy's strong belief that

medicines should be affordable, and that deprivation could be alleviated by improved health and opportunities for livelihoods. This ethos would also inspire his many philanthropic efforts.[2]

The memorial is set in the grounds of Reddy's home and laboratories near Hyderabad, India, and was commissioned by his family. Although the memorial's primary aims are to celebrate the achievements of one individual, cementing a personal and corporate legacy, it also fulfils a public function in that it hopes to impart to visitors something of Reddy's community spiritedness and determination to succeed.

Architect Sanjay Mohe, an acquaintance of Reddy, set out to convey through the memorial's architecture a paradoxical sense of 'the presence of absence'. Throughout the 1.2 acre landscaped site, architectural elements channel the visitor along paths, determined by existing trees, which celebrate different aspects of Reddy's character

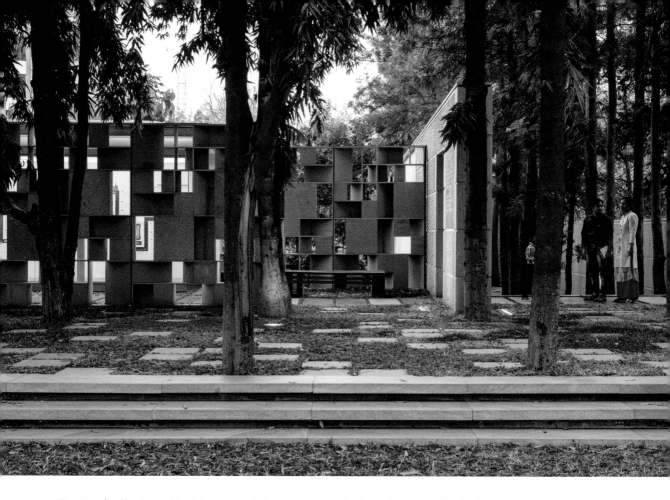

31 Tree-lined paths guide visitors through the memorial, while the architecture affords glimpses across the site

and life story. The paths surround a black granite water feature and void, symbolically placing absence at the memorial's heart. Together these narrative pathways amount to a rich and multifaceted life story.

The most straightforwardly addressed theme is Reddy's career success. The sloped 'Entreprenurial Path' follows a line of Silver Oak trees, with the young Reddy's motorbike in a display case at the start and his Mercedes Benz at the end. The metaphor requires little explanation: 'A walk along this path would motivate and inspire one to set and reach higher goals', says Mohe.[3]

The 'Path of Samadhi', or reflection, is characterised by a grid of Gulmohar trees and a linear body of water, which reflects the sky

and denotes absence. The circular 'Pradakshana Path' represents a cycle of returning to nature, and is characterised by permeable walls and gaps between palm trees. These voids increase until only the open sky is visible. The 'Path of Discovery' cuts through a line of Ashoka trees, and here the texture of the floor transitions from rough to polished in another allusion to Reddy's successful life story. This path culminates in a Bodhi tree, symbolising enlightenment.

The memorial's complexity matches that of Dr Reddy's life story and marries earthly, materialistic concerns with more transcendent ones. In the spirit of philanthropy, it aims to give something back, to the laboratory staff members and to the public who visit the site, in the form of a peaceful, contemplative space, which could inspire them too.

11

Flowing Paperscapes of the War Memorial

Architect: Willy Yang Architects and Planners
Location: Yilan County, Taiwan
Year: 2021

The Chung Hsing Paper Corporation, established in 1935 during the period of Japanese colonial rule, was at one time the largest paper mill in Southeast Asia.

Throughout its long history, the factory produced all manner of weights, textures and applications of paper, from newsprint, its primary product, to banknotes, lottery tickets and more. Paper was of significant importance to Taiwan's economy, and the factory was a huge employer within its province.

The mill became a state corporation in 1959 and ceased operations in 2001. In 2014, Yilan County Government took over the 35-hectare site and converted it into a cultural incubator, the Chung Hsing Cultural and Creative Park (CHCCP). Keen to preserve its industrial heritage, some buildings were converted into historical galleries; human stories are of particular importance, given that a large number of the elderly local population spent their entire careers at the factory.[1]

The Flowing Paperscapes commemorate the victims of a Second World War air raid on 15 February 1945. A US aircraft bombed the site, killing a large number of Taiwanese and Japanese workers. In honour of his co-workers, 87-year-old Lin Pai-lien, who survived the raid, petitioned for a memorial in 2016.[2]

The memorial's other aim is to provide much needed outdoor space, serving people in their current needs as well as commemorating the past. 'As the Flowing Paperscapes preserve memories from the past, they also bring hope for the future', says architect Janmichael Antoni. 'It was our firm belief that a memorial park does not always have to be melancholy, but can also be enjoyable for the visitors.'[3]

Consequently, the memorial integrates numerous accessible landscaping features, including places to sit and rest and sloped areas for children to play in.

The long, thin plot has been divided into narrow strips running in parallel along its length. In turns these are planted with lawn, occasional trees and grasses of different lengths – including fountain grass, *Pennisetum*, historically used in papermaking. Staggered segments are paved or covered in gravel. At one end, blocks for seating are arranged geometrically along the seams. These light the memorial after dark.

The geometric arrangement is also a symbolic reference to 'the scars that were inflicted on humanity by war', yet the overall effect is soothing and pacific. The strips of landscaping rise and fall in an undulating wave formation. Seen from above, these textured and flexible strips of 'paper' appear to be gently floating in a breeze. From the side, they are carried away on the surface of a stream.

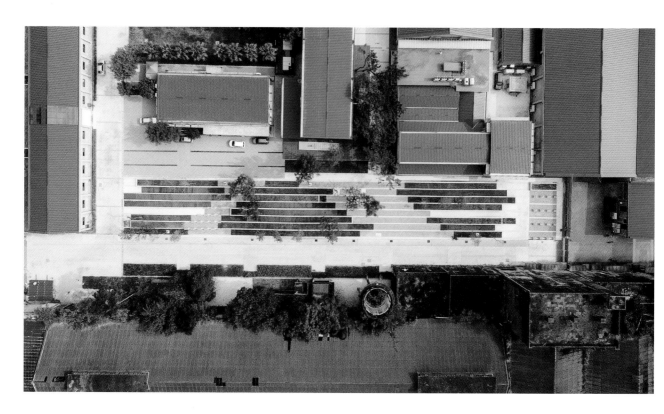

32 From above the landscape memorial resembles strips of paper floating in a stream

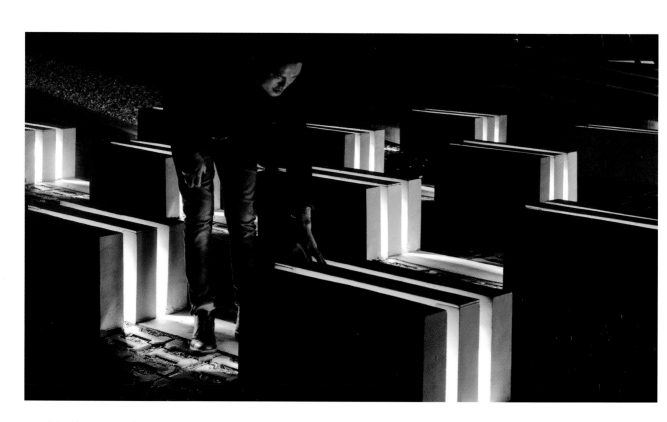

33 The memorial integrates accessible landscaping features such as seating, lighting and areas for children to play

12

Gwangju River Reading Room

Architect: Adjaye Associates (David Adjaye) and Taiye Selasi (author)
Location: Gwangju, South Korea
Year: 2013

Literacy is fundamental to an equitable society, which is why authoritarian regimes target academic institutions, demonise intellectuals and undermine attempts to educate the population. On the banks of the Gwangju River, architect David Adjaye and novelist Taiye Selasi's reading pavilion monumentalises the power of the written word.

Commissioned for the Gwangju Folly project, part of the Gwangju Biennale, the pavilion commemorates the pro-democracy demonstration

that took place on 18 May 1980. The demonstration was brutally suppressed, resulting in the death of 240 staff and students of Chonnam National University. The military's violent response galvanised citizens to escalate the conflict over the next ten days, resulting in a death toll some believe to be closer to 2,000. The uprising is seen

34 Inspired by Korean vernacular architecture, the pavilion's geometry appears to change from different angles

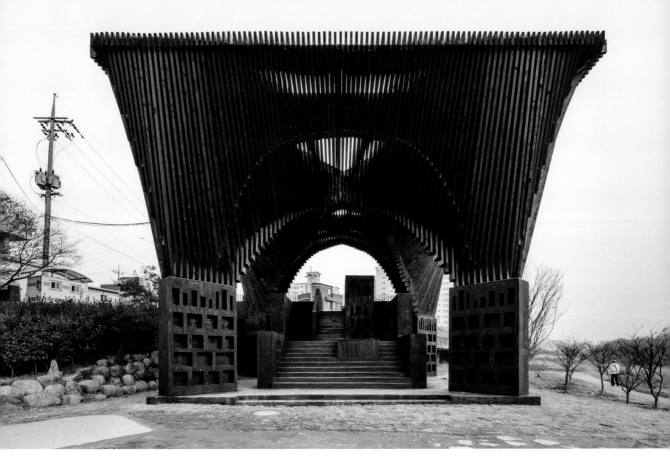

35 Niches in the concrete pillars were designed to accommodate books, integrating them into the structure

as a painful but critical turning point in the path to democracy, not only in the history of South Korea but, according to UNESCO, also influencing the democratisation of other Asian countries.[1]

Adjaye's concrete and timber construction, a public reading room, aimed to keep the spirit of the students alive through the exchange of books and ideas. Selasi selected 240 titles on the theme of democracy and freedom with which to populate the library. 'When I think about how most of those young people were students, I can't help but feel a certain grief. I asked myself, how can the grief be kept alive but in a triumphant way?' she explained.[2]

The books were placed in niches in pillars of the memorial such that they appear to be integrated into its fabric. Borrowing and sharing was facilitated by tables, seats and viewing platforms within the two-storey structure.

Loosely based on Korean vernacular architecture, the pavilion's complex geometry appears to change form as one moves around, giving the appearance of constant transformation – much like memory itself. From its position on the riverbank, the concrete base is submerged at high tide, giving the timber structure a floating appearance. The pavilion forms a stepping stone between the river and the street level above.

The Gwangju Folly project organisers sought to explore the folly – an ambiguous structure associated with frivolity and eccentricity – as a 'tool for critical enquiry'.[3] Adjaye and Selasi's response to folly is to shore it up with books, the tools of education.

Hegnhuset Memorial and Learning Centre

Architect: Blakstad Haffner Arkitekter (Erlend Blakstad Haffner)
Location: Utøya, Norway
Year: 2016

Hegnhuset – meaning 'safe house' – is an important part of the rebuilding efforts on Utøya, Norway. It was here, on 22 July 2011, that a far right terrorist massacred teenagers attending the Labour Youth Party (AUF) summer camp, an event which shook Norwegian society.

The building is both a memorial and an education centre which sits on the site of the original cafe. Blakstad Haffner Arkitekter worked with the AUF to devise the new complex, in the firm belief that the Norwegian values of democracy and participation should not be compromised by an act of terror.

The history of Utøya is tied in with such values. The island was acquired by the labour movement in 1932 and later handed to the AUF where it became a retreat and centre for political gatherings – literally a 'safe haven' for the expression of ideas.

The former cafe was the point on the island which bore the most visible traces of the attack. In the assembly hall, 13 people died, yet in the nearby restroom, 19 survived. These two buildings are preserved within the new structure, which retains their traces but forms a protective visual shield between these architectural remains and the rest of the site.

The new structure is oriented to the other new buildings on the site, at an angle from the existing buildings. This shift in axis signals an ideological shift, 'a new historical layer and a new chapter on the island's history'.[1]

Hegnhuset has a double-skinned envelope. It is a glass and timber-framed construction, and the footprint of the building is bounded by 69 wooden pillars, one for each of the victims who were fatally shot. This transparent building is further encircled by a perimeter of 495 slender wooden slats, the number of survivors. These form a kind of cloister that guides visitors through a spatial sequence. 'One feels trapped in the building's symbolic constituents, entrenched but seemingly free. Openings to the outside are constant but the way there, in and out, is difficult to find immediately', the architect has said.

Hegnhuset honours the dead and the living, and preserves an architectural memory. 'These [remaining traces] carry with them important memories and stories', says Blakstad Haffner. 'We wish to keep these traces for posterity, so that new generations can learn and take responsibility for safeguarding our democracy.'[2]

overleaf, top

36 Hegnhuset, meaning 'safe house' has a double-skinned envelope, encircled by a perimeter of 495 wooden slats, screening it protectively

overleaf, bottom

37 The original structure is encased within the new envelope, and the building is used for memorial gatherings and education

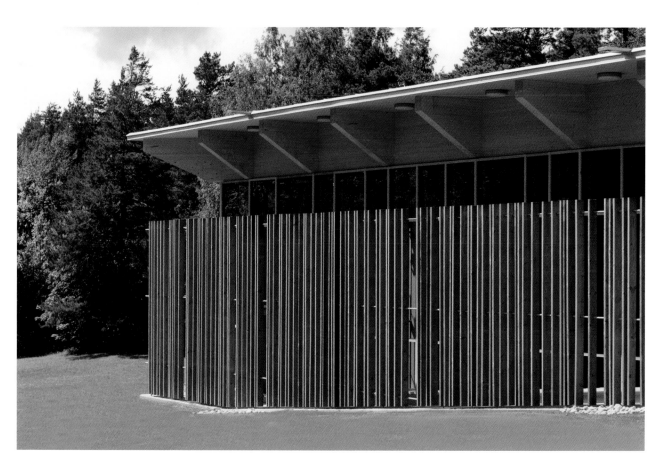

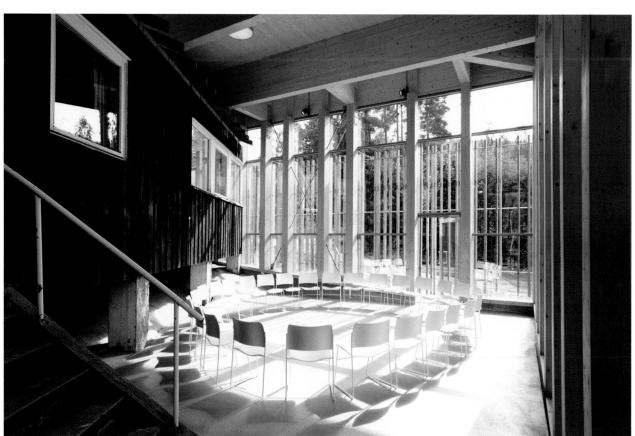

Japanese Immigration Memorial

Architect: Gustavo Penna Architects and Associates
Location: Belo Horizonte, Brazil
Year: 2007–2009

Brazil is home to the largest Japanese population outside Japan.[1] The history of this migration dates to 1908, when Okinawan farm labourers, affected by the decline of feudalism in Japan, arrived to work on coffee plantations. The migrant population boomed in the early part of the 20th century and is now around 1.5 million people.

The Japanese Immigration Memorial in Minas Gerais, Brazil, is a celebration of the relationship between these two nations and a recognition of the influence of Japanese culture. It was built to coincide with the centenary of Japanese migration and, in the words of architect Gustavo Penna, represents 'what this relationship was able to construct, both concrete and immaterial'.[2]

The memorial structure, whose built area is 500 square metres, houses a small museum.

It sits in a landscaped park spanning a body of water and is accessed from both sides via planted pathways. The building is comprised of two sweeping curvilinear forms, stretching from either side of the small lake to intertwine in the middle. From above, this point of convergence resembles the whorl of a cyclone, or two overlapping spirals of a yin and yang symbol. The circular form in the middle directly alludes to the centre of both the Japanese and Brazilian flags.

The two independent but interlacing forms become a bridge. In so doing, the memorial symbolically creates a connection between two countries separated by ocean, metaphorically connecting territories, times, ideas and ideals.

38 The memorial's centre unfurls like a ribbon and appears to hover over the lake

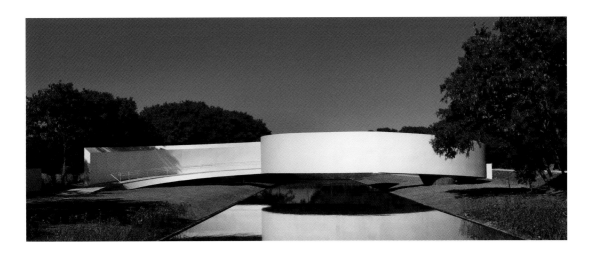

1 - GARDEN
2 - BUSH AREA
3 - WOODS "IPÊS"
4 - WOODS "CEREJEIRAS"
5 - WALL
6 - SIGN OF MINAS GERAIS' FLAG
7 - SIGN OF JAPAN'S FLAG
8 - REFLECTING POOL
9 - RAMP – PUBLIC ACCESS
10 - MEMORIAL

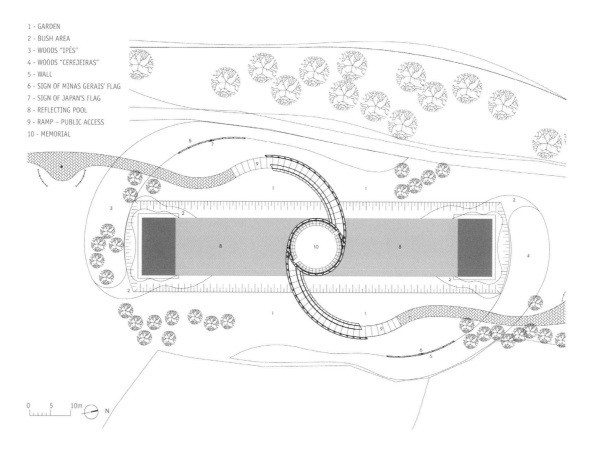

39 Two avenues, one symbolising Japan and the other Brazil, culminate in a whorl at the centre, across a body of water

The memorial sits within the Parque Ecológico da Pampulha, outside the state capital Belo Horizonte, home to Oscar Niemeyer and Roberto Burle Marx's Pampulha Modern Ensemble. This 1940s collection of modernist buildings was designated a UNESCO World Heritage Site in 2016; Gustavo Penna's memorial references this architectural heritage with its white, minimalist design.

The soft curves of the structure are intended to denote both cohesion and continuity, as well as convey a sense of movement;

experiencing the memorial entails traversing the body of water, 'in a small way experiencing the passage from one country to another'. The route symbolically leaves one shore, planted with Japanese cherry trees, for the opposite bank of white ipê (*Tabebuia rosea-alba*) trees.

'The symmetrical bridge shape with interlacing curves evokes cohesion, continuous movement and interdependence at the same time', said the architect. 'It is a museum-monument to friendship and its metaphors.'

Judenplatz Holocaust Memorial

Artist: Rachel Whiteread
Location: Vienna, Austria
Year: 2000

Artist Rachel Whiteread's Holocaust memorial in Judenplatz, Vienna, is a bold interruption in a public square.

The sculpture is a concrete cast of a hermetically sealed library. Measuring around 4 metres high, 10 metres long and 7 metres wide, it is modelled on a typical room in the neighbouring buildings, and its scale is eerily familiar.

From a distance it resembles a bunker. Only at close proximity does the viewer realise the implications of what they are seeing: handleless doors that remain forever closed and rows of books on shelves, their leaves facing outwards, which will never be read. It is an impenetrable, inescapable space, solidified in time.

As with Turner Prize-winning *House* (1993) – the controversial cast of a house in east London – and *Monument* (2001) – Trafalgar Square's fourth plinth, eerily transposed in resin – Whiteread's practice has long explored concepts of negative space. *Nameless Library* is also a cast, space turned inside out, an inversion of how things should be. Concrete has filled a void left by those that are gone. Concrete has permanently set the air that should have occupied the space.

There are plenty of symbols to read into this artwork, some unsettlingly literal: inescapable chambers, unwritten histories, Judaism as a 'religion of the book'. But like her sculpture, which is formidably mute, Whiteread has on occasion refused to open up to interpretative discussions, once telling an interviewer: 'I think its references will be apparent. I've spent a year and a half thinking it through. You don't engage in a project like this lightly.'[1]

Commissioned in 1995, the project was beset by a five-year battle between various parties at odds over both aesthetics and politics. The site itself also brought up unexpected archaeological discoveries, being the site of the Or-Sarua Synagogue, which burnt down in 1421 during the Vienna Gesera pogrom.

Whiteread opted for concrete as it is a material to which everyone can relate, but whilst the memorial mirrors the scale of neighbouring buildings, it does not communicate with them. The base of the monument reads: 'In memory of the more than 65,000 Austrian Jews who were murdered in the period from 1938 to 1945 by the National Socialists', and also includes a Star of David and the names of concentration camps. Otherwise, this austere monument gives and receives minimal explanation.

The viewer can work it out for themselves, and read into the allusions of an inaccessible library what they will.

overleaf

40 Rachel Whiteread's bunker-like memorial sits unapologetically in the centre of the public square

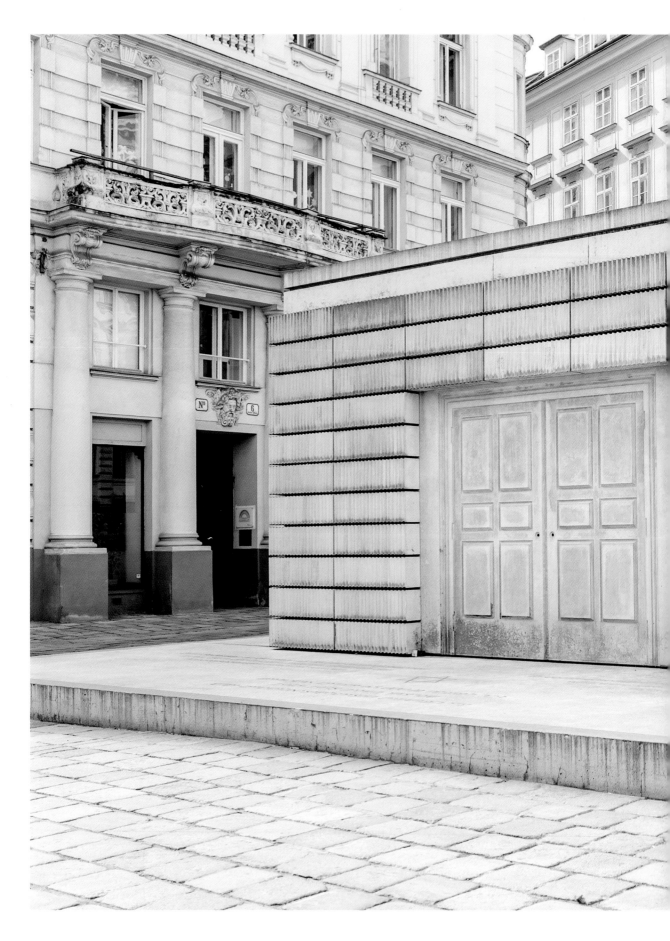

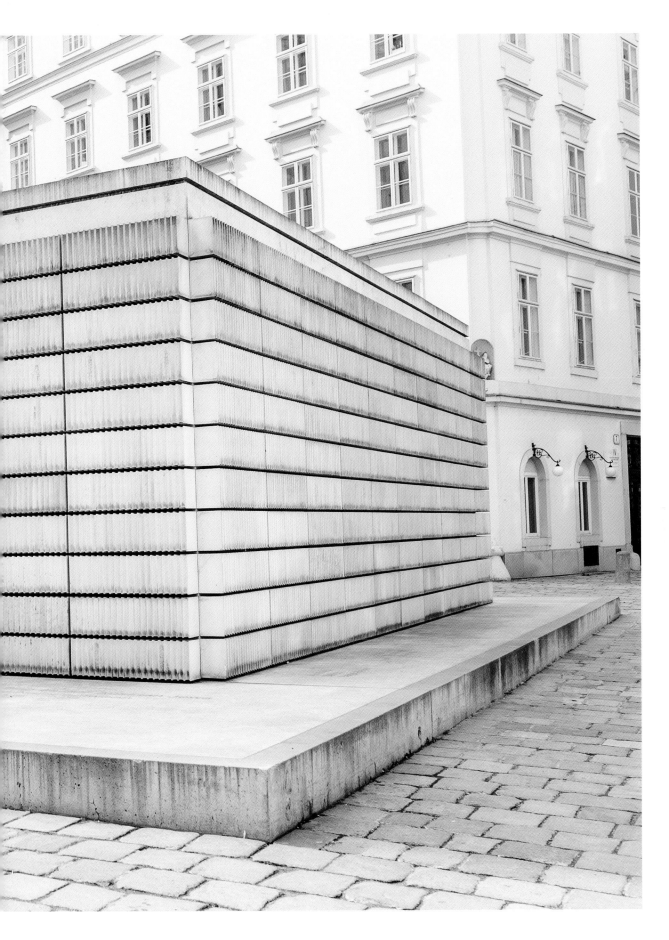

Katyń Museum

Architect: BBGK Architekci
Location: Warsaw, Poland
Year: 2017

41 Personal effects salvaged from the burial site were imprinted into the concrete as a reminder of their departed owners

The Katyń Forest, 20 kilometres west of Smolensk, Russia, is the site of a mass grave where 22,000 Polish officers and intellectuals are buried. They were murdered as part of a purge ordered by Stalin between April and May 1940. This event was rendered darker still by a 50-year cover-up. Until 1990, Russia

denied Soviet involvement, incorrectly blaming Nazis soldiers. Allied leaders were aware, but chose to allow misinformation to continue.[1]

It is understandable, therefore, why the Polish should want to commemorate their compatriots at home. And the Warsaw Citadel, despite its geographical distance from Katyń, is contextual. The imposing red-brick citadel had been built around 1830, by order of Tsar Nicholas I, after the suppression of the November Uprising – an armed rebellion by the Polish against the Russian Empire. In addition to housing the Tsarist garrison, the citadel was a notorious prison where Polish national activists and revolutionaries were detained and executed.

The citadel was turned into a museum complex in 1963, and since 2017 has housed the Katyń memorial. The adaptations, by BBGK Architekci, are located in the southern part of the citadel site and include three historical buildings. An exhibition narrative flows, in a manner akin to a documentary, between these repurposed buildings, with architectural interventions connecting the disparate sites and directing the course.

The main exhibition space is arranged on the historic, caponier fortification across two levels. The first level contains historic information, including artefacts unearthed from the site. The second is devoted to personal accounts, constituting a place for contemplation. Outside, the exhibition route continues. In

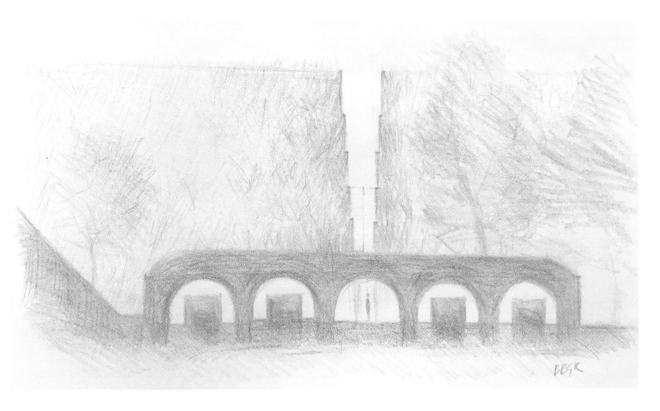

42 Architect's sketch of the cannon stand with the steep staircase behind it, which ascends towards the light

43 One hundred trees at the centre of the site recollect the forest at Katyń

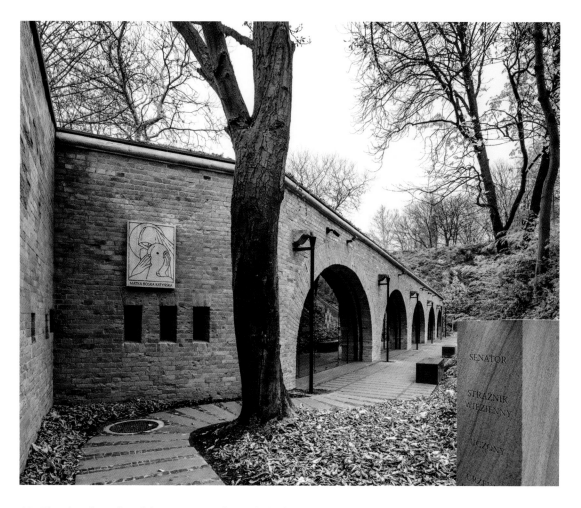

44 The glazed arcades of the cannon stands, in which plaques with names of officers are displayed

sympathy with the red brickwork, the architects made use of stained concrete, imprinting artefacts into the fabric to create an expressive and tactile surface. Chess pieces, excerpts from letters and military badges leave their mark in the wall, a reminder of their missing owners.

The exit of the museum is termed the 'death tunnel', which is a sombre 20-metre-long, black, concrete passage. This opens towards the more open 'alley of the missing', a passage filled with empty pedestals, onto which the names of the deceased civilians and their professions are engraved. This path leads visitors to the cannon stand with its glazed arcades, where the plaques of officers' names are displayed. Dividing the site, a staircase occupies a narrow gap with 12-metre-high walls, ascending hopefully towards daylight.

In the main square are 100 trees, a reminder of the forested site at Katyń. An oak cross placed among the trees concludes the dramatic narrative route. BBGK's researched, bold and sympathetic reworking of the pre-existing architecture is a skilful example of architectural intervention, which has allowed Poland to re-appropriate the way that this story is told.

Levenslicht

Designer: Studio Roosegaarde (Daan Roosegaarde)
Location: Netherlands (various sites, initially Rotterdam)
Year: 2020

Levenslicht, meaning 'light of life' in Dutch, is an interactive memorial. It was commissioned by the National Committee for 4 and 5 May – the body which helps determine how the memory of the Second World War is honoured in the Netherlands – for the 75th anniversary of the liberation of Auschwitz. This work challenges the typology by using new technologies to create an interactive memorial that can be experienced in different places while still retaining its contextuality.

The installation remembers 104,000 Dutch Holocaust victims with the corresponding

number of luminescent stones. It draws on a Jewish tradition of placing stones, rather than flowers, to honour the deceased. In the installation, stones containing fluorescent pigments are arranged in a circular formation. These light up every few seconds then extinguish, creating an ever-changing display, which the artist describes as 'a breath of light'. The impression created by the stones, glowing in the winter darkness, is affecting and surprising.

45 The innovative memorial was designed to be located in various towns across the Netherlands

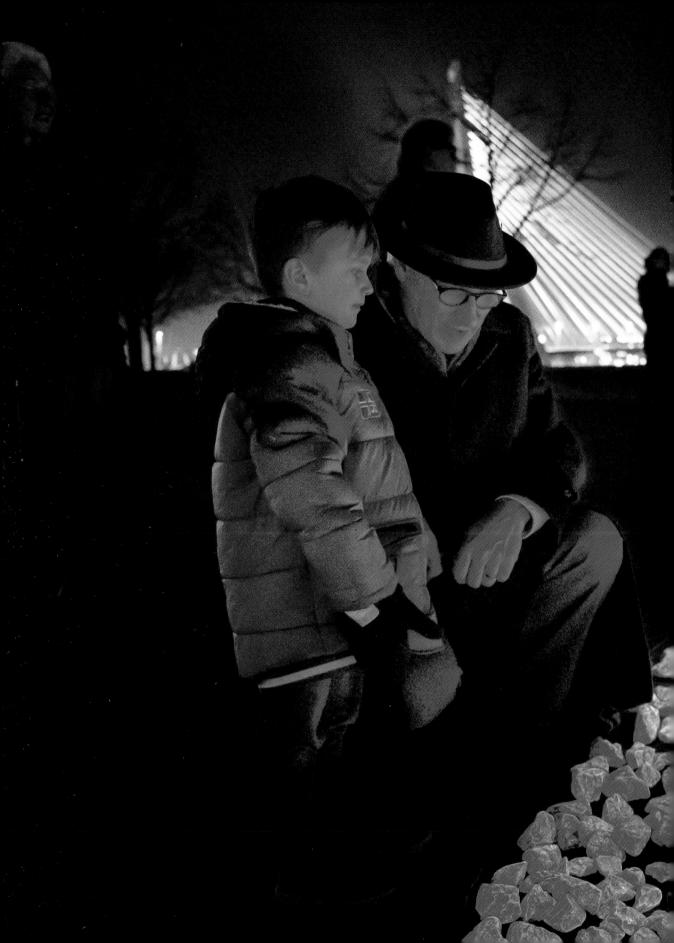

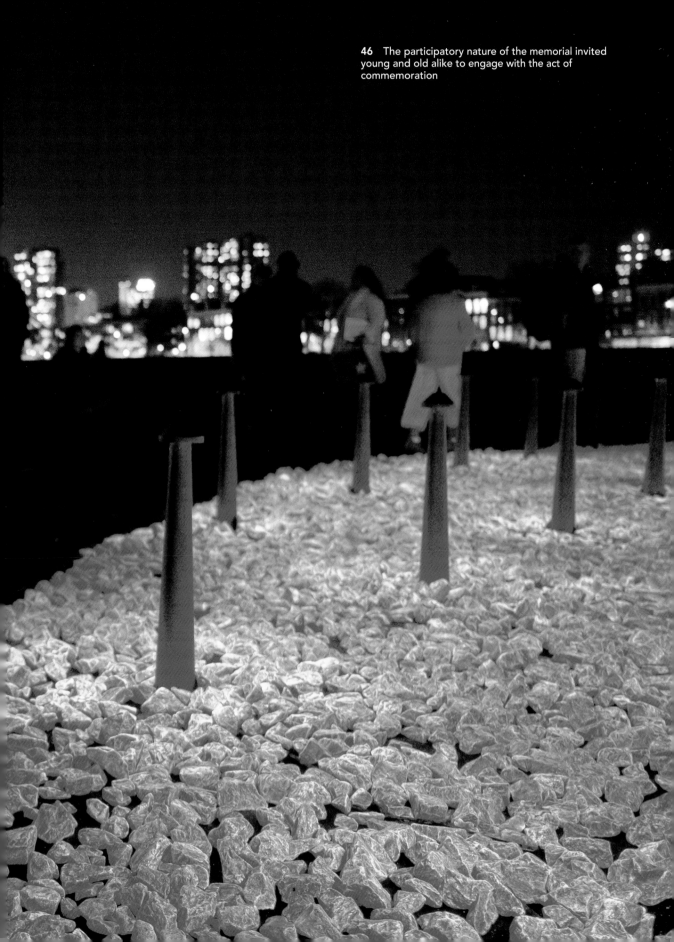

46 The participatory nature of the memorial invited young and old alike to engage with the act of commemoration

The installation was first displayed in Rotterdam, then rotated around 170 municipalities, each of which had historic ties to the tragedy of the Holocaust. The intention was to encourage maximum participation, as well as to assist in the effort to educate children about Holocaust history; the Jewish Cultural Quarter developed an online learning environment aligned with the artistic project.

Visitors to the memorial were invited to handle the stones, making for a symbolic and performative act of commemoration. 'I wanted to add something new to what a memorial monument can be', Daan Roosegaarde told us. 'So, we made a monument of light, not concrete and not solid, but sharable. The emotional response that many people described was that they had to get used to the idea of this different kind of memorial monument. But after the opening, people engaged with it in a very beautiful and emotional way, placing the memorial rocks one by one together with their children and sharing personal stories. It was very special to see that the project came to life.'[1]

This memorial is atypical in its use of new technologies to create new avenues for remembrance, as well as sparking dialogue. Roosegaarde says, 'I often call my work "techno-poetry": it is a mix of technology and creativity. I think this combination is the engine that drives social change.'

'I think a contemporary monument should involve all people, young and old. That is why my approach is aimed at interaction and sharing', he explains. This monument, with light as its primary material, makes for a tactile and visually stimulating environment and draws connections between sensory experience, space, the urban realm, emotions and the commemorative process.

'This assignment got me thinking about what freedom means to me personally', elaborates Roosegaarde. 'The dividing of the stones across the Netherlands was to commemorate the victims throughout the country. For me, freedom is more about being connected than being completely detached. As an artist, I feel especially curious to discover, critique and design things that don't exist yet and change our view of the world. That's the beauty of art.'

Mausoleum of the Martyrdom of Polish Villages

Architect: Nizio Design International (Mirosław Nizio)
Location: Michniów, Poland
Year: 2021

This striking site combines a memorial museum and chapel with expressive sculptural forms and symbolic meanings. Michniów is a village that has become a symbol for all the pacifications and repressions that occurred in Nazi-occupied Poland during the Second World War. Pacification was an aggressive, punitive and preventative system exacted against communities for engaging in resistance efforts. It was part of a systematic and brutal extermination policy and resulted in over 20,000 murders, including of children as young as 18 months, the elderly and wounded – not limited, therefore, to resistance fighters. Many villagers were trapped and burned alive in wooden barns.

47 The site of the Michniów memorial seen from above

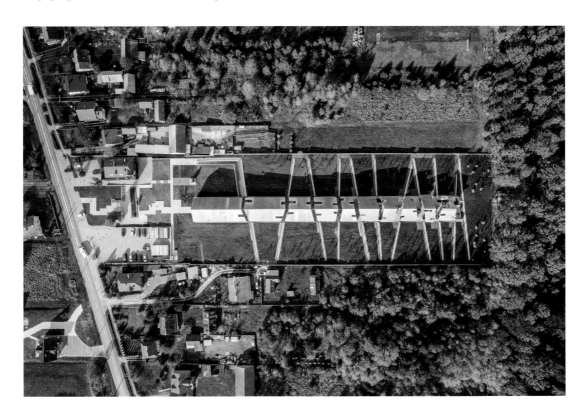

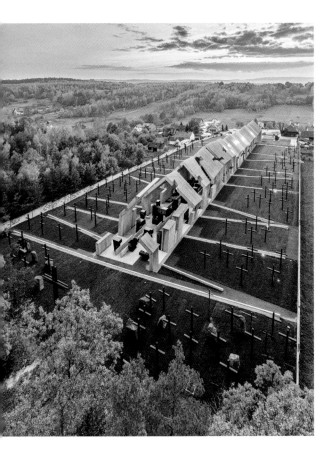

From the north and south elevations, it takes the shape of a simple, gabled rural house, with a plain, pentagonal section. The main entrance, in the first module, resembles an intact dwelling. This is the chapel space, with blackened wood pews, altar and crucifix. Nizio describes the chapel as 'a sign of wholeness and unity, a symbol of a home, a family hearth'.

However, the elongated structure is dramatically broken up along its length with wide cracks. These divide the monolith into segments, five of which are open and six enclosed with glass. Through the voids, one can see the larch crosses surrounding the building, which resemble wooden headstones, scattered in the immediate, landscaped vicinity. As Nizio explains, 'These crosses were brought here from various places during the 1980s; it was a symbolic gesture to bring back the memory of the murdered inhabitants of Michniów and other Polish villages that suffered during the Second World War. At one point, however, these crosses began to be associated only with a cemetery, and not with a memorial site that could provide some knowledge about the history of the local population.' These are now coherently integrated into the memorial landscape.

48 The monolithic barracks becomes increasingly fragmentary along its length, embodying a process of destruction

The tragedy of Michniów unfurled between 12 and 13 July 1943. The wider region was occupied between 1939 and 1945; in retaliation for partisan activity there, two massacres took place in the village, resulting in 301 deaths. A further 11 people were sent to Auschwitz, where six died.

The new memorial museum and chapel by Mirosław Nizio is a sculptural form which marries architecture with historical narration.

Occupying a long site which slopes downwards from east to west, the building is a long, monolithic, almost brutalist, concrete barracks.

The individual modules of the building simultaneously crash together and appear disintegrated from one another, as if ruptured by a seismic catastrophe. The segments appear more deformed and disparate along the building. The chambers created in the segments reduce in length from west to east and in sections they rise in height gradually before dropping again, following the contours of the site. This progressive deconstruction of the building symbolises the escalation of wartime violence.

As Nizio told us, 'Looking at archival photos of a pre-war village – cottages, inhabitants, scenes from everyday life – we feel that we are communing with something full, complete, and

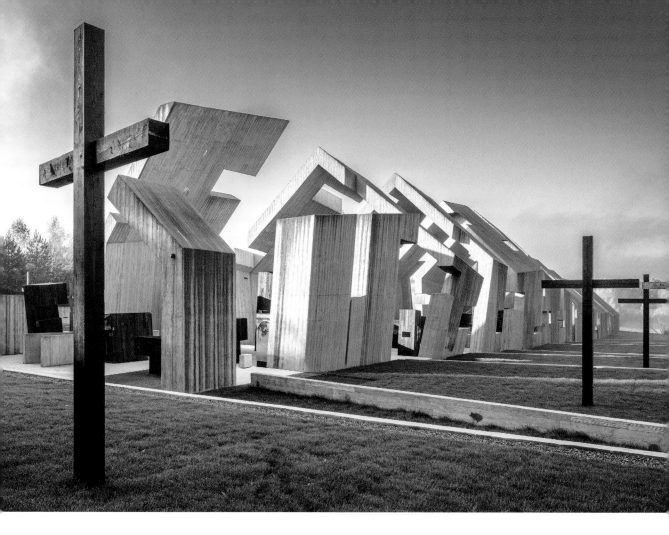

49 Larch crosses resembling headstones surround the building

with a naturally flowing life. On the other hand, when examining photos of pacification, we are witnessing a very painful story. We experience emotions accompanying a sudden "break in the lifeline", and we get a sense of increasing destruction.'

The interior is lit through the cracks between the segments, creating an atmospheric exhibition space of 1,700 square metres (the whole site is 16,225 square metres). Concrete, wood and hot-rolled black steel dominate the interior design, a materiality intended to affect the visitors' senses: charred wood has a distinctive smell. The woodgrain texture in the concrete becomes more pronounced as one passes through the building, a detail which

links the structure with the interior furnishings and continues the sombre reference to rural materials and their destruction and burning.[1]

'The building is a kind of freeze-frame reflecting the violence and brutality of the events that took place', summarises Nizio, and the architecture distils a profundity of feeling. 'These are stories of displacement, deportations, murder: it was natural that we would not build this facility on dry facts – its form and content are also dictated by emotions', he explains. 'We manage these emotions, we tame them, we do not manipulate them in any way.' Rather, he concludes, 'we had an impulse to design a body that emanates these emotions.'

Mémorial du Camp de Rivesaltes

Architects: Rudy Ricciotti, with Passelac & Roques
Location: Rivesaltes, Pyrénées-Orientales, France
Year: 2015

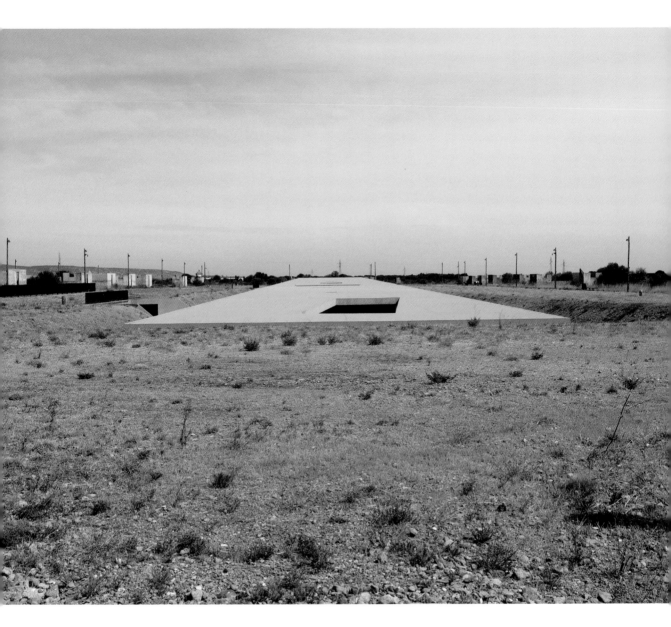

The deserted Rivesaltes camp, at the foot of the Pyrenees, is a punishing landscape. Exposed to the glare of the Mediterranean sun, there is seemingly nothing for miles around, save pylons, the motorway to Perpignan, and wind turbines on the horizon.

Camp Joffre, as it was known, began life as a military barracks. But it would become the site of thousands of forced displacements and internments resulting from the conflicts and decolonisations of the 20th century, including the Spanish Civil War (1936–39), the Second World War (1939–45) and the Algerian War (1954–62).

Countless people considered 'undesirable' by the French state would be detained here. In the 1930s these were refugees of the Spanish Civil War. In the 1940s, under the Vichy regime, Jews and Gypsies; after the Liberation, prisoners of war and those suspected of collaboration. In the 1950s, the camp was a transit zone for foreign auxiliaries to the French army and a prison for members of the Algerian FLN. After 1962, it was a 'regrouping centre' for Harki families (Algerians who fought for France in the Algerian war). Later, the camp housed Guinean and North Vietnamese immigrants from 'French Indochina'.

In 2006, architect Rudy Ricciotti won the memorial design competition, in association with local firm Passelac & Roques. Situating his project 'between the need for emotion and the refusal of forgiveness', Ricciotti's response to the 'deaf brutality' of the site is to confront it with a mute architecture that neither sensationalises, softens, nor excuses what went on here.[1]

The memorial building occupies the only open space on the site, the gathering place in the middle of former Block F. Around it stretch rows of huts in various states of demolition. Despite its imposing volume (200 metres long by 20 metres wide), the memorial structure is – on first arrival – barely noticeable. Semi-submerged into the terrain, its roof at the entrance is flush with the ground, gradually

left

50 The ochre-coloured bunker is subsumed into its terrain, sphinx-like and mute

above

51 The deserted buildings of the former camp are left to silently attest to their role in the site's history

rising in the eastwards direction, but never exceeding the ridge of the barracks.

The monolithic mass appears to be part of the landscape. The ochre concrete, which blends in with the soil, was cast in situ using a method which avoids the need for concrete formwork holes, contributing to the massive appearance and resembling prisons and desert bunkers.

It is accessed indirectly via a tunnel-like ramp with an abrupt end. Inside, the building offers no views of the exterior other than a narrow, featureless internal patio. The dark, cool interior houses an exhibition space which lays bare the chronology of the camp; its goal is to educate and question what leads society to ostracise its outsiders.[2]

Standing in the barren camp of Rivesaltes in the blinding summer sun leaves one almost devoid of thought and feeling. In Albert Camus' 1942

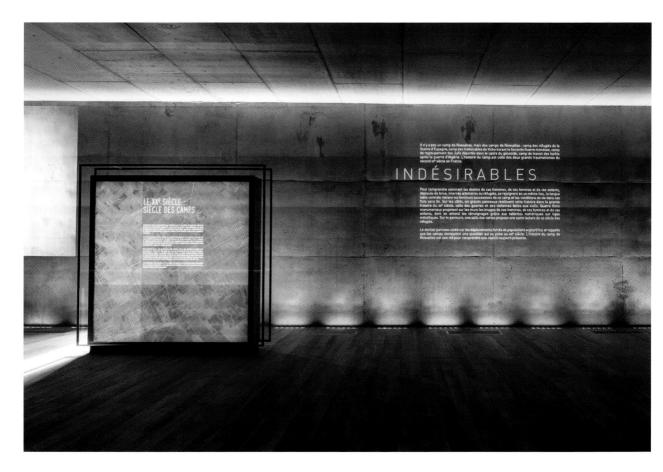

52 The exhibition space within the memorial museum does not shy away from the history of the forced incarcerations at the camp

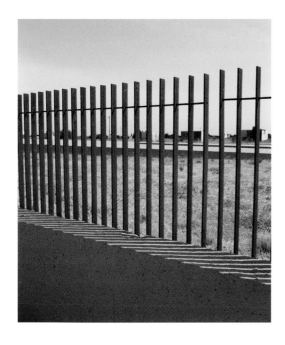

novel *L'étranger*, the protagonist Meursault kills a nameless Algerian on a beach in a banal, absurdist gesture which he blames on sunstroke. Seven decades later, concurrent with this memorial, Kamel Daoud's Prix Goncourt-winning novel *Meursault, contre-enquête* [The Meursault Investigation] gives the victim a story, a bereaved family and a name – Musa. The detainees of this camp were considered strangers, dehumanised by the state; this memorial finally acknowledges their stories too. And its 'sphinx-like' architecture deliberately leaves questions open.[3] Questions such as: has society really changed its attitude, or have we simply created new outsiders?

53 The materials and architecture of the memorial centre evoke the paradoxical sense of being imprisoned in an open space

Memorial Hall For Israel's Fallen

Architects: Kimmel Eshkolot Architects, with Kalush Chechick Architects
Location: Mount Herzl, Jerusalem, Israel
Year: 2017

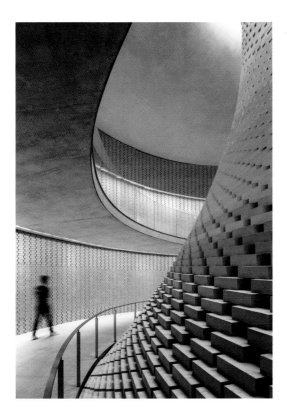

54 Natural daylight cascades inwards, illuminating the undulating funnel-like structure at the centre of the memorial

Inaugurated in April 2018, the 70th anniversary of Israel's foundation, this memorial hall honours Israel's fallen soldiers. It was established by the Department of Families and Commemoration at the Ministry of Defense of Israel and is sited at the entrance to Israel's national cemetery in Jerusalem.[1]

The memorial tackles an important and sensitive subject – in a country where most 18-year-olds are drafted into compulsory military service – about how to commemorate soldiers who have died in polemical conflicts. Some such battles are sufficiently controversial to have no officially agreed-upon name amongst Israelis.[2]

It was essential for the architects to handle fraught political issues with sensitivity, respect and equanimity. According to architect Etan Kimmel, the intention was therefore to create a space that could 'touch everyone, but without imposing a uniform interpretation'.[3] The memorial has been constructed through excavation into the mountain. Externally, the primary structure takes the shape of a white, terraced tumulus of Jerusalem Stone, evoking a funerary context, dialoguing with the mountainous landscape and tying the fallen soldiers to the land of Israel.

Inside, over 23,000 concrete bricks form a curved, rising wall of names, listing every individual who has died in military service since 1860; each block is individually engraved with the name and the date of death, laid in reverse chronological order.[4] A ceremony is held every morning at the memorial: on the occasion of an anniversary, the particular brick dedicated to the soldier concerned is illuminated by an LED.

The wall is 0.25 of a kilometre long, taking visitors on an emotional journey from the entrance along an ascending spiral route, which wraps around an undulating, hollow, funnel-like

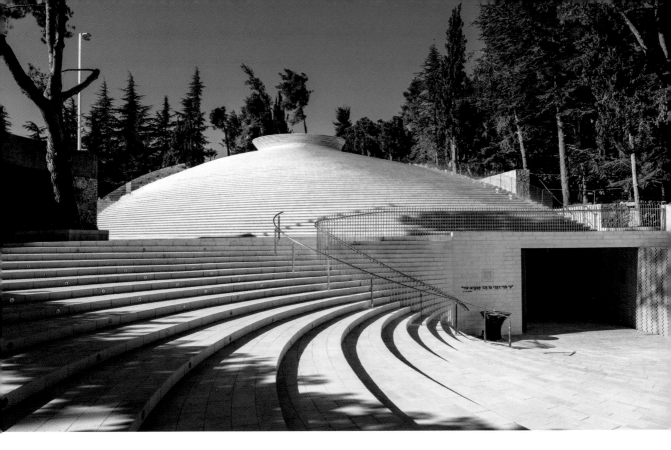

55 Externally, the memorial references vernacular funerary architecture with its tumulus mound

structure of 9,000 white, concrete bricks. It is possible for visitors to approach the centre of the funnel from underneath, where above them an oculus illuminates the cavernous interior. The almost fantastical funnel structure provides a powerful backdrop for contemplation, further enhanced by natural daylight cascading inwards and given nuance by the dark shadows created by the gaps in the bricks. Altogether these effects create an atmosphere of repose.[5]

Given the memorial's sensitive and intricate context, the architects have achieved the seemingly impossible outcome of eschewing overt reference to emotive politics – which serve only to exacerbate the pain of grieving families – and instead have harnessed the universality of abstraction and minimalism. The unassuming design avoids forcing an authored narrative, offering an original, emotive device with a fluid interpretation that allows for personal acts of remembrance without official imposition.

56 A cross section of the tumulus structure

21

Memorial to the Murdered Jews of Europe

Architect: Peter Eisenman
Location: Berlin, Germany
Year: 2005

Peter Eisenman's memorial in central Berlin is instantly recognisable and unforgettable.

The 1.9-hectare memorial comprises 2,711 concrete stelae arranged in a grid, which stretches across an open urban plain. The seeming limitlessness of the stelae stretching across this vast and sprawling memorial field is bewildering – much like the statistics of the Holocaust, in which six million Jews were murdered.

The slabs are all 95 centimetres apart, obliging those that enter this sombre maze to walk in single-file. The slabs' dimensions are eerily coffin-like, at 95 centimetres wide by 240 centimetres long, and they range from zero to four metres high. Beneath them, the ground itself undulates, such that, from a distance, the memorial's upper surface appears to ripple and swell like an enormous pin-screen.

The memorial's rectilinear formation initially seems well-ordered but in fact is determined by a complex model that produces irregularities at the intersection of several notional grids. The resulting unevenness is jarring; certain spaces expand and constrict, dissolving any illusion of safety rising from the apparent orderliness of the arrangement.

According to Eisenman, 'this project manifests the instability inherent in what seems to be a system . . . it suggests that when a supposedly rational and ordered system grows too large

and out of proportion to its intended purpose, it loses touch with human reason.'[1]

In German, *denkmal* (memorial) stems from the verb 'to think'. Eisenman's paradoxical monument exhorts its visitors to think very hard while simultaneously thinking nothing at all: 'In this monument there is no goal, no end, no working one's way in or out. The duration of an individual's experience of it grants no further understanding, since understanding the Holocaust is impossible', Eisenman has said. 'In this context, there is no nostalgia, no memory of the past, only the living memory of the individual experience.'[2] The lack of defined boundaries at the memorial's edges makes it a porous space for people to wander in and out of. On the lower stelae people sit, contemplate their surroundings and otherwise pass the time.

The quandary, however, is that nothing, save the name of the monument, guides one's thinking. Eschewing proscriptive interpretation enables the visitor to experience the space without interference, yet this strategy has – inadvertently or by design – encouraged unusual responses to the architecture. Yoga, juggling and sunbathing, for instance, are borderline irreverent behaviours in memorial contexts.[3]

Nonetheless, Eisenman has created a strong and memorable experience: 'When you turn a project over to clients, they do with it what they want' he has observed. 'It's theirs and they occupy your work. What can I say? It's not a sacred place.'[4]

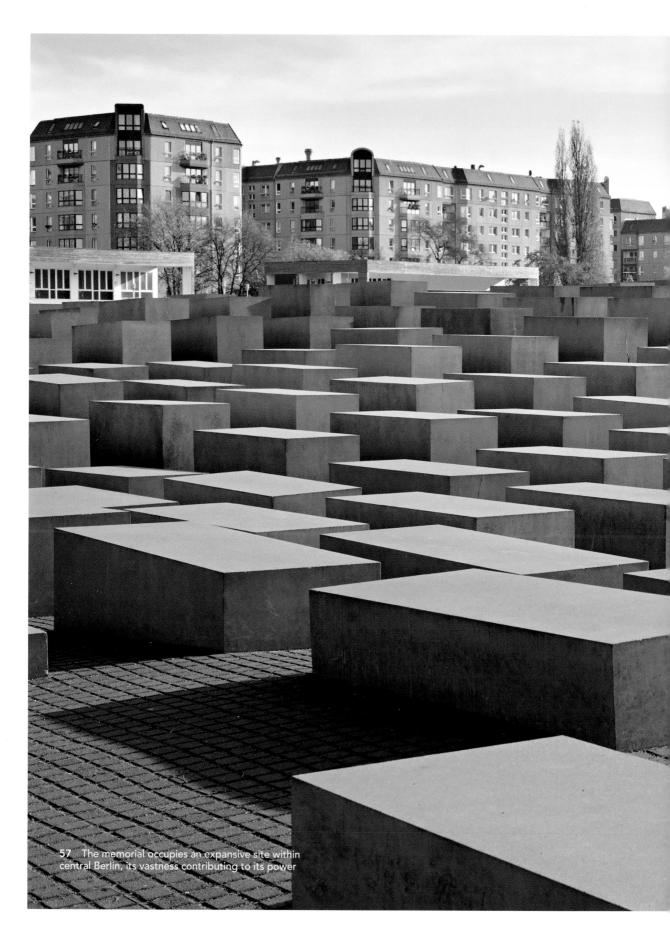

57 The memorial occupies an expansive site within central Berlin, its vastness contributing to its power

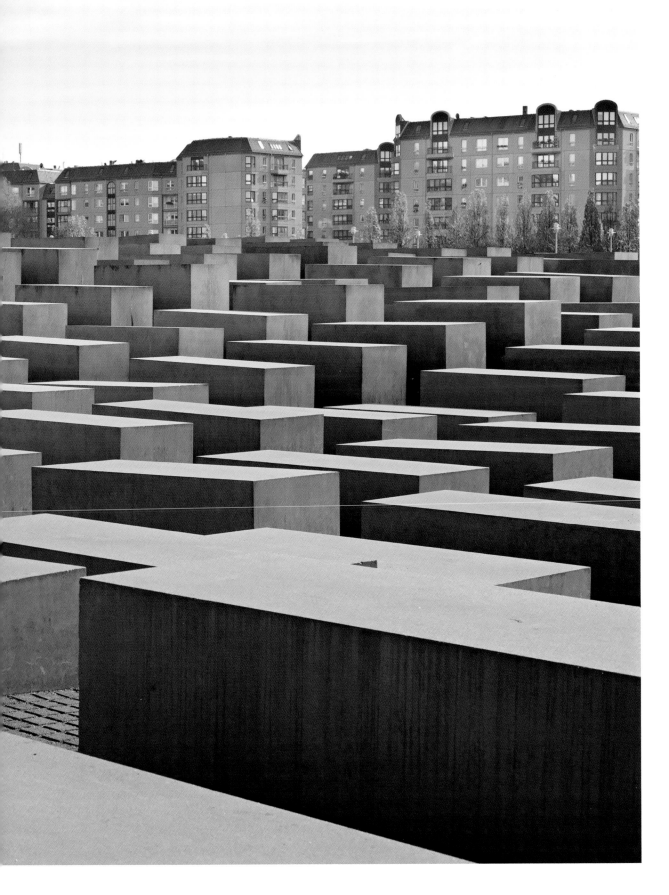

22

Memorial to Victims of Violence in Mexico

Architect: Gaeta Springall Arquitectos
Location: Chapultepec Park, Mexico City, Mexico
Year: 2013

Chapultepec Park is a large and forested site within Mexico City which dates back to pre-Columbian times and now acts as the green lungs of a sprawling, frenetic metropolis. 15,000 square metres of the forest was opened up to accommodate this memorial, which addresses one of Mexico's overriding social problems: the memorial was partly funded by money seized from drug cartels, honouring those who have suffered as a result of violent crime.[1]

'Violence is destruction', says architect Julio Gaeta, 'and if violence is destruction, we have to build.'[2] The architects' intention was to materialise a large, open wound by creating an arrangement of solids and voids, presences and absences. The memorial is made of 70 Corten-steel walls, of

three types, each with different implications: in its natural state, the materiality is unperturbed, a symbol of peace and non-disturbance; in its rusty state, it refers to the marks and scars that violence leaves on those it affects and the continuation of violence as the rust develops; in its stainless form, it has a reflective quality which mirrors the trees, the nearby water, the other surroundings and the people, multiplying life. Conversely, the gaps between the walls refer to the emptiness of loss.

At 12 metres tall, the stelae are imposing. They blend in with the trees, creating a duality

58 The memorial's steel walls are arranged within a forested site around a reflecting pool

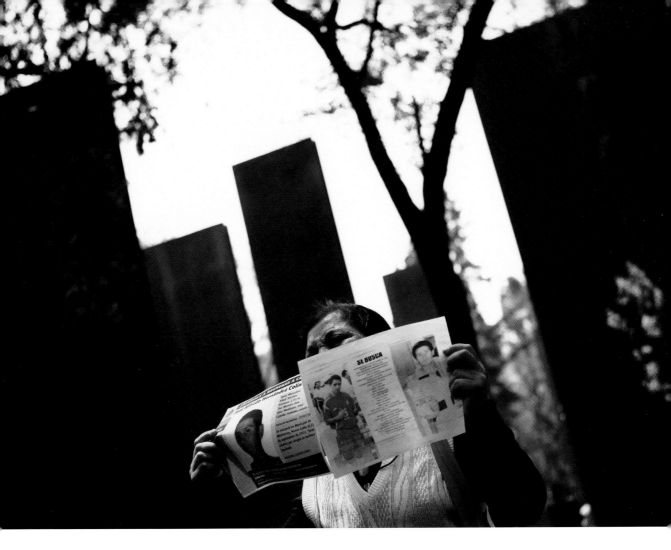

59 A grieving relative holds a poster for her missing nephew at the monument's inauguration in 2013

between the artificial and natural environments: steel and concrete, like memories, are man-made, while trees and visitors are alive in the here and now. At the centre of the memorial site is a fountain, water being a ubiquitous symbol of life and healing.

One of the most important parts of the project is the appropriation of the steel walls, where visitors are encouraged to write their loved ones' names in chalk, or express their loss and anger. These temporary inscriptions sit alongside permanent quotations by writers such as Martin Luther King Jr and the Mexican poet and diplomat, Octavio Paz. Intimate messages and simple names are rendered

even more poignant against the formidable backdrop of steel.

Whether this memorial represents an appropriate use of funds has caused debate. The land is adjacent to the Secretariat of National Defense (SEDENA), whose efforts – according to many families – would be better directed towards fighting organised crime and corruption. Nevertheless, the memorial's architecture has garnered praise, and does at least offer a means by which ordinary people can openly express their grief.

The chalk will eventually be washed away – and, one hopes, someday so will the pain and suffering caused by violence.

Mitsamiouli Stele

Architects: Keldi Architectes (Mahmoud Keldi) and Nadia Moussa
Location: Mitsamiouli, Ngazidja (Grande Comore), Comoros
Year: 2011

On 30 June 2009, Yemenia Airways Flight 626 crashed into the Indian Ocean, just off Mitsamiouli, Grande Comore, the largest of the four islands of Comoros.

Of the 153 passengers on board, only one girl survived, 14-year-old Bahia Bakari, who was rescued clinging to wreckage after a 13-hour ordeal. Most of the passengers were dual French citizens heading to Comoros for the summer vacation via Sana'a, Yemen.[1]

This accident was one of the most serious in the history of Comoros and caused considerable trauma, particularly in Marseille, where the Comorian diaspora is in the hundreds of thousands. Following the tragedy, thousands of people demonstrated against the unsafe and low-quality aircraft serving the route.

Two years after this catastrophe, a memorial to the victims was unveiled at Mitsamiouli, sponsored by the French Embassy in Comoros. The tall, thin stele measures 4.2 × 1.8 × 0.4 metres. Its materials are black volcanic stone interspersed with gilded stainless-steel plates. Volcanic stone is a local material, whereas the steel comes from France, connecting the two countries. 'The volcanic stone represents the Comorians', Mahmoud Keldi told me, 'and the gold represents elsewhere – the West, France – where Comorians go into exile to make their fortune.'[2]

These two materials are not uniform – they catch the light, darken and sparkle to create a living and vibrant work that is never quite perceived in the same way each time. This changeability is also an allegory regarding the differences between the individuals caught up in the tragedy – 'all different, all social classes, but united in this drama'.

A vertical slit pierces the volcanic stone, giving a glimpse of the sea. At sunset, light filters through, bathing the sculpture in a warm glow. Said Keldi, 'A wall rose up in front of the lives of children, women and men but one person opened a glimmer of hope, the one and only survivor, the little girl.'

The ground immediately below the stele is also clad in volcanic stone, resembling a person and their shadow. The volcanic stone permanently anchors the stele in the Comorian soil. But the stele is far more than a slab on a base. Its commemorative power also comes from its architectural space, influenced by its Comorian context, which has been designed after a Bangwé (a traditional Comorian public space) and sits in between two such spaces, 'Place des jeunes de Djao' and 'Place Mvéridjou'. The memorial is intended as a place of dialogue and cultural exchange between Comoros and France. It is an expression, not only of memory, but also of a commitment from France, Comoros and other countries regarding aviation safety.

In the words of its architect, this stele 'is a symbol of hope and of resilience, because this accident will not stop Comorians from making this return journey. Life goes on'.

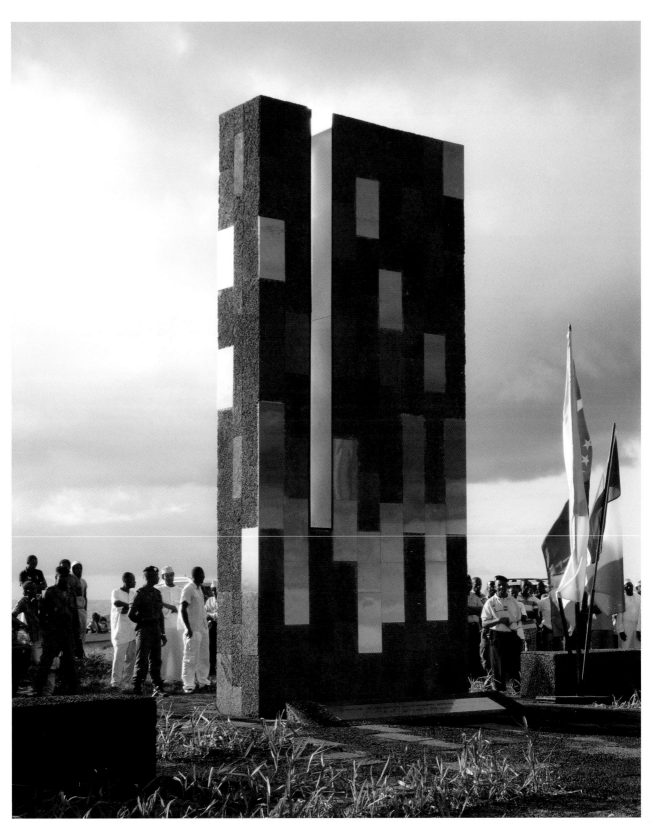

60 The local volcanic stone of the stele represents Comoros, whereas the gilded panels represent the far afield countries where Comorians go to seek their fortune

Monument to the 100th Anniversary of the Alcorta Farmers Revolt

Architect: estudio Claudio Vekstein, Opera Publica
Location: Alcorta, Santa Fe, Argentina
Year: 2018

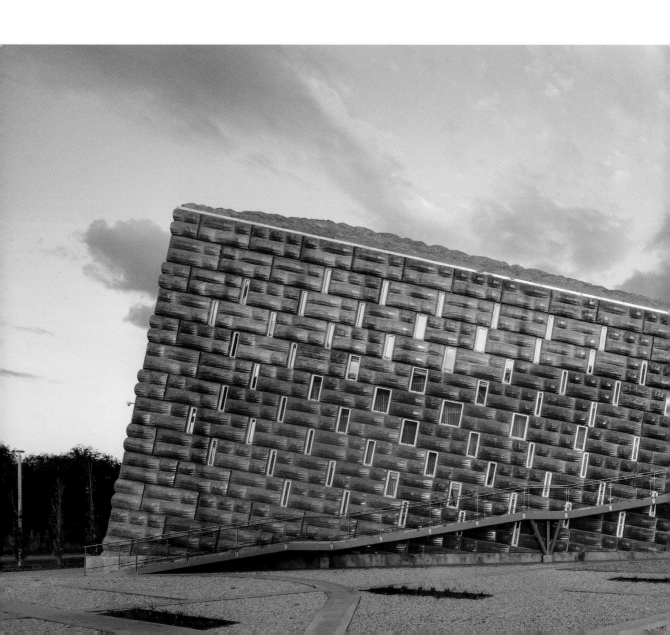

El Grito de Alcorta (the Cry of Alcorta) was a rebellion staged by Argentinian tenant farmers in June 1912. Around 75,000 labourers and their families risked expulsion from their homes due to the actions of exploitative landlords.

The strike, which began in Alcorta, lasted four months and eventually spread beyond the province to Cordoba and Buenos Aires, and then across the whole country. Its consequence was the negotiation of fairer terms and the eventual formation of the Federación Agraria Argentina (FAA).

At the point that architect Claudio Vekstein (interview, pp 99–100) was commissioned by the FAA Assembly to create a memorial centre – including offices, auditorium, plaza and gallery – the site was almost completely denuded, prompting Vekstein to undertake a considerable amount of archival research. The resulting architecture draws on influences from both deconstructivism and high-tech, as well as a radical interpretation of historic material.

61 The memorial complex with its burlap and resin facade; the structure brings in references from both high-tech and deconstructivist architecture

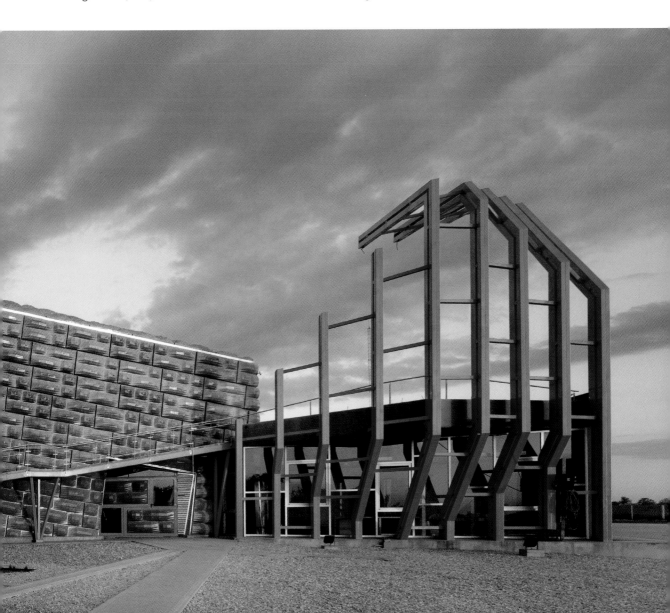

62 Archival photography was used to reimagine historic scenes and the original temporary constructions of the workers

63 Shadows cast through the burlap and resin material, as visitors ascend the ramp, create an effect of frozen time

The buildings making up the complex are clad in corrugated metal, sheltered by a monumental wall along the northern facade, which slopes and folds to protect the building. It is held up by red steel frames to form a sort of portico.

Made up of 275 panels, the imposing, semi-translucent and textured wall is made from burlap, resin and fibreglass moulded in wooden frames, a new material devised for the project. These textured panels overtly allude to the rudimentary constructions made by the labourers in 1912: burlap sacks of corn stacked regimentally on top of one another. The wall's incline references images of labourers carrying sacks on their shoulders in single file up a ramp in order to shore up their constructions. Vekstein opted for the use of resin after discovering the work of artist Ayelén Coccoz, who uses the material when working with historic images.

The semi-translucency of the facade creates a direct link to the ancient photography. When visitors climb the ramp, the sun on their backs, their silhouettes are visible on the other side like ghostly shadows emerging in a darkroom developing tray.

The angle of the ramp is counterbalanced by the angle at which the resin panels are arranged: as the visitor ascends, the architecture descends.

The rough, furrowed and sun-hardened texture of the facade, and the array of different textures at different scales across the whole monument, is also partly inspired by the range of textures present in Antonio Berni's painting *Manifestación* [Demonstration], itself inspired by the Alcorta revolt.

At the top of the building is the first in a series of terraces overlooking the land so laboriously toiled over.

INTERVIEW WITH CLAUDIO VEKSTEIN, OPERA PUBLICA

What was the Agrarian Federation of Argentina (FAA)'s impetus to build a memorial at this roadside location, and why did they opt for a complex of functional buildings rather than a monument?

The location for the new memorial was simply that the land was the property of the FAA, and its position along Provincial Route 90, right at the entrance to the town, made it the best option, I assume.

There was a lengthy discussion about the actual programme for the project. Four groups were involved as clients of the commission: the FAA (President Mr Eduardo Bussi), the People of Alcorta's Commune (Mr Vicente Martelli), the Government of the Province of Santa Fe (Dr Antonio Bonfatti) and the Argentine Republic Federal Government (President Dr Cristina Fernández de Kirchner). These four groups had different political affiliations – from classical nationalist to leftist Peronism, moderate Socialism, etc. – and very different goals for the work, reflective of their respective ideologies.

Some wanted a very expressionist, figurative and monumental statue, inactive and distant, to the other extreme where some wanted a more neutral container but active for social events. This we adopted, as a small interior that took away from the exterior budget, as it provided a small auditorium, a small gallery and a generous open space for public events within the memorial.

I decided to look at the history and the people's stories with open eyes – if possible, without ideological biases – so I talked to the people working at the FAA's archive, the elders and the assembly, to gather materials. That is where a series of historical pictures emerged, portraying

the Italian and Spanish immigrants to whom the memorial is dedicated, their conditions and struggles before the revolt, and also those stockpiles of corn bags that the producers piled up as these amazing constructions, being the collective fruit and pride of the farmers' hard work.

I chose this motif to work on, and the FAA reacted very enthusiastically and emotionally. One elderly lady cried at that moment, remembering her father, a worker, and how everything she had at home as a kid was made out of burlap, even the bed sheets and tablecloths.

Resin, fibreglass and burlap are unique as construction materials; what gave rise to the decision to utilise an experimental materials palette?

After presenting the first ideas – which involved the farmers' stockpile constructions reinterpreted in the object as this large screen – I was struggling myself to come up with the right way to materialise it. We went through multiple iterations, including a panel system made out of thin concrete, moulded by flexible fabric formwork. We did a series of collaborative tests, conducted by Professor Mark West, founding director of the Centre for Architectural Structures and Technology (CAST) at the University of Manitoba, Canada.[1] Meanwhile, we had to readapt the structure of the project from concrete to steel, given the only labour availability in the area was due to silo construction, still being produced in local shops in the area, so I had to think of much lighter panel solutions.

At that point, by chance I met the artist Ayelén Coccoz[2] from Rosario who at that time

was working on encasing objects, and more specifically manipulating historic images within resin blocks, creating a sort of weird oneiric effect that sparked memory and mirage.[3]

We decided to experiment on these materials together; we discussed the aesthetic qualities of her work and the possibilities for these panels, and she helped us figure out the first resin composition tests (albeit she was not involved in the design or production of the panels). Her atelier was next to this luthier's workshop, with whom we produced the wooden moulds, and we also worked with some local boat fabricators for the first scaled tests.

Our idea was to produce them on site, with our instructions and the participation of the community, but the contractor finally fabricated them in a workshop, with a small, local company of craftsmen from Rosario. We were not tasked with supervising the final production; we just had to trust our rudimentary specifications, which in basic terms explained the material composition of the panels, the pattern of repetition, the choice of sizes of the window openings, the aperture of the access space to the exhibition area and the method of fixing the panels to the frame using self-drilling screws. We also specified how the moulding should take place, using MDF moulds and facilitating rapid de-montage.

Our office did the architecture design in all phases: conceptual, schematic design, design development and construction documents. We had a general role in construction overseeing, but not construction supervision or management, which was done by the Province Department of Architecture and Engineering (DIPAI) and the Special Projects Unit from the Ministry of Public Works and Housing, Government of Santa Fe Province . . . we did inspect the job several times and suggested some adjustments to the execution methods to the contractors.

In photographs of the finished memorial, we see visitors illuminated through the facade as they ascend the ramp, evoking the figures of the workers on archival photos. It seems to have something to say about image traces, shadows of former existences, the embodiment of physical labour . . .

Indeed! We gathered and manipulated some archival photographs of those stockpiles of corn sacks, which were already very scenographic, and thereby recovered their almost classical theatrical three-dimensionality. Then, by adopting a simple procedure of folding the photocopies, reinterpreted these edifices that enigmatically reflected the labour and process built in them.

Along with preserving the public gathering space in the front, the strategically positioned ramp to build the stockpile, the side pavilion, the unfinished state of the work – and the long exposure of the picture, which provided this oneiric quality of frozen time, the shadowy effect of people's posture that I tried to carefully retrace in the configuration of the structure . . . (as can be seen in early models). It also included, transcribed and embodied, in the repeated and changing portico's V sections, the victorious physical gesture of the workers lifting the sacks.

Claudio Vekstein is Professor of Architecture at The Design School, Arizona State University and a Doctor Honoris Causa of the National University of Rosario, Faculty of Architecture, Planning, and Design, Santa Fe, Argentina. Vekstein is also an architect, founder and principal of the public architecture office Opera Publica. His work includes: the Montessori School in Lujan, Buenos Aires; the Memorial Square to Ernesto 'Che' Guevara and the Mill Cultural Factory, both in Santa Fe, Argentina; and the Amphitheatre and Monument Homage to Amancio Williams in Buenos Aires, Argentina.

National 9/11 Memorial – Reflecting Absence

Architects: Michael Arad (architect) and Peter Walker (landscape architect)
Location: New York City, USA
Year: 2011

From the roof of his East Village apartment, architect Michael Arad witnessed a plane – hijacked by members of terrorist group Al-Qaeda – fly into one of the towers of the World Trade Center on 11 September 2001. The scene left an indelible mark on his memory – an ever-present vision of horror jarring with the stark absence of the two huge buildings which once dominated the Lower Manhattan skyline. A dreamlike

below

64 The National 9/11 Memorial – Reflecting Absence, illuminated at night, with Snøhetta's Memorial Pavilion in the background

overleaf

65 The enormity of the two memorial pools can be appreciated when viewing the Ground Zero site from above

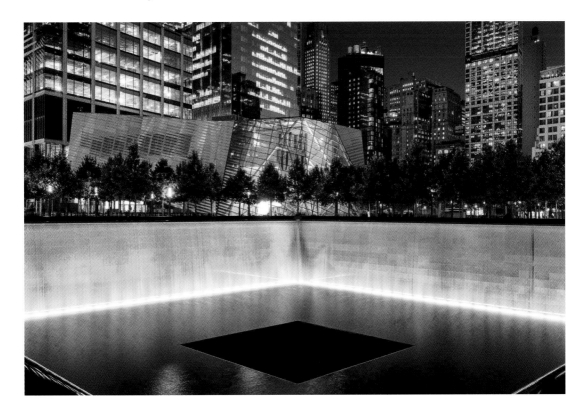

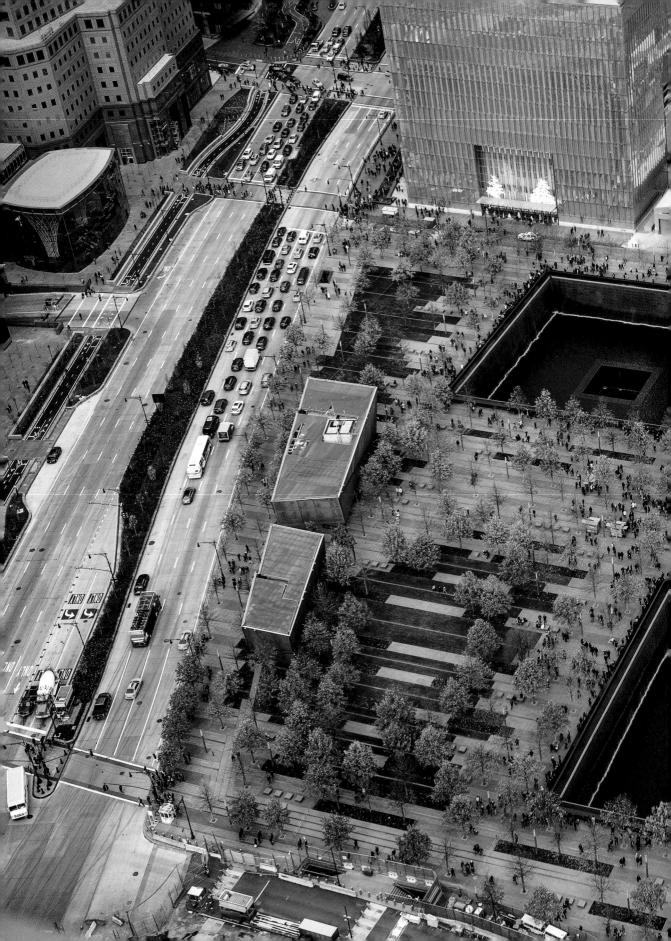

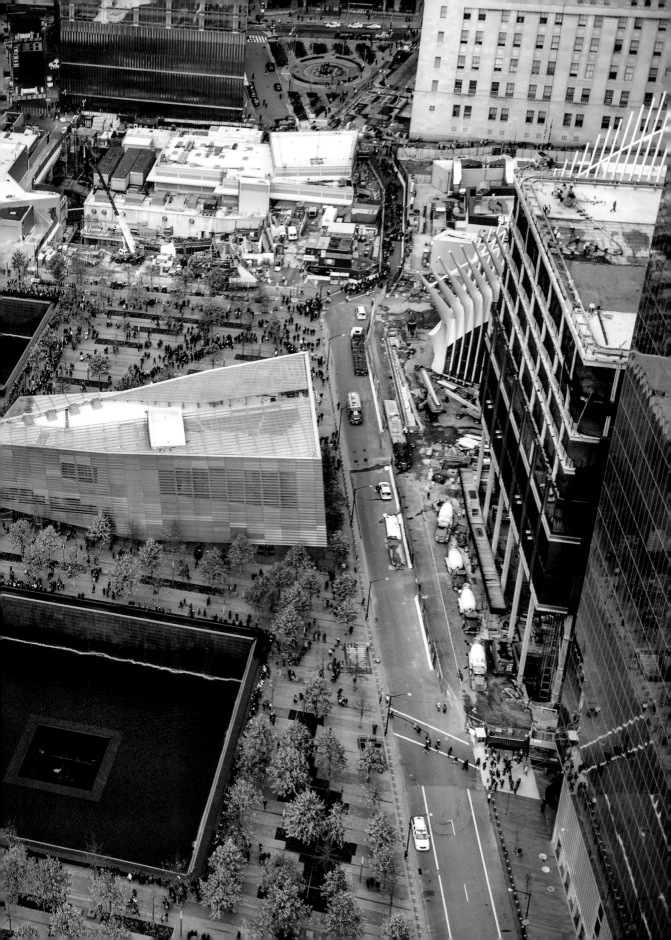

scene, of the Hudson River torn open and the waters disappearing into a gravity-defying void, became for him a visual representation of the incomprehensibility and illogicality of the trauma he witnessed: the unfathomable disappearance of something which had been so tangible and real – a vision of 'absence made visible'.[1]

A sculptural model Arad made for his own private act of memorialisation would evolve into the winning entry for the competition launched in 2003 by the Lower Manhattan Development Corporation, beating 5,200 other submissions. Arad's joint submission with landscape architect Peter Walker, named 'Reflecting Absence', occupies eight acres of the 16-acre site and opened on the tenth anniversary of 9/11.

The memorial's two waterfall pools occupy the footprints of the former Twin Towers and are surrounded by around 400 white oaks. These square voids are surrounded by bronze parapets which bear the names of 2,983 victims; the names are listed according to a system of meaningful adjacency whereby individuals appear in the proximity of colleagues or friends, grouped according to where they found themselves during the attacks or according to the wishes of family members. Names of those who were killed at the North Tower, on hijacked American Airlines Flight 11 and in the 26 February 1993 bombing of the tower, are inscribed on the North Pool. On the South Pool are the names of first responders, those killed

at the South Tower, on hijacked United Airlines Flight 175, on hijacked American Airlines Flight 77, on hijacked United Airlines Flight 93, and at the Pentagon.

The square pools, nearly an acre each in size, are the largest man-made waterfalls in North America. They fall ten metres into a basin and from there a further six metres into a central void. The thundering waterfall paradoxically succeeds in cancelling out the noise of the surrounding city, creating a place of relative tranquillity in the middle of a busy public square.

Born out of a complex and controversial process, with fraught emotions, heated politics and countless stakeholders, the design is an unforgettable, and undeniably bold, intervention.

A modification to the site, the 9/11 Memorial Glade, opened in 2019. This honours victims of the long-term implications of the 9/11 attacks – for example, first responders, local residents, volunteers, and survivors exposed to toxins. Six granite monoliths and various pieces of debris from the original buildings sit along a path through the swamp white oak trees (*Quercus bicolor*) in the memorial plaza. The number of victims falling into this category is not known, but exceeds thousands. A speciality steel-casting foundry in Missouri assisted the process of using recovered World Trade Center steel, melted down and formed to fit the fissures that were carved into the monoliths, representing strength through adversity.

INTERVIEW WITH MICHAEL ARAD,
HANDEL ARCHITECTS

Could you tell us a bit about the personal journey behind your designs?

What drove me personally was being in New York and witnessing first hand one of the planes crashing into one of the towers from the rooftop of my East Village apartment building.

Until then, I had felt like a stranger in New York. I was not an American citizen. I was young and disengaged in a big city. But after the attack I no longer wanted to skate on the surface of things. We all craved a sense of connection and community.

New York's open public spaces – its street corners and squares such as Washington Square and Union Square – allowed New Yorkers to come together physically and emotionally. There was a collective stoicism and compassion.

There was something about [9/11 that brought people together] and I don't think that the perpetrators expected that. They wanted to sow fear and division, but they united a country, unintentionally.

Witnessing that, and feeling for the first time a sense of belonging, prompted me to feel personally and emotionally engaged, and to respond through design.

There was a show at the Max Protetch Gallery where he invited architects to submit proposals for rebuilding the World Trade Center, and I left that exhibition somewhat disappointed. Now, perhaps, I'd be less judgemental; some people coped by imagining rebuilding right away.

I was actually thinking about a memorial but couldn't imagine rebuilding at the World Trade Center; it was scarred, too sensitive to touch. I imagined something in the Hudson River nearby. There was something about the surface of the river being shorn open to form square voids that the water would cascade into but never fill up.

It would be almost like a device that would measure time, or the passage of time, through its absence. Eventually I went back up to the top of my apartment building and photographed a small architect's model I had made against that skyline. There was something very cathartic but also private about the exercise.

It's difficult to verbalise one's response to the memorial first hand. The roaring sound of the water seems to cancel out the noise of people, enabling space to reflect. And it's shocking to look over the ledge into the void below. Did you envisage such outcomes from the beginning?

You do feel it in your body as you approach that edge. It reveals itself and the sensation of the scale of the space, your relationship to it, your body as it walks around that space – it's something remarkable. The ledge acts as a threshold you can walk up to but not cross. In some ways that alludes to life and death and to experiences that we can observe but not participate in until we cross that threshold ourselves.

That was always an important aspect of the memorial design. That moment of walking up to the edge, and the way it reveals itself, is something that we studied extensively. I wanted that moment of encounter with the names. For me, it's the most powerful moment of the visit. The plaza overall is a vessel that holds that moment and prepares you for it. It also shields you from the hustle and bustle of the city.

Finding that right balance was important, and the audio quality of that water falling plays an important role in allowing you to experience both sensations at once – solitude and commotion. It doesn't erase every trace of sound from the city, but it builds some separation. You still see the buses through the tree leaves and branches, you still hear that motor, but it's not as exposed.

That was a very concerning part of the design for me. Until I heard that water for the first time cascading 30 feet and reverberating, I didn't know exactly how it would sound. You imagine and you hope. You can claim credit for some things; others are fortuitous.

Water is a fundamental part of the design. Could you elaborate on its use as a symbol here?

The driver for it was this sense of a marker of time, like sand through an hour glass that never fills up. It was something about the mystery of: How is this happening? Water doesn't want to behave that way – it seeks its own level – so how can we mark its absence?

That sense of absence was very important to me: obviously the absence of people, the absence of the buildings and the skyline, and a desire to not let that absence be erased either.

I visited the site as I was one of eight finalists. I recall seeing one of these cut-off steel columns that were embedded into the foundations of the site. They had held up the tower; they were these massive squares – they actually looked almost like my design sketches, just a square with nothing else there. You could just see the rough edges of the steel that had been cut during the recovery effort. You could put a brand-new steel column there, exactly where that one had been. But if you had done that, you would have lost something – the memory of what had been and has gone.

To me, two ideas undergirded the entire design process: the notion of marking absence, of making it visible and tangible in some way; and the notion of creating a public space that was inextricably part of New York City, part of the urban fabric, part of the public realm. It is a place that is part of New York now, which is one of the most gratifying things to me.

How we lay our streets and sidewalks, that's permanent. The public realm is what really makes our cities our cities. They are a shared and remarkable work of humanity, of generations. They show our best and worst, and they make us uniquely human.

9/11 really struck at the heart of US identity. Do you notice any substantial difference between the reactions of American citizens to the memorial and those of international visitors? You have an international background, for instance.

One of the great things about New York is that it truly is an international and cosmopolitan city that welcomes all. If you come here and make this place your home, it is your home. Maybe not on week one or two, but I am thoroughly a New Yorker now. I love New York – it's really home.

I am incredibly humbled and grateful that those responsible for commissioning the 9/11 memorial, and the memorial I am currently designing at Charleston (for the Mother Emanuel African Methodist Episcopalian Church), put their trust in me to help them find a design that reflects their experience and their needs. I know that it is a tremendous responsibility, and I'm grateful that people have the confidence to recognise that we, as architects, can understand other people's experience or empathise to a degree that we can offer something that will address their needs, even if we cannot ever truly experience what others are experiencing.

So, this issue of identity and experience from various viewpoints – I think everybody who comes to the memorial will have a different experience. Some people might find solace and others might leave sadder and angrier. But the important thing is to elicit a moment of contemplation and internal thought. How we, individually, walk away from this memorial – with what actions and thoughts in our future – is not the responsibility of the architect. We can't be so didactic as to say: 'As a designer, I think you're going to feel this and then you're going to do that.' It would be hubristic to think that somehow we can predict how people will respond emotionally to our creations.

Now that so many years have elapsed, how would you reflect on the design process? Could you have envisaged how it would turn out?

For the first few years, all I could do was walk around the site and notice things that I wished we'd changed. I'm able to zoom out now and see the bigger picture. I was proud of our work and felt grateful that the design didn't veer in another direction. It could have easily become a design that was more jingoistic or self-pitying, and I didn't see that in New York and I didn't want that to happen. You don't design alone; you design with a foundation, with the board, with so many stakeholders, and so things get pushed and pulled. You can try and steer them but you're not alone in this. It's a group endeavour.

At the time, our design didn't acknowledge all the people who have died of 9/11-related illnesses. There were a lot of first responders, fire fighters, police officers, that came to the site in the immediate aftermath and stayed there for months. They inhaled very toxic materials. The pandemic has brought this home to me. Their plight was not really addressed in a meaningful way for a very long time. It is estimated that the number of people who will die of 9/11-related illnesses will be greater than the number of people who died in the attack. Over 1,500 have

already died and that number is growing. It was a different kind of suffering and didn't receive much attention.

So, a couple of years ago, we added the Memorial Glade. We created this new path that bisected a clearing that was part of the initial design in an established corner of the plaza. There's an area where we've pulled the trees back, which are almost everywhere else around the plaza. There was this set of paving bands and lawn strips that alternated. We created a new path through there that is flanked by this grouping of stone monoliths that seem to emerge out of the ground. Everything else around the plaza is intentionally held flat to both accentuate the rupture of the two voids but also to allow one's eye to travel around the entire site and take it all in and comprehend it as a single space – it's defined by the buildings across the street around it. This is the one place where we broke that rule to create something that had the feeling of being thrust up and breaking the surface of the ground. Seeing a group of people, who had initially felt that the memorial did not answer their needs, satisfied was meaningful, and I was happy that we were able to redress that error.

Michael Arad's design for the National September 11 Memorial at the World Trade Center site was selected by the Lower Manhattan Development Corporation from among more than 5,000 entries submitted in the 2003 international competition. Arad joined Handel Architects as a partner in April 2004. A native of Israel, Arad was raised there, in the UK, the United States and Mexico, before settling in New York. In 2006 Arad was one of six recipients of the Young Architects Award of the American Institute of Architects (AIA). In 2012, he was awarded the AIA Presidential Citation for his work on the National September 11 Memorial, and in the same year, the Lower Manhattan Cultural Council's Liberty Award for Artistic Leadership.

National 9/11 Museum and Pavilion

Architects: Davis Brody Bond (museum) and Snøhetta (pavilion)
Location: New York City, USA
Year: 2014

Memorials sometimes behave as thresholds between two different worlds. The 9/11 Memorial Pavilion, by Snøhetta (pp 102–3), is one such place, a 'naturally occurring threshold between the everyday life of the city and the uniquely spiritual quality of the Memorial', in the words of founding partner Craig Dykers.[1] The pavilion, which opened in May 2014 at the World Trade Center site, alongside the museum by Davis Brody Bond, is the only above-ground building on the memorial plaza – a liminal zone between the light and bustling outdoors and the solemn subterranean world of the museum.

The pavilion's low, horizontal form and combination of reflective and transparent surfaces invite passers-by to peer inside, wonder, then enter the museum that now occupies the footprints of the former World Trade Center. It is a glassy portal to the deep and expansive space below.

The 9/11 Memorial Museum was designed by Davis Brody Bond. 'Typically, museums are icons which contain exhibits. This is the inverse – the exhibit is the icon', says partner Steven M. Davis.[2] Beginning at the plaza level, a ribbon-like ramp takes the visitor on a downwards journey over 20 metres, via different gallery spaces, to the bedrock of the Twin Towers. It is a monumental underground site that confronts the void left by the towers' destruction by revealing the enormous footprints of the buildings.

'It was important for us to maintain that view from above', explain the architects, hence the ramp integrates a series of overlooked positions which, while giving a view to the space below, do not reveal its full extent. 'We were careful not to expose [the enormity of the scale so early]', they continue, hence the view is progressively disclosed from these vantage points. It is only on descending the ribbon, which evokes the ramp used to remove debris from the site, that the footprints' massiveness is revealed.

At the bedrock level, the visitor is confronted with the void, and with several dramatic architectural artefacts: the base of the 9/11 memorial, Reflecting Absence (p.101), which dominates the interior space as it occupies the footprints of the original buildings; the Vesey Street Stair (or Survivors' Stair), which was used by hundreds to escape to safety, and is ensconced between the final escalator and flight of stairs; and the slurry wall – the original retaining wall that was built to withstand the Hudson River and which survived the towers' collapse. At 60 metres wide, its extreme strength and power is breath-taking.

In this dramatic public space, the exhibits are iconic – such as fire trucks used in the rescue mission, and the Last Column, the final slab of steel removed from the Ground Zero site. But in the traditional gallery spaces are more intimate artefacts – personal effects which poignantly reveal the victims' stories.

Emerging back into the light, the escalators are double width – a consideration that the architects introduced so that no visitor need leave the museum processing the magnitude of their emotions standing there alone.

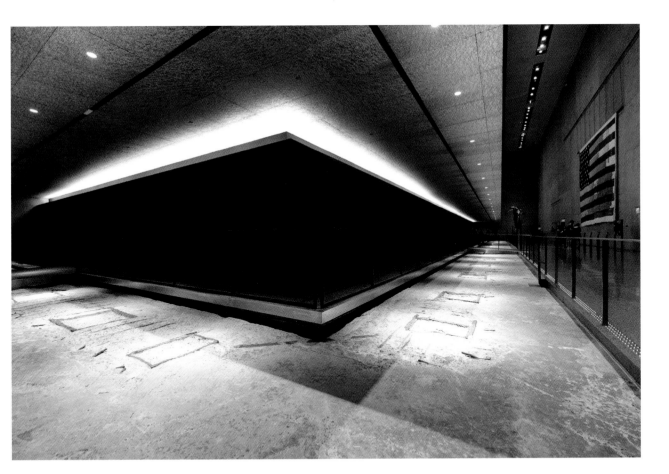

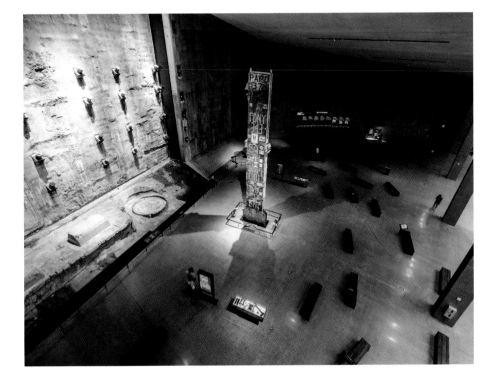

66 The base of the National 9/11 Memorial – Reflecting Absence is visible at the bedrock level within the museum; the pools occupy the footprints of the original Twin Towers

67 The slurry wall (to the left) – the original retaining wall built to contain the banks of the Hudson River – survived the towers' collapse

National Holocaust Monument

Architect: Studio Libeskind
Location: Ottawa, Ontario, Canada
Year: 2017

'Canada has upheld the fundamental democratic values of people regardless of race, class or creed, and this national monument is the expression of those principles and of the future', said architect Daniel Libeskind, on the inauguration of Canada's first national monument dedicated to the victims of the Holocaust.

Located opposite the Canadian War Museum, the site connects the museum to the historic centre of Ottawa. It is an in situ cast-concrete structure that, from above, takes the form of an elongated, deconstructed Star of David. The constituent parts – six triangular concrete volumes – create different experiential spaces and house different programmes: an interpretation space, three contemplation spaces, a large central gathering space, and a towering, 14-metre 'sky void' where an eternal flame of remembrance burns.

The triangles themselves take the form of another visual symbol of the Holocaust, that of the triangular badges used by Nazis to label and humiliate homosexuals, Roma, Sinti, Jehovah's Witnesses and other targeted groups.

Two physical ground planes offer different symbolic meanings: one which descends, leading visitors in a labyrinthine procession to interior spaces of introspection and memory; and another which ascends, more positively, to light and to the future.

Large-scale monochromatic landscapes, photographed by Edward Burtynsky, of the remains of Holocaust sites in the present day, are painted on the walls of the triangular spaces, opening up the enclosed spaces to wider dystopian landscapes.

From the central gathering space, however, rises the Stair of Hope, which cuts through an inclined wall in the direction of the Parliament Buildings, a statement which can be read as the triumph of the democratic process over the forces of Nazism. At night, this stairway is illuminated to form a glowing and positive beacon.

Coniferous trees around the monument serve to protect it from the bustle of the surroundings, as well as symbolically referring to the emergence of a new generation of Canadians – survivors and their children – who have contributed to the growth of an inclusive and peaceable Canada.

68 The illuminated Stair of Hope glows warmly within the memorial at night time

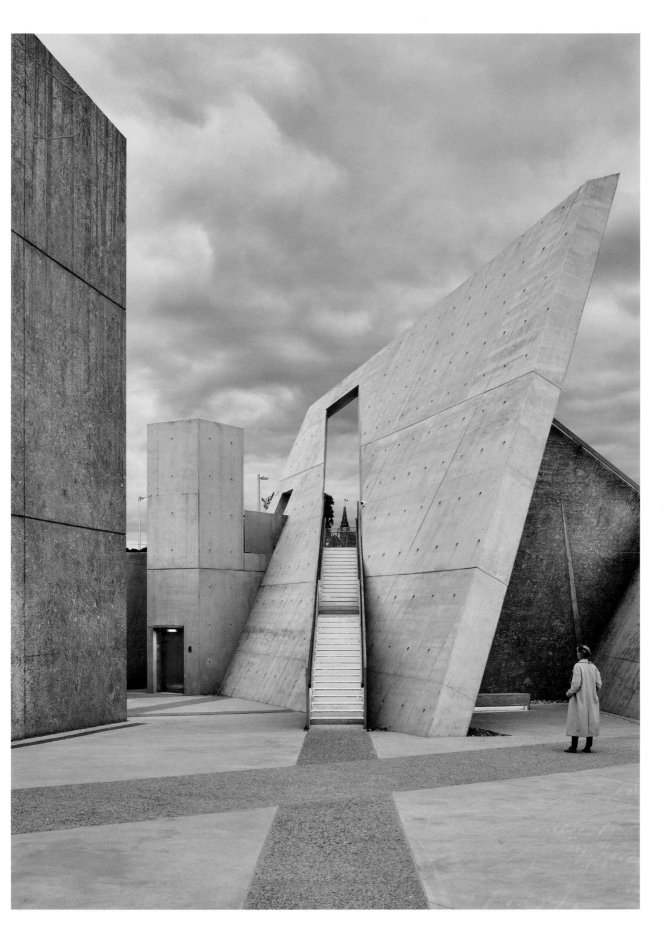

National Memorial for Peace and Justice

Architect: MASS Design Group
Location: Montgomery, Alabama, USA
Year: 2018

From 1882 to 1968, there were over 4,743 recorded lynchings in the US, horrific acts of racially motivated violence for which the perpetrators often escaped justice, or worse, were endorsed or celebrated.[1] Thousands of predominantly Black people were hanged and tortured by lawless mobs for baseless crimes, or simply for violating received social norms, deemed to undermine the status of white people. Millions more fled the South to escape the culture of racial terror.

These appalling crimes may seem historic, but the implications remain more relevant than ever as the country still struggles in its fight against racism, police brutality and extreme right-wing politics. The murders of George Floyd and Ahmaud Arbery bear chilling resemblance to lynchings, as broad daylight 'punishments' without due process.

The National Memorial for Peace and Justice was instigated by the Equal Justice Initiative (EJI), which challenges racial and economic injustice and protects human rights. It sits within a six-acre parkland site in Montgomery, Alabama – the city where, in 1963, Governor George Wallace had proclaimed 'segregation forever', but also where, in 1955, Rosa Parks had refused to relinquish her seat on a bus for a white man.

The memorial is an open monument building with a flat roof which, from a distance, appears to be held up by columns, like a classical colonnade. Only inside does one realise that these Corten-steel columns are in fact hanging from the ceiling. The effect is startling and deeply unsettling. The hanging columns represent the 810 counties where lynchings occurred, and they bear the names of the known victims from that place.

Outside is a field of duplicate columns. These are intended to be adopted by the counties they relate to, and taken there, as part of a process of accountability. Expressive sculptures by artists Kwame Akoto Bamfo and Dana King are also situated outside.

'Southern trees bear a strange fruit', sang Billie Holiday in 1939. 'Blood on the leaves and blood at the root.' Abel Meeropol's graphic lyrics to 'Strange Fruit' resonate still; at the EJI's Legacy Museum, several blocks away, soil collected from the sites of lynchings are displayed in glass jars, along with the location and victims' names. Is there still blood at the root of those trees?

The memorial has had a huge cultural impact, contributing to Montgomery becoming one of the most visited cities in the US, in part

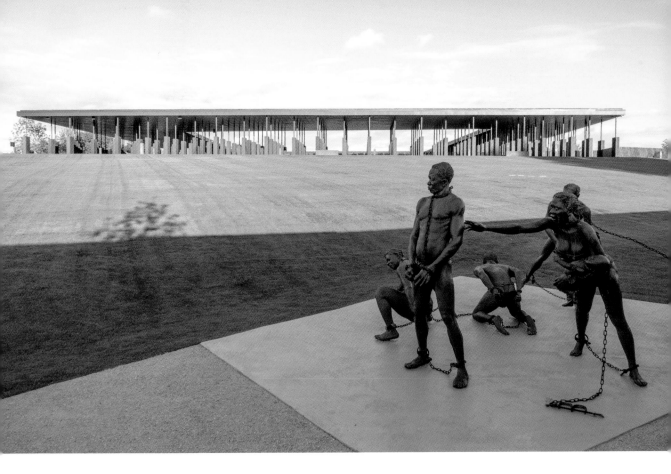

69 Ghanaian sculptor Kwame Akoto Bamfo's poignant *Nkyinkyim* artwork stands in front of the memorial pavilion

thanks to its bold and original architecture. As architect Michael Murphy told EJI founder Bryan Stevenson, '. . . I think your building project is maybe the most important project we could do in America and could change the way we think about racial injustice.'[2]

The memorial will continuously evolve. Corten steel was chosen specifically for its living patina, and its propensity to 'bleed' onto its surroundings as it oxidises, bringing the topic of lynchings deeper into the emotional and tactical realm. Likewise, based on the collection of duplicate columns, it will become apparent over time which counties have accepted or refused to claim their memorial columns and accept historic culpability. The memorial, like the restoration of justice itself, is as yet unresolved. As Murphy has said, 'Buildings are not simply

expressive sculptures. They make visible our personal and our collective aspirations as a society. Great architecture can give us hope. Great architecture can heal.'[3]

overleaf, left

70 Duplicate slabs are arranged outside with the intention of being adopted by and transported to the relevant county

overleaf, right

71 Over 800 slabs hang from the ceiling in a dramatic and startling gesture

113

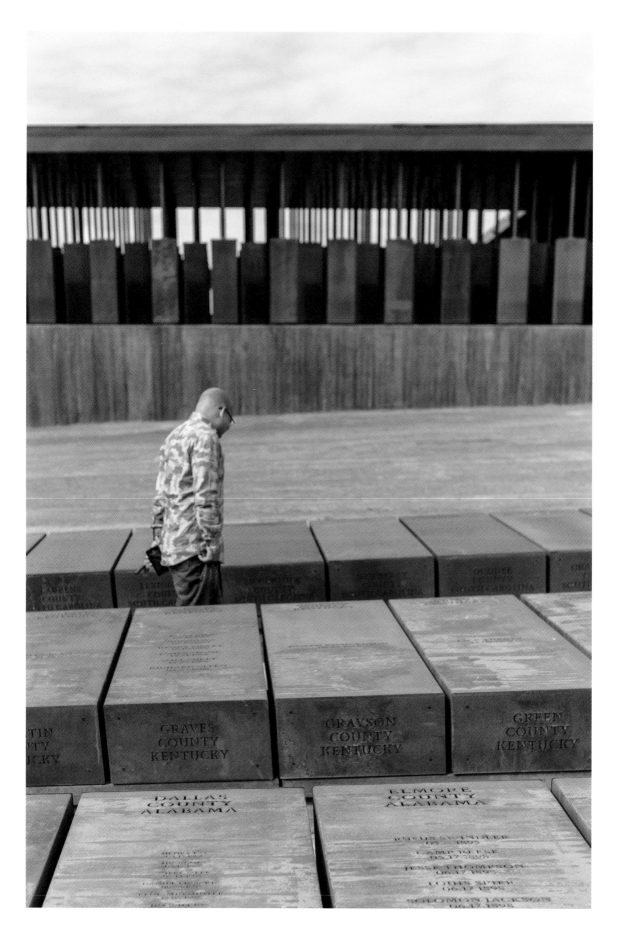

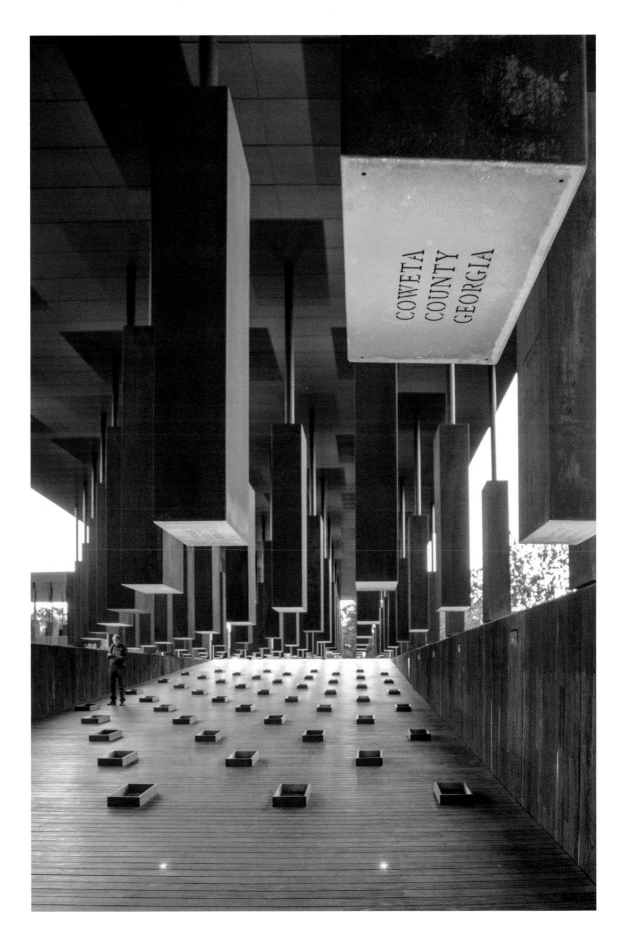

INTERVIEW WITH MASS DESIGN GROUP

This memorial really doesn't shy away from the brutality of racial terror. How did you navigate the need to be confrontational while also promoting peace and justice?[1]

The Equal Justice Initiative (EJI) managed the outreach and engagement for the memorial and navigated many tough conversations. The importance of truth-telling has always been critical to their mission and work.

We designed this through a process of deep reflection on the purpose of the memorial, and through reflections with our team about the role of memorialisation, as well as truth and reconciliation in Rwanda and South Africa. We needed to consider how not to just memorialise, but to advance truth-telling and inspire action in our nation to wrestle with its history of racial injustice.

When we first began the partnership, it was very early on, and the project had no site. So, we designed the idea of the module being twinned – leaving one static and one to be moved to the location of the atrocity. It wasn't enough to have a single space that told this truth – we sought a way to seek accountability and reckoning across the country. This duel memorial, requiring participation, engagement, local action and truth-telling, still lives in this future form, and drives the design.

There are many well-justified accolades for this memorial. What sort of feedback have you received? Why do you think it has taken so long for such a memorial to come about within the USA?

We've been overwhelmed by the positive, heartfelt and emotional responses people have shared. So many people have made the pilgrimage to Montgomery. Memorials should engage us to not just reflect but to act, and the amount of action we have seen is encouraging, sobering, hopeful. Our country, of course, still has a long way to go in our fight against racism and for justice, but we find inspiration in things like the anti-lynching bill that finally passed the House of Representatives in 2020, and the recognition of the need for this memorial.

It's hard to answer why America has yet to wrestle with its history of racial injustice, terror lynchings or slavery. But it is telling that, instead of monuments to abolition, we have monuments to the confederacy and to rebels fighting to continue slavery that still stand, and only today are starting to get reconsidered. America has so much work to do, but it also hasn't wrestled with its past in a complete and honest way. We hope this is part of a beginning to that era of truth-telling.

Have many counties have claimed and relocated their monuments?

The EJI is leading the effort, but counties from across the USA have begun to reach out to the EJI to claim their markers from the memorial. While no counties have fully moved their markers from the memorial (as of 2020), the EJI leads an ongoing effort to work with counties where lynching occurred, and to place historical markers that acknowledge the known and unknown victims of racial violence. Some counties, such as Leon County, Florida and Jefferson County, Alabama, have seen community initiatives calling for their respective markers to be claimed.

The collection of soil from the sites of lynching is deeply symbolic – what lay behind this concept?

MASS imagined the idea of the soil collection from our experience in Rwanda, recalling how ritualised memorialisation processes are there, and that creating a new ritual would be a powerful way for a public to engage directly in the history and truth-telling around lynching.

We wanted people to be able to participate, and a simple act like a jar of soil could be a way to do so. The emotional power that this simple act inspired completely transformed us and we were convinced that something simple and powerful could change minds and give us the tools for action.

The EJI worked with community volunteers to collect the 364 samples of soil from sites of lynching in Alabama. This list of names and stories stemmed from the research conducted by the EJI that documented over 4,400 racial terror lynchings in counties across the United States. Architect and director of MASS, Michael Murphy, talks about the idea for the soil collection in his Ted Talk, 'Architecture that's built to heal'.[2]

The EJI is striving to reshape the cultural landscape with monuments and memorials. Why is it that an architectural statement has such power?

Every forum – exhibitions, writing, film, etc. – influences, inspires and changes the way we understand the world around us. But we do believe that architecture is part of the conversation, and a medium to experience this narrative differently, tactically, spatially. There is a profound memory that buildings leave in us. Whether or not we realise it, architecture is an important symbol of our culture and its values. Whether it's a national memorial or our homes, we recall the feel and smell, and light and moisture, and the content seeps in slowly over time, giving us the stage for that information to be read physically and spatially, not only didactically. The architecture is a narrative vessel – we just don't often treat it that way. Great architecture tells the story of its intent spatially,

and we were certainly driven by that ambition in the design of the memorial.

How important is it that a memorial should be physically experienced rather than statically viewed?

There are many examples of powerful monuments that are experienced as sculptures and objects that we move around. But some memorials require narrative transformation for us to not just understand but feel the history in our bones. And this was the need in this case – for something where time was part of how we began to understand our place in the world, and the wrestling with this largely hidden history. It was important for the team that this memorial not be a static memorial. Our legacy of racism and lynching wasn't a moment in time, but one that continues today. And so – through the landscape, the twin monuments and the Corten steel – the experience of the memorial would constantly be evolving.

What do you see as the role of the architect in a case such as this, and are there any lessons?

The architect is a storyteller through stone and bricks and mortar. Some stories cannot only be told on the page of a book – they must be felt, experienced, visited, ritualised and retold. In other words, some stories cannot be fully told without spatialising them. I think the lesson is that buildings are always doing this work, always telling stories, even without our knowledge, and sometimes without our intent. It is our responsibility to be cognisant and aware of, but also to guide, that narrative to be its most transformative and powerful, and hopeful.

MASS Design Group (Model of Architecture Serving Society) was founded in 2008 and comprises over 200 professionals working in 20 countries. The practice was awarded the 2022 AIA Architecture Firm Award by the American Institute of Architects.

National War Memorial

Architect: WeBe Design Lab
Location: New Delhi, India
Year: 2019

India became independent on 15 August 1949, and the desire for a national war memorial, commemorating the fallen heroes of the republic, began almost immediately afterwards.

In 2016, the government of India launched a competition to design a memorial on the C-Hexagon, New Delhi's ceremonial heart. Here, landmarks of national significance – such as the Amar Jawan Jyoti (eternal flame), India Gate (designed by Edwin Lutyens in the 1930s) and the Rajpath (New Delhi's ceremonial axis) – come together to form the country's locus of commemoration.

Introducing new architecture on this site is challenging. The winning design, by Chennai-based practice WeBe, was selected by a 20-member jury: 'It was a dream project for our Prime Minister Narendra Modi', architect Yogesh Chandrahasan explains. 'In his election pledge he promised that by 2019 there would be a National War Memorial built – often government projects get delayed but this one was completed in record time.'[1]

72 Each brick forming the Circle of Sacrifice bears the name of a soldier

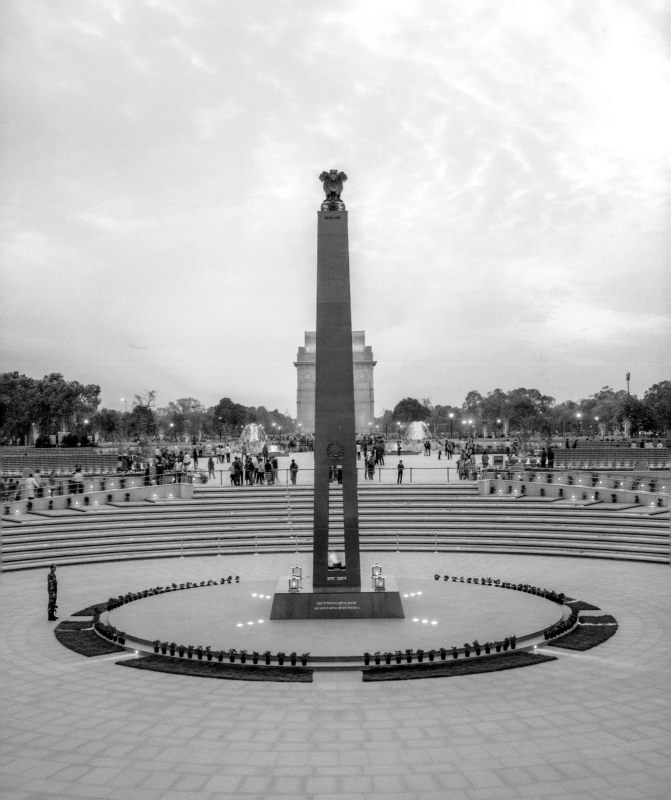

73 The memorial is aligned on an axis with India Gate

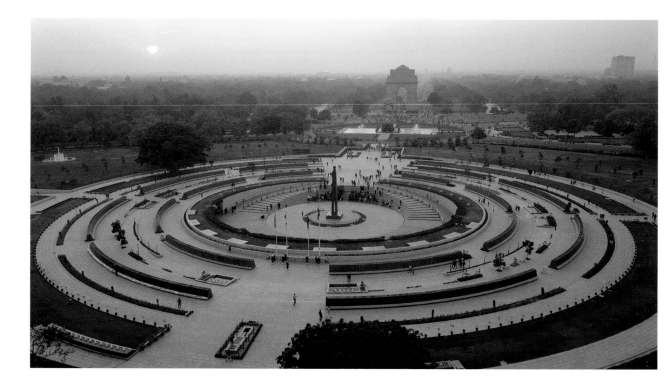

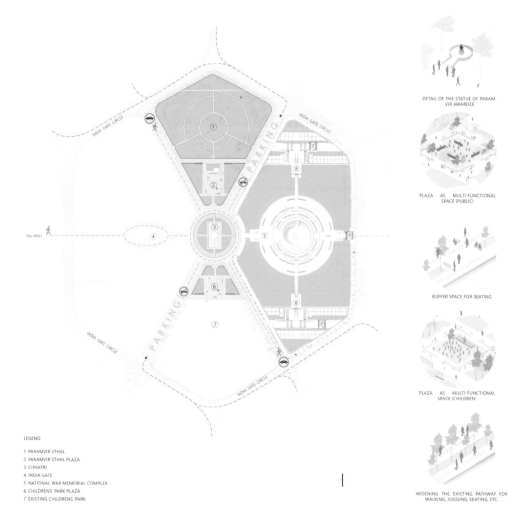

DETAIL OF THE STATUE OF PARAM-VIR AWARDEE

PLAZA AS MULTI-FUNCTIONAL SPACE (PUBLIC)

BUFFER SPACE FOR SEATING

PLAZA AS MULTI-FUNCTIONAL SPACE (CHILDREN)

WIDENING THE EXISTING PATHWAY FOR WALKING, JOGGING, SEATING, ETC.

above

74 India's new national war memorial is conceived as a series of concentric circles with the eternal flame and obelisk at the centre

left

75 Diagram illustrating the wider context of the C-Hexagon and its existing historic architecture

WeBe's design responds to a host of practical challenges, including climatic and topographical conditions and the need to harmonise and dialogue with pre-existing architecture. It also had to navigate historical and political considerations relating to India's national identity, its commemoration rituals, its relationship to the material culture of colonialism, its identity as a secular democracy and the current government's political desires.

The form of the National War Memorial embodies the notion of returning and rebirth, via a series of concentric circles, or chakras. The outermost perimeter is the Circle of Protection (Rakshak Chakra); inside this is the Circle of Sacrifice (Tyag Chakra); next is the Circle of Bravery (Veer Chakra); the Circle of Immortality (Amar Chakra) lies at the centre of the scheme.

Inspiration came from words of Captain Vikram Batra, a posthumous recipient of the Param Vir Chakra (India's highest military decoration). 'He said: "Either I will come back after hoisting the Tricolor, or I will come back wrapped in it, but I will be back for sure"', Chandrahasan tells us. 'Memorials are generally associated with death, but we wanted to redefine that. His quote says that he wanted to come back. His family wanted him to come back, and as a nation we also wanted him to come back. It helped us tie the concept together.'

The memorial's 42-acre plot sinks below the level of its surroundings, rising no more than 1.5 metres above the original site levels, according to local regulations. But this serves the useful function of protecting the space inside from the chaos of surrounding roads and also creating a microclimate. On this perimeter, trees are planted in a formal, military-like arrangement. The sunken courtyard cannot be seen from the outside, creating a sense of surprise on entry.

The Circle of Sacrifice is derived from the *chakravyūha* – a circular, military formation described in the Mahabharata epic. This circle has eight segments, each of which has two walls, and each granite block within these walls represents one fallen soldier. The wall's segments are organised chronologically.

'With the *chakravyūha* there is an entrance but no exit, since it is an ambush, and the soldiers are sacrificing themselves', explains the architect. 'From this we took the idea of a self-supporting continuous structure. As each brick represents one soldier, they form the structure.'

The next concentric circle is a colonnaded, semi-open gallery where six bronze murals depict battles fought since Independence. This structure also holds a large rainwater-harvesting tank, in which water from the sunken central zone is collected and reused for irrigation.

The focal point of the innermost circle, symbolising the immortality of the soldiers, is an obelisk. This holds the eternal flame (transferred from India Gate to this new position) alongside the state emblem of the Ashoka.

'At each layer the narrative is conveyed through a different medium – context, then structure, then artistic representation, then congregation space and so on. The memorial operates on different scales, one for large gatherings and one for reflection on individuals', says Chandrahasan.

'We wanted to depict the life of a solider in a simple, narrative and symbolic way, so that even a child could take away the message: a soldier sacrifices his life, he is brave, and he protects us', concludes the architect.

This memorial attempts to marry the context of the site with the needs and desires of the present. It utilises the same sandstone materiality as the original architecture and respects the formal geometries of the wider C-Hexagon, retaining a sense of the momentous, and the solemn.

Nyamata Church Genocide Memorial

Architects: University of Pennsylvania Stuart Weitzman School of Design
with the Commission Nationale de Lutte contre le Génocide (CNLG)
Location: Nyamata, Rwanda
Year: 2016–onwards (conservation project)

Above the main entrance to Nyamata Church, Rwanda, is a banner in Kinyarwanda, which reads: 'If you had known me, and you had really known yourself, you would not have killed me.'[1] Inside, the walls are pock-marked by shrapnel and the pews are heaped with soiled clothing.

The former Roman Catholic church was a simple, elegant building, designed between 1975 and 1981 by Father Bernard Jobin, a Swiss priest and architect, who drew on the

76 The interior of Nyamata Church still bears traces of the violence

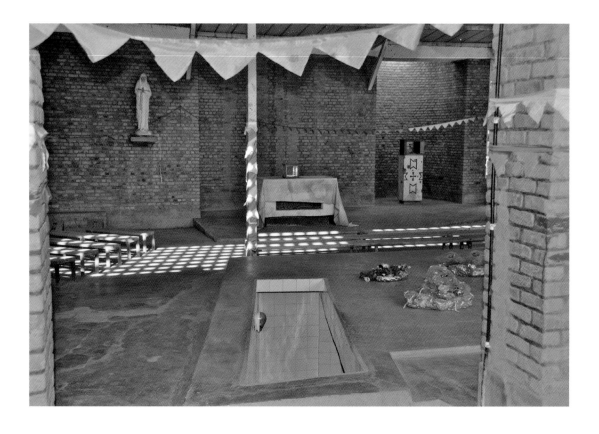

modernist principles of Le Corbusier. The church's material palette was locally sourced brick in line with the vernacular architecture of the Bugesera region of Rwanda. Inside, the altar, baptismal font and tabernacle were surrounded by low pews, while simple archways distinguished a smaller chapel from the main sanctuary.

During the 1994 genocide, many Tutsis sought refuge in local schools and churches. Tragically, these gathering places were then targeted by Hutu *génocidaires*. At Nyamata this began on 11 April 1994 and continued into the following month. Between 3,000 and 10,000 people were killed on the site. Bullet holes penetrate almost every surface, from tin roofs and iron gates to the brick walls and concrete altar.

In the immediate aftermath, survivors identified and hastily buried loved ones in mass graves, separating human remains from the myriad belongings left behind. In 1997, the church was deconsecrated to become a memorial site, and a series of ad hoc interventions ensued, including the introduction of display cases in the catacomb-like basement. Clothes were piled across the pews. Outside is a mass grave.

On the surface, this memorial does not appear to have been purposefully designed. However, over the course of the last decade, a team from the University of Pennsylvania, in collaboration with Rwandan partners at the CNLG, have undertaken a rigorous and challenging intervention whose success lies in its invisibility. Their role has been to maintain the site's ability to speak for itself, and utilise architecture's power to create meaningful spatial experiences whilst rendering itself inconspicuous.

The team of architects, designers and conservation specialists worked to resolve considerable challenges including straightforward building maintenance, pest control, landscaping to minimise dust ingress, humidity control, cleaning systems, and

77 The church's design was inspired by Le Corbusier, and was constructed in the 1970s, in locally sourced brick

research and development of new technologies which facilitate all this in a cost-effective and sustainable way. From researching the application of desiccants as used in the agricultural industry, to devising a tumbling machine with in-built meshes to rid the clothes of accumulated dust without actually cleaning them, this is an application of architecture and building design technology which is unusual and unexpected.

Even more so than any of the new-build memorial projects we have included here, the Nyamata project challenges the architect by questioning the remit of the role and its limits in the face of the urgent social or conscience-based needs of the here-and-now.

As Professor Randall Mason, project leader, has written, while the rawness of the memorial precinct, with its undisturbed appearance and chaotic mass of artefacts, seems to be an uncurated site, it does in fact follow a carefully scripted narrative based on shock tactics and pathos.[2] Architecture's role here is to facilitate this experience, by absenting itself.

31

Shoes on the Danube Bank

Artists: Can Togay (film director) and Gyula Pauer (sculptor)
Location: Budapest, Hungary
Year: 2005

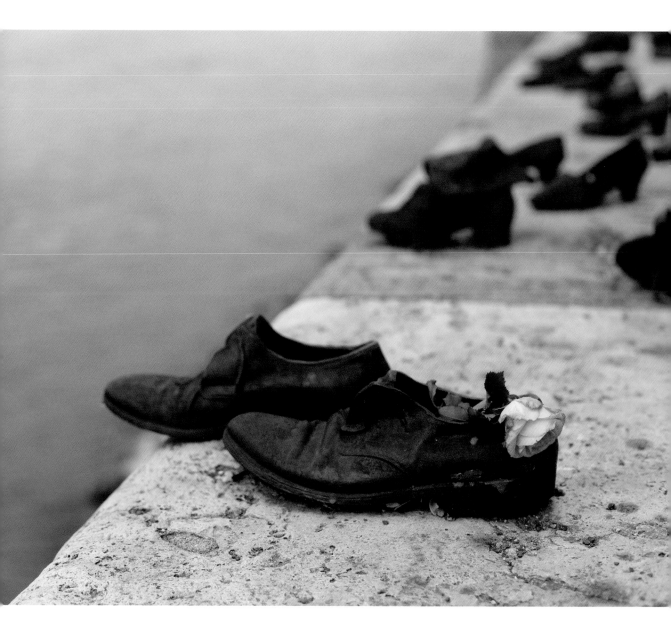

In documentary footage of conflict zones or disasters, abandoned shoes are one of the most personal and haunting symbols of tragedy. The shoes remain but the wearer is gone and has no more need of shoes.

Film director Can Togay was attuned to the poignancy of such imagery when he conceived, along with sculptor Gyula Pauer, this understated but unforgettable memorial on the Danube Promenade. The stretch between the Chain Bridge and the Elisabeth Bridge on the east side of the river is a UNESCO World Heritage Site, and the memorial is sited not far from the Hungarian Parliament. This memorial may not be an architectural structure, yet it forms a piece of the city: it cannot be positioned elsewhere and retain its meaning because it is rooted to this spot.

The history behind the memorial is in fact very literal. It consists of 60 pairs of 1940s-style shoes, sculpted in iron. These realistic shoes, which vary in size and style – loafers, work boots, heels – stand in for 3,500 Jews who were murdered here by the fascist Arrow Cross militia between December 1944 and January 1945. Lined up on the banks of the river, the victims were forced to remove their shoes – which had value on the black market – before being tied together using rope – even shoelaces – and shot down into the freezing waters.

The Arrow Cross was a violently anti-Semitic, far-right, nationalistic organisation which ruled Hungary between October 1944 and April 1945. Despite a mere six months in power, the party left between 10,000 and 15,000 murders in their wake, as well as 80,000 deportations to concentration camps.[1]

Shoes, perhaps more than any other item of clothing, are imbued with symbolism. As purely functional items, they protect our feet and allow us to walk about freely outside. Iron shoes cemented into place are a stark symbol of immobility and curtailed freedoms. But shoes are also particularly personal to the wearer, moulding to their gait and stance; they are revealing of identity, age, life stage, profession and personality. In this haunting memorial, where the sculptor has faithfully rendered all manner of details, the shoes have a personality: shabby, practical, smart or well-heeled. Who were these people, and where would these shoes have taken them, had their lives not been so cruelly cut short?[2]

Cities are nothing without people, and this memorial cements the memories of those individuals, who disappeared in such cruel fashion, into the urban fabric. The placement of the shoes against a panoramic backdrop is a chilling juxtaposition, which forces the visitor to reassess their relationship with the city from a new, tragic, vantage point.

When we walk around a city we occasionally come across an odd shoe on the street. Coming across 60 shoes incongruously placed on the riverbank is a shocking and heart-breaking sight, suggestive of the ghostly presence of their owners. Some pairs are positioned neatly, toes over the edge of the bank, facing the waters head on. Others are more scattered, hurriedly kicked off. A child's boots have been tentatively removed, placed hesitantly on the ground.

left

78 Shoes are deeply personal items of clothing, expressing the idiosyncrasies and humanity of their wearers

overleaf

79 The shoes are lined up along the bank of the Danube, a poignant metaphor of loss

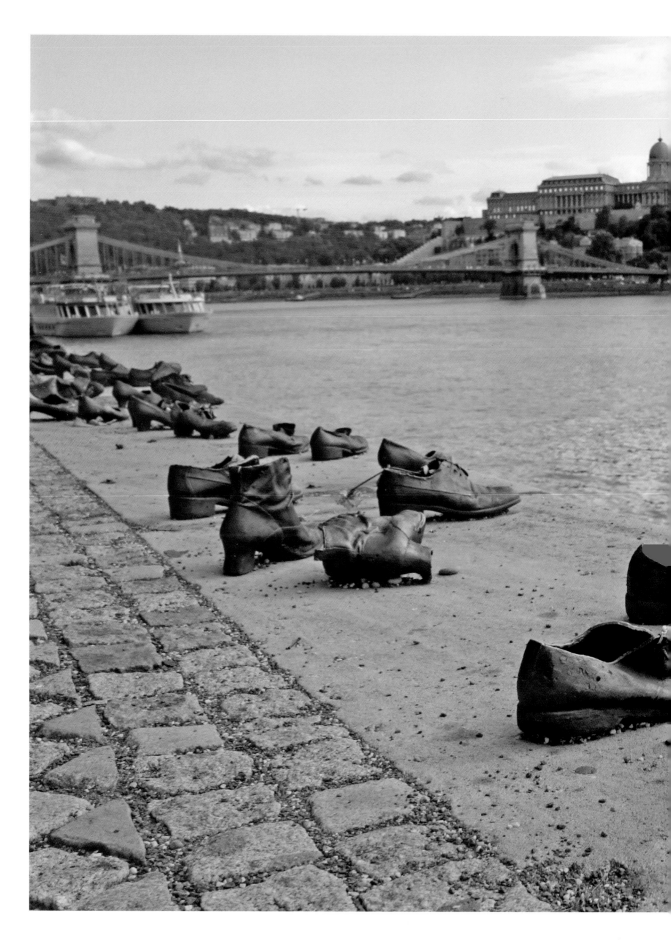

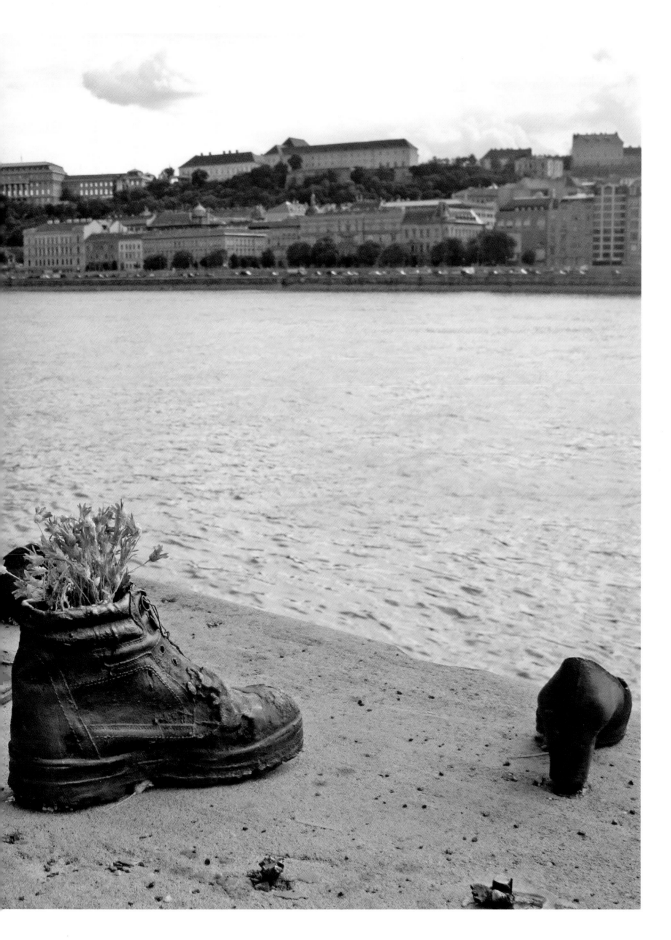

Singapore Founders' Memorial

Architects: Kengo Kuma & Associates and K2LD Architects
Location: Bay East Garden, Singapore
Year: Intended for completion 2027

Shortly after the death of Lee Kuan Yew, in April 2015 – Singapore's first Prime Minister from 1965 to 1990 – the government proposed a memorial project to honour and remember the values and ideals of Singapore's founding leaders who, according to the government, 'led Singapore on a path to independence' and were central to its 'nation building process'.[1]

A steering committee was formed in June of that year to garner public opinion, initiating a two-year-long series of public workshops, involving Tamil, Malay and Chinese groups, as well as historical experts. A shortlist of five, from over 50,000 responses, was exhibited at various locations in 2019, with voting open to citizens, who, alongside a Jury Panel, awarded the competition win to Kengo Kuma & Associates and Singaporean K2LD Architects.[2]

The concept for the 'Founders' Path' takes the image of leading to retrace a series of journeys in the landscape. The design incorporates numerous slopes and curved pathways which

80 The memorial seeks to present Singapore as a Garden City, integrated with the environment

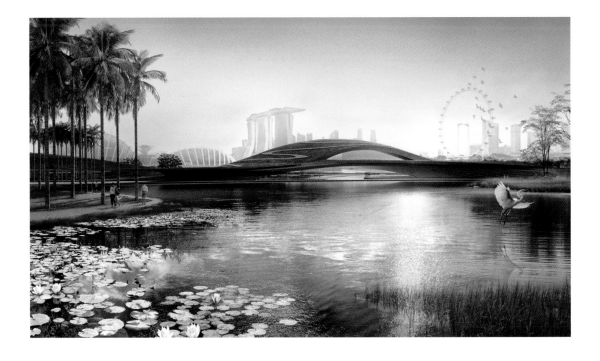

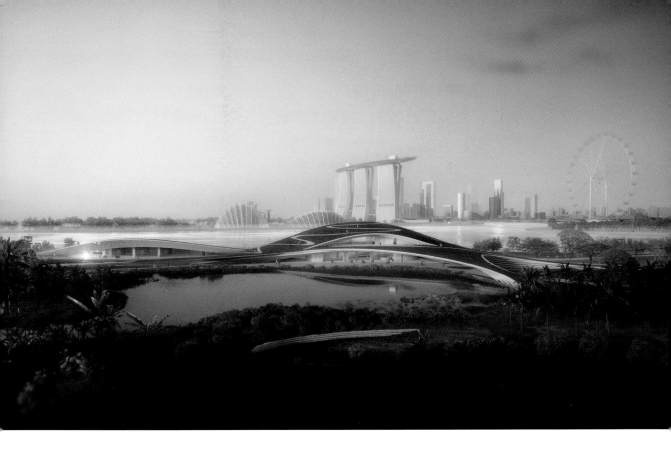

81 Architects' vision of the memorial within the wider urban setting of Bay East Garden

culminate in the centre of the scheme. Interior spaces and canopies – housing various functions such as an exhibition space, an auditorium and cafes – are accessed via meandering avenues.

'The basis of the design, the Founders' Path, is a central spine, which cuts through the garden, defining the new topography with memorial slopes emerging from the landscape to house the program', explains the practice. From the undulating landscape formations, glimpses of the city skyline are captured. Symbolically, the memorial aims to weave together the varied and multicultural lives of Singapore's inhabitants – represented by the multiple pathways – with the temporal notions of past, present and future. These are constantly formed and reformed by movement, of visitors variously ascending and descending through the landscaped monument.

Kuma describes his design as a 'marker along the transformative history of Singapore';[3] its organic form, which appears to rise from the landscape, integrates with the topography of the surrounding garden context. 'Mr Lee's philosophy was about [developing Singapore into a] Garden City, and he thought a city of the future should be totally integrated with the environment', says Kuma.[4]

This characteristic seems to encapsulate some of the very early ideas voiced by the original workshop contributors. 'Singapore is not a very natural country', historian Professor Tan Tai Yong, is quoted as saying. 'It came out from, in a sense, nowhere, because we were part of Malaysia. It is important for us to remember how these [things] were done, and the qualities that took us through to where we are [that] are worth remembering and commemorating.'[5] Completion is anticipated in 2027.

Son Yang Won Memorial Museum

Architect: Lee Eunseok + Atelier KOMA
Location: Gyeongsangnam-do, South Korea
Year: 2017

The South Korean patriot and martyr Son Yang Won (1902–50) was a Presbyterian preacher and pastor of Aeyangwon leper colony in Yeosu. Son was a principled man who refused conversion to Shintoism when Korea was under Japanese colonial rule, and likewise refused to embrace Communism; his own sons were killed by Communist rioters.

Under both regimes he found himself imprisoned, and he was eventually executed on pro-American, anti-Communist charges.

As a fervent Christian, Son openly forgave one of his sons' murderers, Chai Sun, and even went on to adopt him.

The memorial museum by architect Lee Eunseok takes the form of a closed-off concrete cylinder, which physically and symbolically divorces the memorial's interior from the external world.

82 The dramatic cylindrical form of the memorial, with its sweeping ramps, places the visitor somewhere between heaven and earth

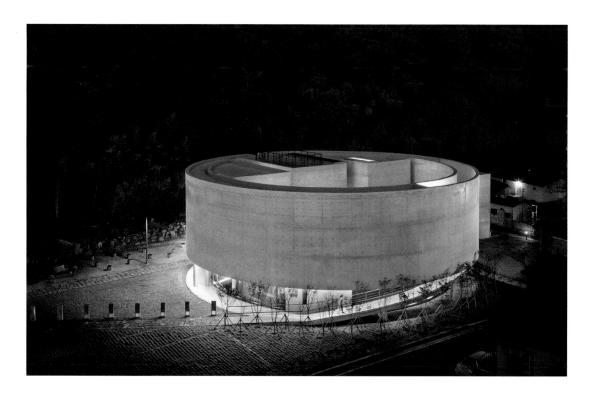

83 The symbolic space memorial is divided into three distinct spaces, each representing a different aspect of Son Yang Won's spiritual life

and reflect on Son's three guiding principles: resistance, sacrifice and reconciliation.

The three interior exhibition rooms are crossed by a ramp. Visitors first enter via a dark, narrow passage into the White Room, which symbolises Son's love of country; its artefacts cover his patriotic endeavours. Next is the Stone Room, whose interior walls are textured with a cracked stone surface. This somewhat graphically relates to the broken skin of the lepers to whom he ministered. Finally, the Red Room, the core space within the memorial, is finished with a coarse-grained wall texture in blood-red hues. This symbolically alludes to his altruistic heart and *agape* (love for mankind), as well as openly referencing his pain and death.

Lee Eunseok's emotionally charged museum is conceived as a 'symbolic space memorial', where visitors follow the spiritual footsteps of pastor Son through the architectural experience, as opposed to a more straightforward gallery of artefacts. 'It was not easy to find a specific relic to commemorate Son Yang Won because he was a patriot who left an inheritance of ideological values, rather than a material legacy, to later generations', explains Lee. 'So, I tried to express the traces left through his life and death through expressive spatial compositions, commemorating three acts of the practice of Christian love; in other words: the love of God – who was the object of consistent faith for him; neighbourly love – the love of those who sacrifice themselves for their fragile neighbours; and love of one's country – as a member of the resistance against the Japanese army colonising Korea, at risk of his own death.'

As Lee explains, disorderly development in the city compromised the tranquillity of the memorial site, which 'required us to surround the memorial with circular walls to protect the space inside from external hassle and to create a neutral space of silence'.[1]

A structural wall, and pilotis distributed in a seemingly scattered arrangement, lift the volume from the ground. It is open only to the sky above and the water below; scudding clouds are reflected in a tranquil pool, creating a dichotomy between movement and stillness.

A narrow, winding pathway leading to the entrance evokes memories of Son's painful life journey. This ascending ramp, between the inner and outer volumes, acts as a transitional space between the noisy outside world and the quiet interior, while providing a space to walk

'Sky, water, narrow roads, the three exhibition halls, the rough materials, the white and red colours, and the nine columns are all symbolic and metaphorical architectural expressions', elaborates Lee. 'The architectural strategy I adopted was to achieve a commemorative effect through the literary expression of space, rather than a relic.'

84 Axonometric diagram depicting the relationship between the spaces shielded by the cylindrical form

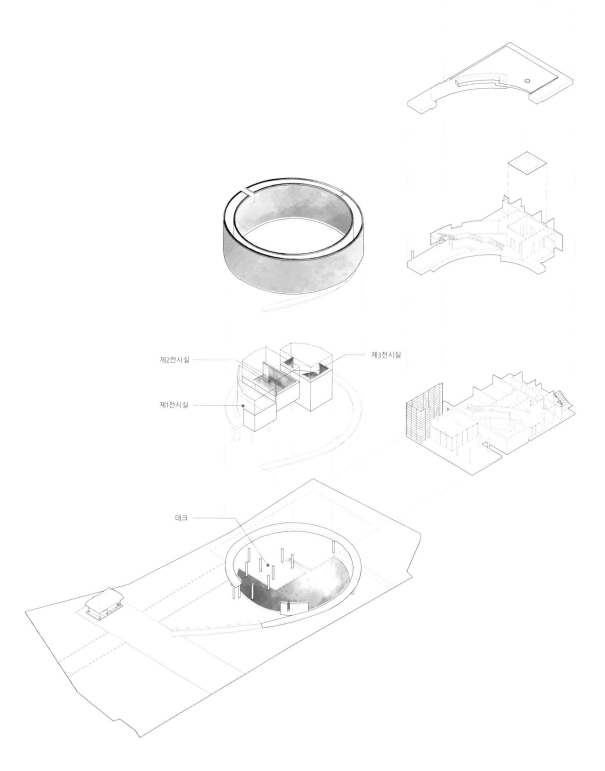

제2전시실

제3전시실

제1전시실

데크

34

Steilneset Memorial to the Victims of Witch Trials

Architect: Peter Zumthor and Louise Bourgeois (artist)
Location: Vardø, Norway
Year: 2011

The fishing town of Vardø, in the extreme northeast of Norway, is situated on an island in the Barents Sea, 260 miles north of the Arctic Circle. The environment is tundra, and it is on a frozen stretch of coastline, a short distance away from the town, that the Steilneset memorial sits: two structures commemorate 91 people burned at the stake in 1621 for supposed witchcraft.

The memorial is located at the end of the Varanger stretch of the National Tourist Routes – an incentive by the Norwegian government, which introduces architectural interventions along 18 of the country's highways.

85 Peter Zumthor's memorial takes visual cues from the structures used by Norwegian fishermen

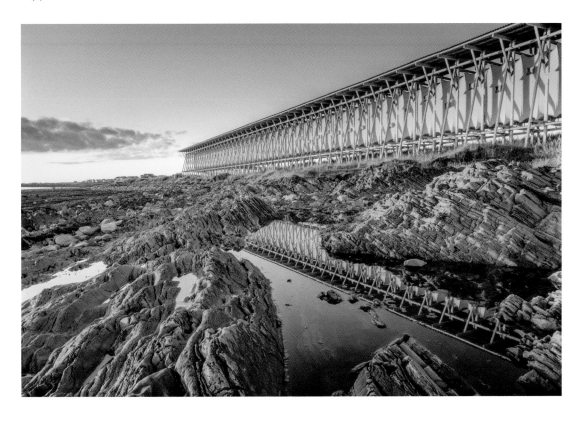

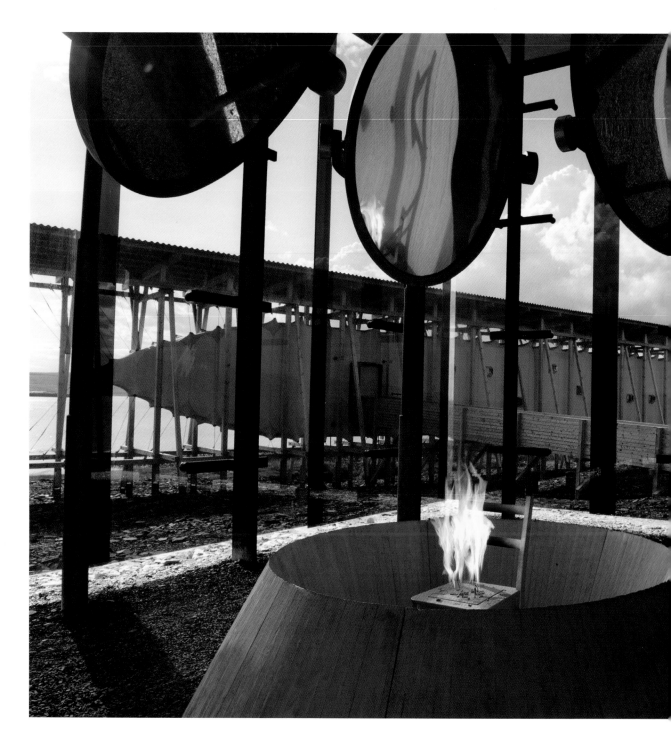

This memorial, therefore, is intended to attract as well as to commemorate.

Architect Peter Zumthor collaborated with internationally renowned artist Louise Bourgeois (1911–2010) on the dual-structure memorial, which was to be her last commission. Zumthor described this collaboration: 'I had my idea, I sent it to her, she liked it, and she came up with her idea, reacted to my idea', he said. 'The result is really about two things – there is a line, which is mine, and a dot, which is hers . . . Louise's

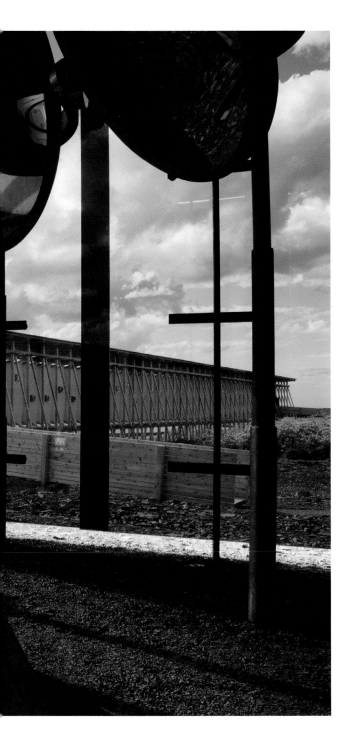

86 Louise Bourgeois' memorial evokes a sense of maddening enclosure using smoke and mirrors

membrane cocoon beneath a corrugated metal roof. Within this fibreglass casing is a long and narrow corridor, 1.5 metres wide, where 91 light bulbs hang within their own small window. Each porthole is accompanied by text with information about the accused written on silk. Zumthor selected the windows' positions arbitrarily, much like the arbitrary 'justice' of trials by water. The pavilion, with its geometric, criss-crossing stalks, is akin to the drying racks used by fishermen.

The second, box-shaped structure of steel and smoked glass contains Bourgeois' installation, entitled *The Damned, The Possessed and The Beloved*. This comprises a circle of seven mirrors surrounding a flaming chair, within a concrete cone. The mirrors stand as if silent witnesses to an execution or as participants in sorcery.

This memorial capitalises on the mystical – even sinister – properties of light and gloom in a landscape which remains in darkness for half the year, and for the other half is rendered eerily bright by the midnight sun. Dancing flames – amplified and reflected by a circle of mirrors in a smoked glass chamber – evoke a maddening sense of horror, illogicality and claustrophobia. In the chilly corridor nearby, the lightbulbs sway in the gloaming like so many nooses.

Zumthor and Bourgeois' memorial is the architectural embodiment of Arthur Miller's *The Crucible* – dramatic, atmospheric and nightmarish. For those caught up in the collective lunacy of 17th-century witch-hunts, remote Finnmark would have been a truly outlandish place, inescapably cold and dark, lonely and unforgiving.

installation is more about the burning and the aggression, and my installation is more about the life and the emotions.'[1]

The larger of these two structures is a 125-metre-long pine scaffold protecting a fibreglass

The Clearing

Architect: 3RW
Location: Utøya, Norway
Year: 2015

'When a big tree in the forest dies, an organic process that creates what we know as a clearing begins', write architects 3RW. This was the inspiration behind their memorial on the Norwegian island of Utøya. On 22 July 2011, this tranquil island was the incongruous site of an enormous tragedy, when 69 teenagers attending a Labour party youth league (AUF) summer camp were murdered by a right-wing extremist (see also Hegnhuset, p.67).

The discrepancy between the scenic surroundings and the tragedy is jarring. Not wanting the beautifully forested island to become a 'landscape of terror', 3RW adopted the stance that 'nature represents hope'.

The Clearing takes the form of a metal ring – a unifying circle 12 metres in diameter – which is suspended from pine trees. A system of cables – springs and fasteners, akin to those used to moor boats – stills and supports the memorial without damaging the trees.

Through the names which are cut out of the metal, sunlight and plants are visible, casting dappled shadows on the ground. As one stands within the circle, one is enveloped by it, and forest, waves and water are all visible, with the coast at Sørbråten in the distance. In the summer, sunset and sunrise can be observed here. The Clearing takes on a sacred quality.

Beneath the metal ring, slate slabs act as a low-maintenance preventative measure for the growth of weeds, whilst planting in the immediate vicinity is chosen to attract butterflies, encouraging biodiversity and life. Poignantly, one butterfly species indigenous to the Tyrifjord area is *Nymphalis antiopa* – *sørgekåpe* in Norwegian, which means 'mourning cloak' in English.

Crucially, the Clearing site was not the scene of any crimes: it was deliberately chosen to detach it from drama. The circle can be seen as a 'kind of void to be filled with the individual's need to process grief', say the architects.

'In the period after the 22nd July 2011, there was a concern that this event could change Norwegian society, and affect Norwegian ideas about community', they write. The designers resolved to address this by proposing a landscape-friendly memorial, built through volunteer work and community, which they deemed to represent the true spirit of Norwegian society.

One of the most important elements of the memorial's construction was this collaborative quality, drawing on the specifically Norwegian concept of *dugnad* – the spirit of community volunteering. The architects saw this collaborative exercise as essential to the healing process: 'the essence of nature is that it can, through transformation, slowly erase all traces of the tragic events that happened here . . . The memorial must, above all else, be a place that exposes these powers of nature; a power to renew and heal.'[1]

87 The suspended ring is positioned in a clearing where the natural environment can be experienced, and can help to heal

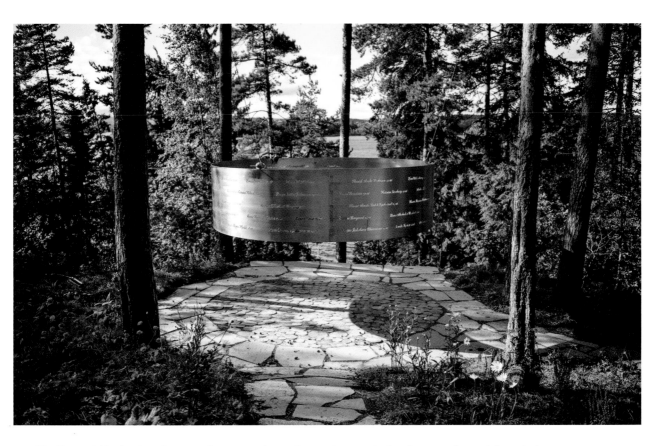

88 From within the ring, the tranquil waters and coastline can be seen in the distance, glimpsed through the cut-out names

Thunderhead 2SLGBTQI+ National Monument

Architect: Public City, with Shawna Dempsey, Lorri Millan and Albert McLeod
Location: Ottawa, Ontario, Canada
Year: Intended for completion 2025

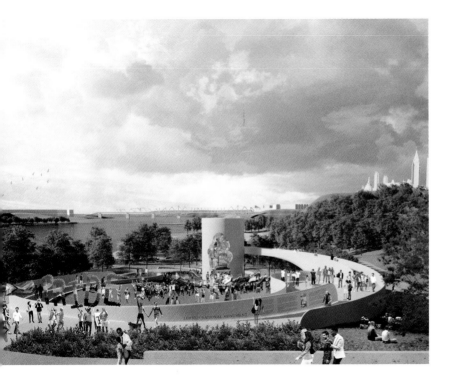

left

89 The architects' joyful vision of the memorial being used for Pride celebrations

right

90 The interior of the columnar structure is carved out to resemble a cumulonimbus cloud, and lined with glass mosaics like a disco ball

Homosexuality was officially decriminalised in Canada in 1969. Regardless, various state institutions such as the Canadian Armed Forces, the Royal Canadian Mounted Police and the federal public service maintained discriminatory policies against their 2SLGBTQI+ employees, violating their privacy, harassing them and 'purging' them from the workplace.[1] It was not until the 1990s that these organisations agreed to end exclusionary practices, but it would take far longer for a toxic culture to change.

In 2018, following a class action settlement, the LGBT Purge Fund was established to manage reconciliation projects. Part of the process of apology and redress is the commissioning of a monument, acknowledging those members of the 2SLGBTQI+ community whose personal lives and careers were wrecked by state-sanctioned

homophobia and transphobia. Although the public recognition of historic injustice is a main driver, the memorial is also intended to educate and celebrate diversity within current society: the trauma is acknowledged, but 'the power of collective rage, activism and hope that has brought us to the present' has been harnessed in this winning proposal.[2]

In March 2022, Thunderhead – a collaboration between studio Public City, artists Shawna Dempsey and Lorri Millan, and Two-Spirit Advocate Albert McLeod – won the competition with its joyful and dynamic design.

The site is designed to create multiple points of engagement. At the entrance, a wide, curving path arcs toward the Ottawa River amidst a verdant setting. It is lined with educational panels which narrate incidents of discrimination, such as the incarceration of Two-Spirit children – who identify as having both a masculine and feminine spirit – in Indian Residential Schools. Another path leads to a large medicinal garden and a healing circle of 13 stones, hand-picked by Two-Spirit Elders, and a firepit for ceremonial use. Other circles dot the north end of the park,

for relaxation and socialising, and a sloping lawn can accommodate 2,000 people.

The focal point, however, is an imposing columnar form that is cut away to reveal a flashing and glowing interior that rises like a cumulonimbus cloud. The interior is covered in glass mosaic tiles like a disco ball, a mischievous celebration of sexuality and camp. 'Thunderhead is a luminous space that literally reflects our many identities', explain the designers.[3] The roiling cloud serves as a symbol of activism and renewal.

As the visitor enters the monument, they will be able to look down to ground level and up into the cloud. The ground level contains two stages – platforms for expression – which, say the architects, 'will be animated by our queer superpower (performance), dancing (which has always been part of our revolution) and protest (for the fight for justice is not over)'.

'This glittering, dynamic memorial stands in contrast to all of the places where we have been rendered invisible in the past and shines proudly into the future', they proclaim.

37

Tiles to the Desaparecidos

Artists: Barrios X la Memoria y Justicia (Neighbourhoods for Memory and Justice)
Location: Buenos Aires, Argentina
Year: 2006 onwards

Embedded on the streets of Buenos Aires are around 1,700 plaques, each commemorating an individual who 'disappeared' during Argentina's military dictatorship of 1976–83. In total, around 30,000 people were abducted, tortured, murdered and ultimately 'erased' during what the military dictatorship contentiously termed the *Guerra Sucia* (Dirty War).

Among those who were made to disappear – some thrown from aeroplanes into the sea, some buried in unmarked graves – was anyone perceived as a political threat to the junta: not only guerrillas and Communists, but also journalists, lawyers, students, trade unionists and workers.[1] Babies also disappeared, many of whom were stolen and illegally adopted.

Originally taking the form of stickers and photos to mark where the victims had lived, since 2006 – the 30th anniversary of the regime's ascent to power – the grassroots collective Barrios X la Memoria y Justicia began fabricating and laying tiles (Baldosas X la Memoria) as a more permanent gesture. Their first tile commemorated 12 people forcibly disappeared from outside Santa Cruz Church on 8 December 1977.

The slabs are embedded into pavements to commemorate the paths trodden by the missing. Each tile, decorated with colourful mosaics, notes the victim's name, birthday, hometown and occupation, followed by the date they were detained. Personal symbols also appear, such as the logo of favourite football teams or – as

in the case of a group of ceramics factory union members – pottery fragments.

Barrios X la Memoria y Justicia is a grassroots memorial collective that prefers to remain at community level.[2] Their deliberate non-involvement with the government allows them to distance themselves ideologically from politicians, such as former president Mauricio Macri (2015–19), for instance, whom some accuse of genocide denial due to his refusal to acknowledge 30,000 as the number of victims.

The process of installing a memory tile involves the family of the disappeared reaching out to the local neighbourhood group, which researches details in the records of human rights organisations. The family contributes towards the slab and participates in its creation. A memorial service is then held at the laying of the tile.

For families of the disappeared, the tiles create a focal point for mourning. On a practical level, in some cases, the tile-laying ceremonies have led to the discovery of witnesses in ongoing investigations.[3] Somewhat akin to the Stolpersteine (Stumbling Stones) – initiated by Gunter Demnig in Cologne, which embed the names of Holocaust victims into the streets where they lived and has now expanded to 1,200 towns – the tiles help to restore a certain physical presence of the disappeared. The victims are no longer simply 'gone without trace'; their unseen footprints are embedded into the physical fabric of the city, and the urban landscape continues to be physically affected by their presence.

above

91 Members of the community collectively laying a commemorative tile

right

92 Tiles placed outside the Italian Hospital in Buenos Aires commemorate those who disappeared from that location, including several doctors

Tree of Knowledge Memorial

Architects: m3architecture and Brian Hooper Architect
Location: Barcaldine, Australia
Year: 2009

Barcaldine, in the centre of Queensland, played a pivotal role in the development of trade unionism in Australia. The town emerged 135 years ago at the terminus of the Central Western Railway, which served the large and geographically dispersed sheep stations of the region. Itinerant workers were recruited seasonally by farm owners and managers who wielded significant control over the pay and

conditions of their workforce, both of which were, predictably, substandard.

The Tree of Knowledge was a ghost gum (*Corymbia aparrerinja*) near Barcaldine railway station, under which members of emerging unions began meeting in the 1890s. It was the assembly point for the workers of the Shearers' Strike in 1891, an event seminal to the formation

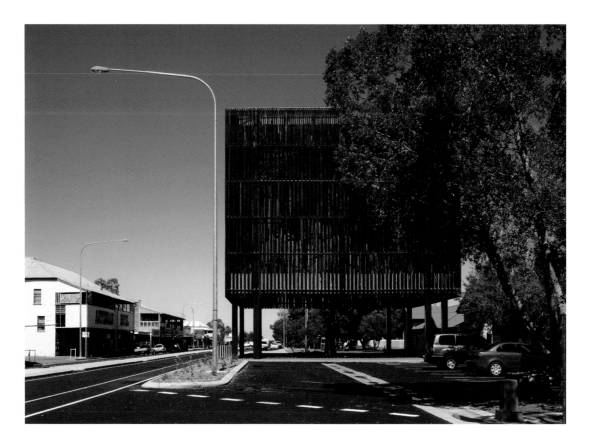

of the Labour Party in Queensland: the manifesto read under this tree on 9 September 1892 is a foundation document of the current Australian Labour Party (ALP). However, in 2006, the tree (which was also a notable tourist landmark) was illegally poisoned using glyphosate. The ALP offered an AUS $10,000 reward to identify those responsible.

To commemorate the significant cultural heritage of the tree, m3architecture and Brian Hooper Architect designed the monument as part of a wider masterplan. Their memorial frames the tree's remains in an 18-metre-high cubic timber and steel structure comprising 3,600 hanging timber batons, intended to represent the tree's canopy. The root ball is displayed beneath a glass floor panel.

Externally, and from a distance, the memorial appears as a charcoaled, slatted timber casing poised over a tree trunk. Yet standing beneath the structure and looking upwards reveals the impressive canopy of suspended batons. Lighting illuminates the memorial at night, allowing it to continue as a popular meeting place at all times of day.

Architect Michael Lavery likened the external protective casing to a veil, saying, 'This finish and its form reference a place of memory. The "veil" provides hints to the form and movement inside but it does not fully reveal the impact of this space. This experience is saved for visitors as they enter the shade of the "tree".'[1]

Underneath the structure, a plaque commemorates 'the loyalty, courage, and sacrifice in 1891 of the stalwart men and women of the west from whom, beneath this tree, emerged Australia's labour and political movement'.

The memorial has garnered several accolades, including winning the Lachlan Macquarie Award for Heritage Architecture and a National Commendation for Public Architecture at the

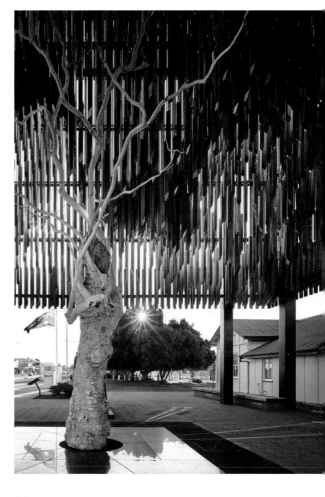

left

93 The remains of the historic ghost gum tree are preserved within an 18-metre-high cubic structure in the centre of Barcaldine

above

94 The root ball of the historic tree is preserved under a glass slab. Above the trunk hangs a canopy of suspended batons

National Architecture Awards of the Australian Institute of Architects, 2010. Meanwhile several cuttings propagated from the tree are growing at the National Arboretum in Canberra.

Wahat Al Karama

Architect: bureau^proberts and Idris Khan (artist)
Location: Abu Dhabi, UAE
Year: 2016

Rising from the middle of the United Arab Emirates Memorial Plaza are the imposing pillars of Wahat Al Karama, a sculptural collaboration between British artist Idris Khan and Australian architecture practice bureau^proberts. The structure – of 31 monumental, aluminium-clad tablets – is a memorial to Emirati military and civil servicemen and the UAE's fallen heroes.

The challenge for the architect-artist team was to create a space for reflection on loss, which would simultaneously convey hope, unity, solidarity and mutual support. The resulting memorial complex contains the Pavilion of Honour, the Wahat Al Karama monument (manufactured by specialist foundry UAP) and the Memorial Plaza (designed by AECOM), in a 42,000-square-metre plot.[1]

Wahat Al Karama (Oasis of Dignity) makes a bold statement about the reciprocal relationships between the seven emirates and their citizens. Despite the monumental scale of the individual slabs, they appear to gently rest on one other, reassuring in their strength. The two front-most tablets stand vertically, instilling a sense of humility in the approaching visitor. The tablets are crafted using a hand painting technique which achieves a gradient of colour on the material's surface that captures rather than reflects light.

The monument is conceived as a 'unifying poetic moment'. Engraved into the surface of the tablets are poems and quotations from several of the UAE's current and former leaders, including the late Sheikh Zayed bin Sultan Al Nahyan and Crown Prince Sheikh Mohamed bin Zayed Al Nahyan. These invite the viewer to read, reflect on and touch the surfaces, creating a personal relationship between visitor and monument. Qur'anic inscriptions further emphasise the religious link between the memorial and the Sheikh Zayed Grand Mosque directly opposite.

The Memorial Plaza is surrounded by travertine, amphitheatre-style seating for up to 1,200 people. At this location visitors can witness a daily Honour Guard march before sunset, while a national public holiday on 30 November honours the lives of fallen soldiers. A shallow circular pool reflects both the memorial and the mosque within its still waters.

Beyond the plaza is the quiet and contemplative Pavilion of Honour. Here, individual cast-metal panels bearing the names of the UAE's heroes line the curved walls. At the centre sits a sculpture comprised of seven glass panels representing the seven emirates. On each panel is printed the UAE's Pledge of Allegiance. The metal used in the plaques was reclaimed from UAE Armed Forces' vehicles; the layered roof of the pavilion takes its cues from regional vernacular architecture.

While the commemoration of military service and valour is its primary purpose, this striking and imposing memorial communicates a

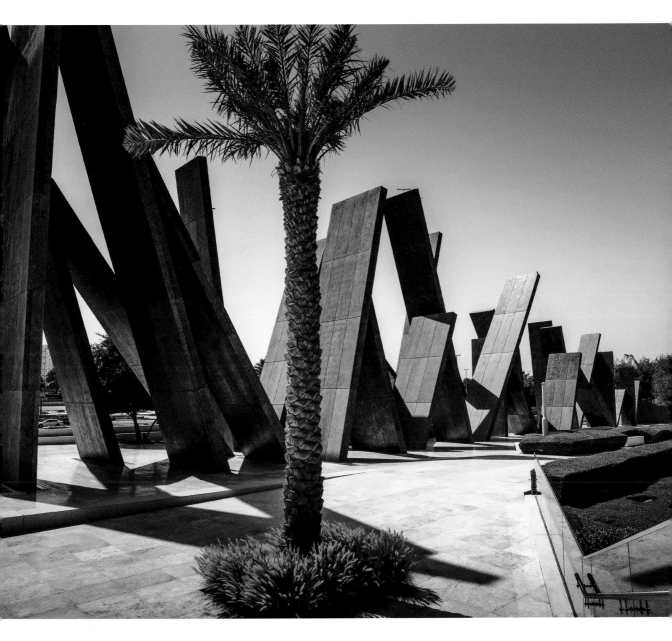

95 Idris Khan's monumental sculpture forms the focal point of the memorial complex. The towering slabs rest upon each other in mutual solidarity

tightly interwoven socio-political, religious and cultural message about Emirati solidarity, the country's leadership and its place in the world. It also serves the strategic objectives of the UAE's UNESCO Culture Agenda 2031, to 'celebrate national identity, heritage, and cultural authenticity', and therefore is as much about remembrance of things past as it is about expressing the future aspirations of the country.[2, 3]

Wang Jing Memorial

Architect: DnA_Design and Architecture (Xu Tiantian)
Location: Wang Village, Lishui, Zhejiang Province, China
Year: 2017

The ancient Chinese village of Wang had, for many years, been overwhelmed by industrial development, with modern factories overpowering its historical ruins. A walk into the centre of the village would discover some traces of the old fabric, albeit overshadowed by grey, multi-storey cement buildings. Any remaining traditional timber-framed, rammed earth-walled houses were in poor condition, and based on these alone, it would be hard to envisage that this settlement was once the most prosperous in the county, with an illustrious history.

The town's most famous son was Wang Jing (1337–1408), an imperial scholar in the Ming Dynasty. He was the chief editor of the 'Yongle Encyclopedia', the largest body of knowledge to be assembled in China at that time. Harnessing the villagers' pride in this history, DnA used a memorial for Wang Jing as a springboard for further redevelopment in the town, centred around cultural heritage.

96 The building's exterior is modest, but the interior is dramatically theatrical

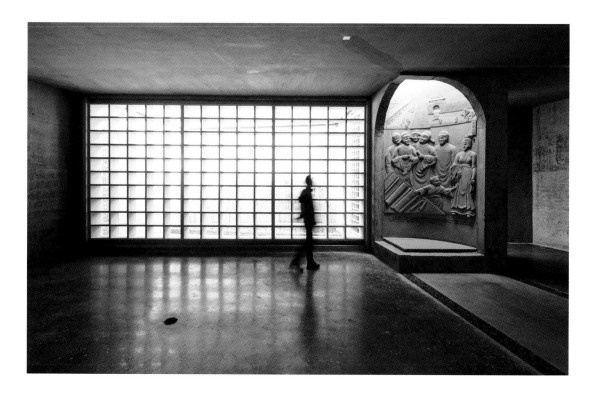

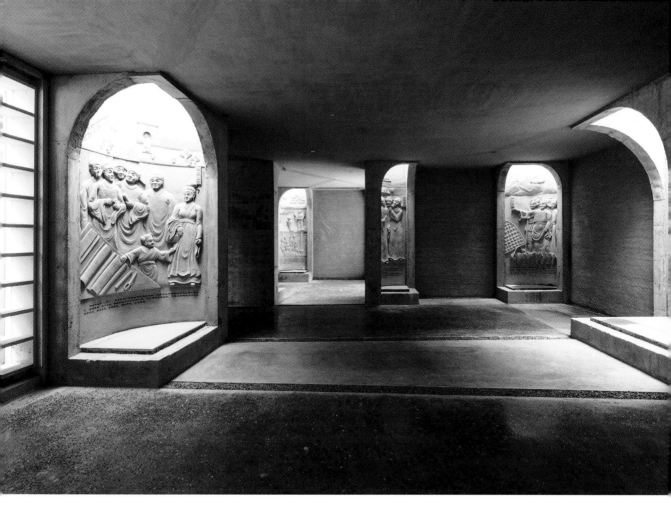

97 Sixteen key moments of Wang Jing's life are depicted in relief sculptures
inserted into lightwell niches which form part of the structure

The site for the new memorial was the village centre facing the ancestral hall. The road between them had been the regional historic trade route, and the area is in close proximity to the scenic Songyin River. The intention was to encourage the formation of a touristic and cultural focal point.

Based on the timeline of Wang Jing's life, 16 key moments were identified, which were each allocated a corner within the building. Each corner is a concrete vertical volume containing a lightwell and stone niches with relief sculptures. These nodes fulfil a structural as well as a memorial function. Two of the historic episodes, during which Wang Jing

returned to his hometown, were placed facing the village and the ancestral hall.

Each of the concrete volumes is wrapped by rammed earth walls at the ground level and extruded from the roof, to create a humble exterior appearance in keeping with the surroundings. While the exterior is modest and unobtrusive, the inside is dramatically theatrical.

The memorial fulfils the function of reinjecting a sense of history to the town; it presents a narrative that links the town with a wider story relating to national history, and assists with creating a sense of identity for the place and its villagers.

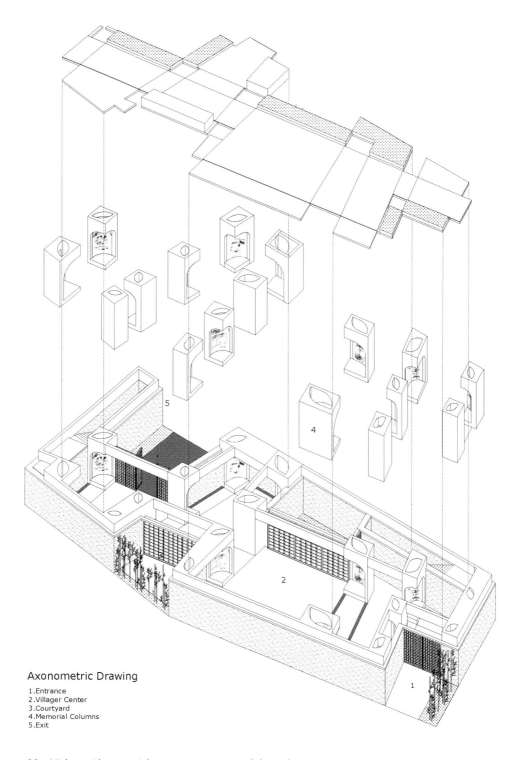

Axonometric Drawing

1. Entrance
2. Villager Center
3. Courtyard
4. Memorial Columns
5. Exit

98 Niches with memorial scenes are positioned throughout
the building, allowing the narrative to flow

41

War and Women's Human Rights Museum

Architect: WISE Architecture
Location: Seoul, South Korea
Year: 2012

In south-east Asian territories occupied by the Imperial Japanese Army, as many as 200,000 women – mostly from Korea but also from Japan, China, the Philippines and Thailand – were coerced into sex slavery at military brothels known as comfort stations. For these 'comfort women' – more respectfully referred to as 'halmoni', meaning grandmother in Korean – this period of cruel and violent treatment was

followed by decades of shame; the first woman to openly come forward about her experiences did so in 1991, almost 50 years after the end of the war. Many women were never able to return

99 The memorial museum was a former domestic house. Maximum space was made of the restricted plot by extending the museum into a garden

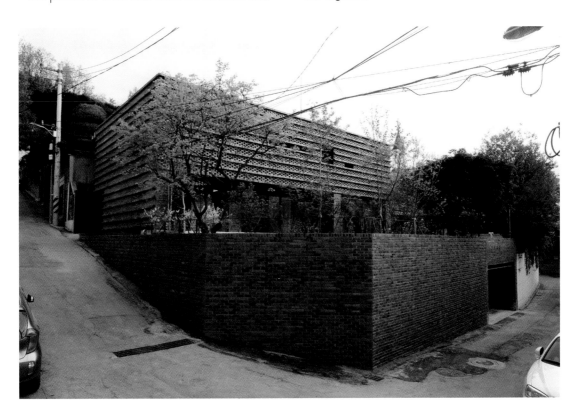

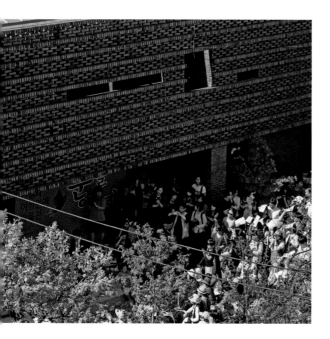

100 A perforated, black brick screen disguises the original house and creates a semi-outdoor area between the original house and garden

does not offer such protection; rather, it is a terrifying prison. This distressing thought was the starting point for the architects: inside the museum there is no reception area and no means for the visitor to orientate themselves. Instead they are met by a guide and taken immediately downstairs via a narrow corridor. This deliberately seeks to make the visitor uneasy. 'The spatial sequence and the experience of the museum is unkind. It was our intention that people should face the same uncertainty as those young and naïve 15-year-old girls did', said Sook Hee Chun (interview pp 152–3).

The building is wrapped in a perforated, black brick screen, disguising the original house and creating a semi-outdoor area which can be used for exhibitions. A new wall runs along the site's perimeter, enclosing the garden which also forms part of the museum experience, along with two upper storeys and a basement. Maximum usage has been gained out of the restrictive site.

This lack of space and context prompted the architects to respond with a narrative approach, organising the spaces according to the themes of Memory, Remembrance, Healing and Record. A continuation in the materiality – black brick – between the existing house and the new addition also adds a layer of narrative history to the building.

The journey through the spatial sequences of the museum ends in the wildflower garden. 'We wanted to end the exhibition sequence at the wild flower garden [so that] people can be relieved and healed', explained the architects. 'We want visitors to the museum to leave with a memory of healing, not the cruelty of war.' Like the survivors themselves, this memorial museum may seem unassuming, but it has a powerful story to tell.

to their homeland and those that did faced social exclusion, hardship and silence.[1]

The War and Women's Human Rights Museum is located in a house within the residential neighbourhood of Seongsan-dong, Seoul. This location was the result of various deliberations over an appropriate site for such a museum, and is more or less arbitrary. Sook Hee Chun and Young Jang, of WISE Architecture, were therefore faced with the challenge of converting a wholly uncontextual building into an emotive and informative museum worthy of honouring the survivors, some of whom volunteer as guides within the museum.

Home is a place of security, domestic comfort and shelter, but for trafficked women, home

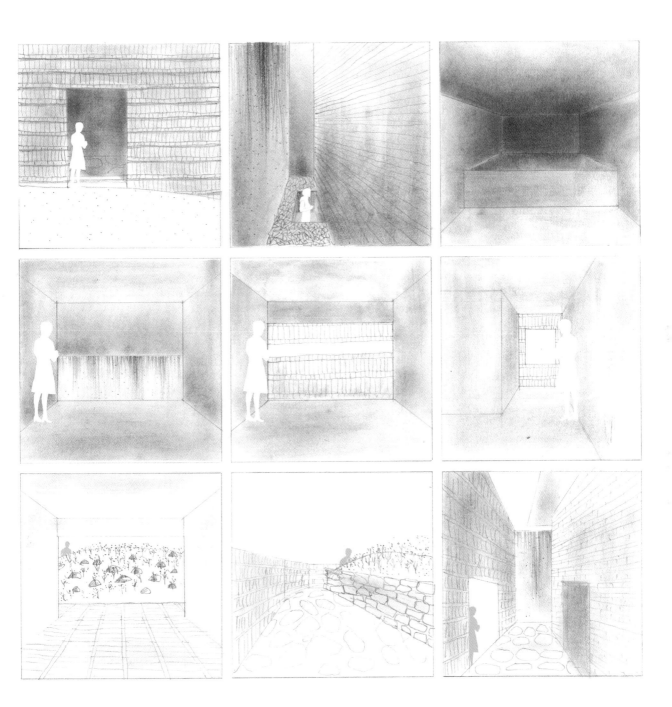

101 Architects' conceptual sketches of spaces within the building and garden

INTERVIEW WITH SOOK HEE CHUN, WISE ARCHITECTURE

What did you learn from hearing the stories of the 'comfort women' and working with them on this project?

The more we learned of their stories, the more we understood about how cruel war is to people, especially the young, and young women most of all. Most of the women we spoke to had been forced into sex slavery during the war. Strikingly, they were mostly teenagers, around the age of 15 or so, and as such they were too young at the time, and too naïve, to know where they were going, what they would have to face, and most of all, why. One of the victims we met, a lady called Won-ok Gil, once said to me that she has one hope and that is for 'NO WAR', so that no one else need experience what she went through. Surprisingly simple and true.

Could you explain the context of the site of the house in Seongsan-dong, and the challenges involved in converting it to its new function as a museum?

There was in fact no context to the house in Seongsan-dong; it was basically unconnected and irrelevant to the history of the Museum of War and Women's Human Rights. There were a few examples of co-op housing and a library for people fighting for sexual equality, but other than that, nothing especially relevant to the museum which would be accommodated there. This formed part of the challenge with the architecture. I have observed that the context of the site has in fact been supplemented since the museum has been completed, as activists have started to act based on their experiences of the museum.

What led to the design of the perforated black brick screen on the facade, and the relevance of the bricks with names?

The black brick materiality was inherited from the existing 30-year-old house, so we decided to continue its usage. There are two types of black bricks: one is 30 years older than the other. In order for us to make the museum bigger, we wrapped the existing house with an outer skin in order to generate layered spaces. We made the outer layer perforated because it was not necessary for it to be weather-proofed, structurally, and therefore people can see outside through the perforated black brick screen. Initially, we wanted to make further use of the light and shadow effect generated by this brick screen, by placing a transparent acrylic cylinder with the victims' names and faces engraved on it with a laser technique. But due to the exhibition's budget limitations, the museum improvised on our initial idea by using a system of name tags.

As a former residential house, the visitor experience is uneasy; homes are familiar, but to the trafficked women, homes became a place of terror. Could you talk a bit about this narrative, and about the importance of conveying this sense of the uncanny?

It was unavoidable and intentional at the same time. The limitations of the project were given and something that we could not change, so we had to work with them. These included the location being a house in a residential area, the size of the space, the low budget, little secured contents for the exhibition, and so on. So we looked at it from another angle. We used both the inside and the outside of the existing house so that the spatial experience could be optimised.

We made use of every single room, including the boiler pit, to turn them into an exhibition space. We decided to leave the existing trees

and to plant wild flowers to save on budget, and also to provide flexible outdoor spaces for an annual convention that takes place in August.

The spatial sequence and the experience of the museum is unkind. It was our intention that people should face the same uncertainty as those young and naïve 15-year-old girls did. There is no proper entrance or big lobby; instead there is a narrow outdoor hallway and stairs to the basement chamber, where people first encounter the elderly lady who lost her native language and was unable to come back to her hometown. This uncomfortable exhibition sequence was made possible via two means: firstly, the museum offers docents to assist those with disabilities.

Secondly, it was agreed that the museum is for people who are alive now, and although it commemorates the victims and the cruelty of wartime, their everyday lives are without war today. Therefore, the place should be

somewhere, for those alive now, to live peaceful and loving ordinary lives, without worrying about war any longer.

We wanted to end the exhibition sequence at the wild flower garden. The reason for this was that we want people – having experienced the unkind exhibition sequence and synchronised themselves with the feelings of the victims – to be relieved and healed. A wild flower garden is something that the then-young and naïve girls would have seen in their hometowns in their childhoods. We want visitors to the museum to leave with a memory of healing, not the cruelty of war.

Sook Hee Chun and Young Jang jointly established WISE Architecture in 2008. The practice has completed several meaningful projects focusing on the materiality of the everyday in Seoul. In 2012 they won the Seoul City Architectural Prize for the War and Women's Human Rights Museum and in 2011 the fourth Korea Young Architect Award.

Wenchuan Earthquake Memorial Museum

Architect: Cai Yongjie
Location: Beichuan, Sichuan Province, China
Year: 2013

Sichuan Province, China, suffered a devastating earthquake on 12 May 2008 in which over 70,000 people died, a further 18,000 remain missing and 4.8 million were left homeless. Wenchuan county, at the foot of the Himalayas, was severely affected, and Beichuan Middle School – the site of 1,300 students' deaths – became a focal point of media coverage.[1, 2]

It was here that the government decided to build the National Earthquake Memorial, a commission given to the architecture faculty of Tongji University, Shanghai. From within the department, Cai Yongjie's proposal, integrating a museum into a memorial landscape, won the competition. This opened to the public in 2013.

Cai's unique memorial spans the whole valley with its system of pedestrian walkways that cut

102 Seen from above, the memorial resembles fissures in the landscape

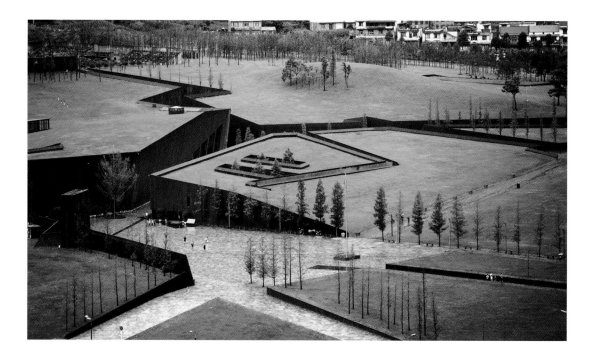

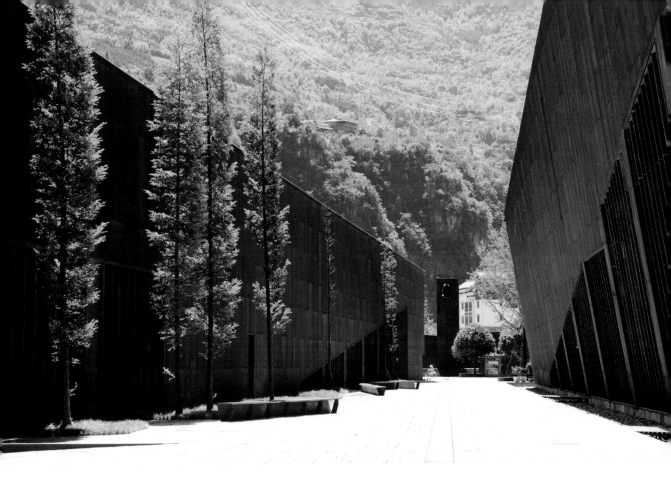

103 The Corten steel-clad walls lean inwards, creating a sense of enclosure

104 The site seen from above

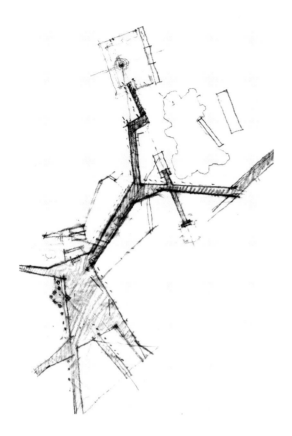

105 Cai Yongjie's sketch incorporates elements of the destroyed school into the plan

In response, the designs integrate the building's footprint into the concept. The sports field is now a memorial courtyard, a mound covers the ruins of one of the school buildings, and the former entrance gate is now the starting point of an axis cutting through the site to the memorial courtyard.

The expansive plot – covering 15 hectares – is bounded by a road and a highway on two sides, beyond which are forested slopes. Within the valley, the road leads to old Beichuan town, also preserved as ruins in memory of the 20,047 who died there.

Cracks carved through the grassy landscape are lined with Corten steel, concealing the services behind them, and lined with slate slabs. Cai's choice of material was two-fold: 'First was artistic expressiveness', he explains. 'I wanted to use a durable material, capable of visual changes and strong expression. The second was to choose a refined material that looks both artificial and natural, in order to strengthen the theme of the dialogue between these two conditions.'

into the ground like huge fissures. 'I knew that there were still thousands of bodies buried under the collapsed building, and my instinct told me that houses should not be built here', Cai told us.

The government's insistence that the school buildings should be demolished did not sit well with the design team. 'Intuition told me that the school should be preserved', says Cai. 'Demolition was something that I could not understand and accept, because the school was a subject of public attention during the earthquake and disaster relief, and its story should be passed on. Only in this way could we do justice to those lost lives.'[3]

The walls are angled dramatically, creating a sense of enclosure, and their red appearance contrasts strikingly with the verdant green of the landscaped site. The network of paths is non-hierarchical and the entrances are deliberately understated, sharing the same weathered steel materiality. The main entrance is accessed via a public square with a small clock tower.

'Because the underpinning desire was for the memorial to demonstrate reverence for nature, from the very beginning it was never the intention to express monumentality. The shape of the crack is a way of representing the event, and it is also a record', Cai elaborates. 'We cannot overcome nature; we must live with nature', he says. And further emphasising nature's awesome power, dawn redwoods (*Metasequoia*) have been planted on the site. These will grow to a height of 60 metres, bringing new growth to a ruptured landscape.

Westerbork Camp Commander's House Intervention

Architect: Oving Architekten
Location: Westerbork, Netherlands
Year: 2015

In the merciless system of detainment, deportation and death that underpinned the Holocaust, transit camps were staging posts from which victims of Nazi persecution were transported elsewhere to be murdered.

That a domestic family home could exist comfortably within such a setting is deeply disturbing.

Westerbork – 'gateway to hell' – in the northeast Netherlands, was one such place.[1] Between 1942 and 1945, over 100,000 Jews, Roma and Sinti were deported from here. The camp was liberated by Canadian forces in 1945, and after several decades was dismantled by the government.[2] The SS Commandant's home – an unassuming green and white timber house – was the only remaining original building on the site.

From the 1980s onwards, memorial initiatives began at the site, including the introduction of the Oorlogsgravenstichting (war graves foundation) archive, the Appelplatz (a memorial of 102,000 stones) and the restoration of certain elements including routes, a barracks and two freight cars.[3]

Oving Architekten's intervention to the camp commander's house involved shrouding it in a conserving skin of glass as a preservation measure.

The compound is accessed – only several times a year – via a small, Corten steel rear

106 The house is mummified, a grim exhibit in a museum cabinet

entranceway, a transitory space between the outdoors and the glass enclosure. Immediately within the glass compound is a gathering area for around 100 visitors. The glass roof directly above slopes upwards, until it skirts the roof of the timber house. Here it becomes flat, creating

107 A domestic residence in such a context is a deeply discomfiting prospect. The architectural intervention preserves the structure whilst protecting viewers from the toxic legacies housed within

an enclosure that resembles a glass box held together by a prominent steel frame.

This glass skin facilitates views in and out, maintaining the human scale and relationship with the forested surroundings. Meanwhile the steel frame accentuates the sense of enclosure, resembling, to some extent, a cage.[4]

This deceptively simple intervention adds a layer of complexity to the viewer's interpretation of the site. Enclosing this last vestige of the camp in a glass capsule would seem, at first glance, to be simply protecting a historic artefact from ruin. (It is, however, naturally ventilated, so not impervious to decay at some future date.[5]) Yet, arguably, it also protects the viewer, safely creating a barrier between them and the house. The glass enclosure creates a shield against the home's damaging ideologies and sinister memories.

This discomfiting and grim curio is now locked in a vitrine, to be observed and held up for scrutiny. It is a sealed-off contaminant, belonging to a different era.

World Memorial to the Pandemic

Architect: Gómez Platero Architecture and Urbanism
Location: Montevideo, Uruguay (proposed)
Year: Designed 2020 (construction, to be confirmed)

Perhaps destined to be the first permanent memorial to the worldwide COVID-19 pandemic, Gómez Platero's dramatically positioned monument is conceived as a testimony to loss, physical separation, the power of nature and the interconnectedness of people.

The COVID-19 pandemic 'entangled us all in a state of collective uncertainty', explains Martín Gómez Platero. It upended the lives of most of the world's population, and in Uruguay specifically, it resulted in 7,215 deaths.[1]

'It was precisely this breakdown in our way of life that forced us to think about how to present human vulnerability in an analogous way', Gómez Platero continues. 'We think we are able to control everything, but day after day nature

shows us its enormous power. What did nature teach us this time? That it is still in control.'[2]

The proposed monument – comprised of a concave bowl accessed by a long, thin walkway – stretches out from the coast on Montevideo's waterfront towards the open sea. Its position, distanced from the shore, is intended to draw visitors away from urban life towards an encounter with the vastness of the ocean. 'The edge of the sea is understood as a dialectical frontier', Gómez Platero explains. 'It is the place where the "conditioned", known and stable territory of the urban meets the indeterminate,

108 The memorial is intended to be positioned at a dialectical frontier between land and sea

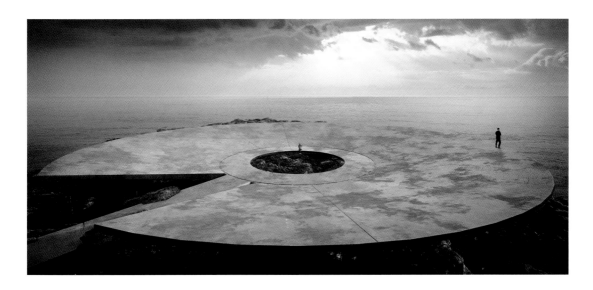

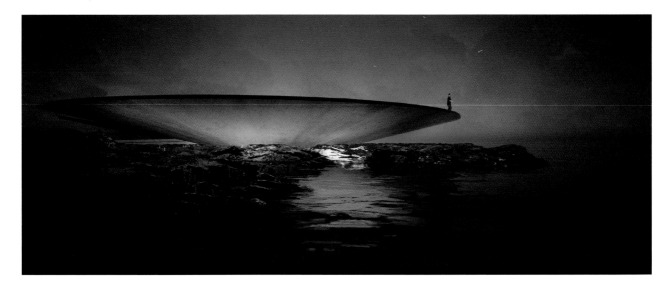

109 The COVID-19 pandemic physically isolated us all, yet connected us in a common condition. From its position on Montevideo's waterfront, looking out to the world, the memorial is intended to be a reminder of this paradox

dynamic and mutant of the natural liquid territory . . . The idea was to step away from the anthropic security (of the city) and put ourselves in the place where things we cannot control happen, to understand and respect them.'

Such a spot also faces outwards, toward the rest of the world, a reminder of the paradox that we were all simultaneously separated from, and connected with, the global population through the shared experience of the pandemic.

The practice is currently in discussion with the government of Uruguay about where the memorial could be sited in practical terms. 'Although we conceived it for Montevideo, this is a piece that can be recreated in other sites – as long as it is a frontier situation – because the phenomenon has been the same, the human perception has been extraordinarily similar', the architect believes.

The visitor to the memorial enters at a lower level, whereby the crown of the structure obscures views of the horizon. The effort of regaining connection after a period of isolation is represented by the effort it takes to climb the slope of the bowl and reach the edge. When the visitor stops looking outwards, and instead turns around, they see the other visitors likewise standing within the concave bowl of the memorial.

Yet the circular platform contains an open void at its centre, a point of introspection, which also represents a separation: what is on one side of the circle cannot be united with what is on the other side. This is a reminder of the countless separations brought about over the past two years. On the other hand, the circular form of the platform alludes to unity. We were physically distanced but globally united in a common condition.

'We are together but separated. And what separates us is what is in the centre, nature itself, the rock, the sea. If the memorial is understood as an amphitheatre, what is on stage is nature. She is the protagonist', says the architect.

110 Concept sketch of the memorial. At the centre of the concave bowl is a void, physically separating those on either side

Yad Vashem: The Holocaust History Museum

Architect: Safdie Architects (Moshe Safdie)
Location: Jerusalem, Israel
Year: 2005

Yad Vashem, the World Holocaust Remembrance Center, is an internationally significant multifunctional complex dedicated to both memorialisation and research. Meaning, in Hebrew, 'a memorial and a name', Yad Vashem was first established in 1953 by an act of Israel's supreme legislature, the Knesset, and is situated on the western side of Mount Herzl, the Mount of Remembrance, in Jerusalem. It is, in many ways, a sacred place.

The campus-like site comprises monuments, memorial gardens, education centres, museums, galleries and religious buildings. The Hall of Remembrance – which includes the memorial flame and crypt containing the ashes of concentration camp victims – is the locus for commemoration on the site, honouring the six million Jews who perished.

While the Second World War retreats further into the past, the shameful event of the Holocaust continues to cast its ugly shadow. The need to bear witness, to ensure that voices are heard and memories not erased, is increasingly urgent as

top

111 Architect Moshe Safdie's concept sketch of the interior of the central corridor, looking out to open sky beyond

bottom

112 Yad Vashem, 'Thoughts on a scheme', by architect Moshe Safdie

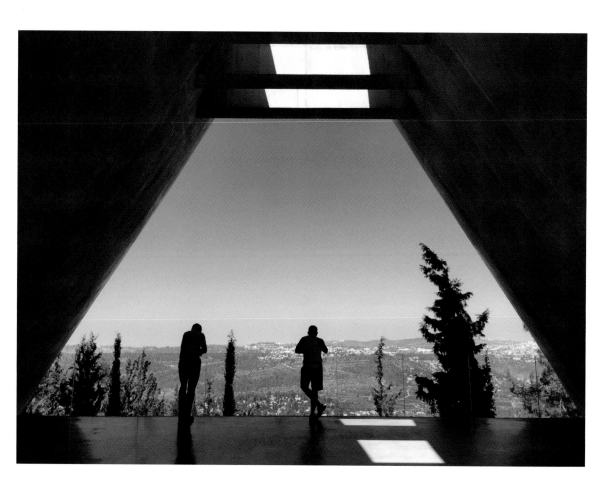

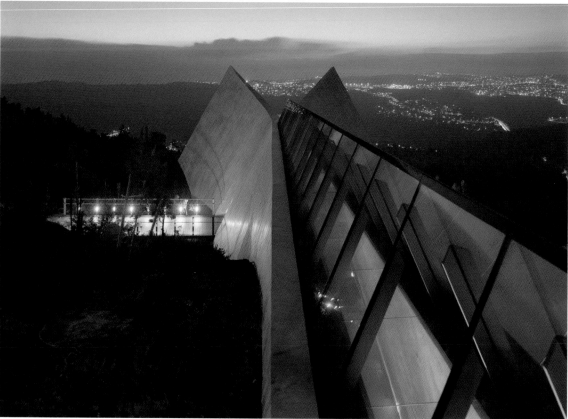

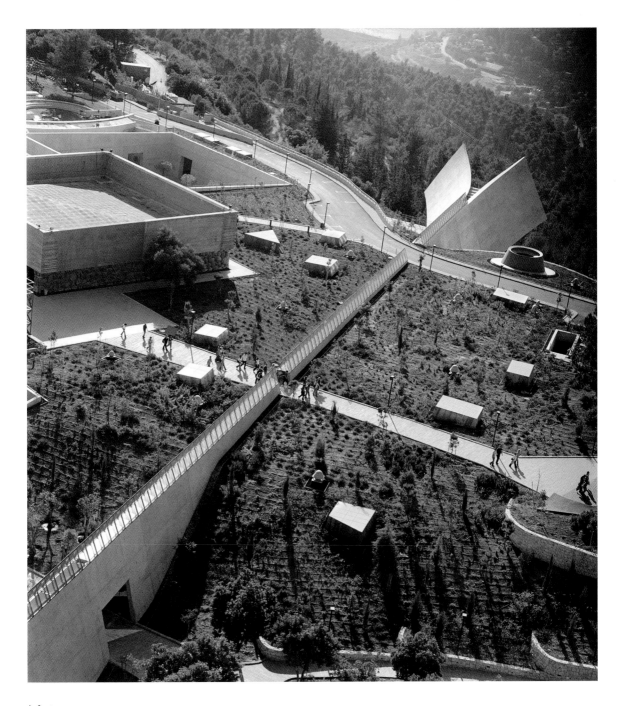

left, top

113 The the memorial museum culminates in a view over the landscape – the ideological end to the journey is the land of Israel

left, bottom

114 The building's interior is illuminated by the central skylight running along the length of its spine

above

115 An aerial view of Yad Vashem shows how the structure punctures the mountainside to burst triumphantly from the other side

generations of survivors pass away. Every year, almost two million visitors attend Yad Vashem, demonstrating its continued global significance.

Moshe Safdie's prior work at Yad Vashem included the Children's Memorial (1987) and the Memorial to the Deportees (1995). In 2005, the new Holocaust History Museum, replacing the 1950s facility, was inaugurated. Its rebuilding included the *mevoah* (new visitors centre), the Hall of Names, a synagogue, galleries and a learning centre, as well as parking facilities. New and existing buildings were knit together with landscaping by Shlomo Aronson. This incredibly complex programme must balance the prosaic and practical with solemnity and ritual; Safdie Architects' work on the site – akin to a masterplan – successfully and gracefully integrates and balances these conflicting requirements.

The *mevoah* – a concrete pavilion under a trellised roof – is directly inspired by the Succah, the temporary building constructed for the Jewish festival of Succot. It is a porous structure, allowing for comings and goings between the broad, stone plaza and a semi-circular platform overlooking the new museum.

The principal architecture on the site – the museum – is a 16.5-metre-high and 183 metre-long structure of triangular section. This cuts dramatically through the rock of the mountain. 'As I faced the program with its lists of required spaces and walked the site, which I knew so intimately, some thoughts started to become clear', writes Safdie. 'The breakthrough idea . . . was to avoid building on the hilltop altogether. Instead we would cut through the mountain, penetrating it from the south, extending under, emerging, indeed exploding,

to the north.' A narrow skylight would be 'a reflective knife edge across the landscape that would disclose the museum's presence'.[1]

The central nave is therefore bathed in light, thanks to this prominent skylight running along the structure's spine. Light from the tunnel's open north end is also always in sight, yet the visitor must take a convoluted path to reach this destination. It is not possible to bypass exhibits by walking directly from one end of the museum to the other; visitor traffic is channelled to criss-cross the main passageway into chronologically and thematically arranged exhibits either side. Shallow, angular trenches in the tunnel's floor dictate this direction of movement, guiding people from the light-filled main aisle into darker exhibition spaces, then back into the light once more.

Before reaching the end, the Hall of Names is encountered. This is a conical structure, 9 metres high, which houses the personal records of all known Holocaust victims. Reciprocating this upwardly directed cone is an inverted cone, which tunnels into the bedrock, commemorating those whose names will never be known.

The end of the prismatic tunnel opens out to the north with a winged, cantilevered platform looking out towards Jerusalem below. In answer to the Nazi's so-called 'Final Solution', the architecture presents an alternative journey's end – the grand finale of a Zionist homecoming. A 1930s recording of a Czech children's choir singing 'Hatikva' (The Hope) – the Israeli national anthem – is played, whilst the sunlit balcony takes in views of the city below. 'Years before, designing the Children's Memorial had given me an inkling of the power of emerging into light. It meant that life prevailed', says Safdie.[2]

INTERVIEW WITH MOSHE SAFDIE,
SAFDIE ARCHITECTS

Would you consider this memorial to be one of your proudest projects?

Absolutely. Often, I'm asked which is my favourite building and I can't answer that, because they deal with so many different aspects of life. I say it's like having many children.

I am Sephardic, and didn't lose anyone in the Holocaust [although various close family members did]. So, throughout my life, there's always been an exposure to the story in a very direct, personal way.

For myself, personally, I was lucky to have a moment of grace . . . I think that my knowledge of Israel, of Jerusalem, the moment it happened in my career, somehow prepared me for it.

I would say that the most challenging, emotionally and symbolically charged project of my life is Yad Vashem, for sure.

The museum is located within Mount Herzl, the Mount of Remembrance. Could you tell us about how this idea – of embedding the memorial in the rock – crystallised?

A little preparation occurred when I was looking for a site for the Children's Memorial. I saw this hill that had what looked like an entrance to a cave that had collapsed, and I seized [on that idea, and placed] the Children's Memorial underground.

In the first phase of this competition, I'd built this model – as I always do – of the site. We had a model, but every time I put something on top of that model, meaning on top of the hill, I just couldn't stand it.

There were also practical problems with that approach. [Visitors arrive at the hill from the bottom] so if we were to do what all the other competitors ended up doing, you arrive low, you leave the buses and you leave the cars, then you're going to ascend a good few floors to get to the top of the hill. How do you do that? How do you move big crowds of people up and then down again? Do you do it with escalators? That isn't appropriate.

Then I thought, well, why even go to the top of the hill? If we just go into the hill and out of the other side, we stay at that one basic level, essentially. So, that's a practical solution, but not just practical. It's profound.

That flash – going through the mountain – occurred in almost my first sketches. I worked in one of these sketchbooks – I have it, actually, right next to my table here – a sketchbook like that.

It's always chronologically documented, and in week number one, there's a sketch of the hill and a shaft cutting right through it. So, it was very early, but it scared the client . . . They had a hard time just saying, 'This is it'. It wasn't love at first sight on their part. It was an agonised choice.

You said you had to draw the Hall of Names, there and then, on a blackboard in front of the client. That must have been a daunting experience?

Yes, it was actually wonderful in that sense . . . It just came to me in the meeting and it's one of those things that happen and then you figure out, 'How did that happen?' – but it did.

How did you balance the more reflective parts of the programme with the more prosaic, day-to-day facilities that you need on such a site?

I decided to concentrate all the – what I call – 'profane stuff' in the 'middle aisle', the entry building – the gift shop, the processing and the restaurant. In the middle aisle, you're in the anteroom to the museum itself. I wanted to make it a building which is the beginning of the transformation, and it has a very particular light quality. I have a trellis where the sun comes through and everything is straight from the sunlight. It was like a preparation.

For the entry building, I was thinking of the Succah, which is the little structure that's built by each family for the Jewish festival of Succot, where you just use that roof and the light comes through the leaves of the palms.

Then, with all the other parts of the programme I created this other courtyard, so from the museum you end up in a courtyard. Very austere – I made it just plain concrete – and on the one side you have another gift shop, you have the synagogue and you have the galleries.

Then, that leads you up to the Hall of Remembrance, where the flame is, which we preserve; that was from the previous memorial on the site.

So, you've got the museum narrative and then you've got this courtyard with other stuff all nicely organised. It was also done in a way that if you continued, you could get to the old, big piazza where all the official events take place. So, it was a kind of master planning. I also did the Transport Memorial, which was even earlier. With the exception of the archives and this landscape sculpture of all the towns and ghettos in the bottom of the valley, we re-organised the whole site as part of the building of the History Museum. It was a ten-year undertaking.

Tell us a little about the design and the symbolism.

There was this notion that there's a complexity to the chapters and you get totally immersed in each chamber. At the same time, I wanted to give it coherence and rhythm. I felt that by going in a zigzag, every time I crossed the tunnel, the prism, I would get re-oriented. It's a pause. Then I take it in.

So, it's like having a spacer between each one; and, yet, at the same time as you cross it, you know that you're making progress and you know that you're moving towards something. The floor is also doing this, down and then up – it goes down to the depths and then starts rising.

There's a lot of light and spatial manipulation to create the mood, but also there's a coherence. I think what's unique about Yad Vashem is it's probably the only Holocaust museum where there is total seamless integration between the exhibitions and the architecture. Sometimes, the photographs in black and white, they feel like part of the concrete; they melt into the structure. It's often impressed me as I walk through how sometimes even the observers, the visitors, become almost indistinguishable from the exhibits.

Symbolism in a place like that is extremely subjective. There are all kinds of readings into the building by people who experience it, and sometimes I'm amused, sometimes I'm impressed. I don't believe in the architects who tell you what you should be recognising – the symbolism they meant. They tell you what is symbolic [and what meanings they attribute to, or intend for, the different elements]. I don't believe in doing that.

I think architecture should speak in its own silence without verbal help.

In your poem you write: 'He who considers himself a servant of his fellow beings shall find the joy of self-expression.' Did you manage to find some self-expression in this project?

What I said in the poem is that if your objective is to create self-expression, because that's what

you're into, you'll fail. It's the same when I say, 'If you seek truth, you shall find beauty.' It's different from, 'I seek beauty', because when you seek beauty in its own right, there are a lot of places you can go wrong.

I think if you are obsessed with self-expression or with the ego . . . then your priorities change. So, I think it's a given that a serious architect, who deals with issues – emotional, symbolic, practical – will achieve a kind of self-expression because their being is in it; but it's a by-product rather than an objective.

I think there's a lot about Yad Vashem that is self-expression: the love of the material. The feeling that everything resolves itself structurally in a way that is expressive so that you understand how the building came together, the materiality of it. I think also the humility towards the narrative. Your mission is to tell the narrative in the most effective and honest way, and that underlies everything.

Do you have any thoughts on how Holocaust memorialisation has changed since the original structure was erected on the site in the 1950s?

It's complicated because today I think the Holocaust memory is abused a lot, particularly by politicians, which is a disgrace, I think. It's not about architecture, it's about politics. I think there's something sacred about the memory of the Holocaust, and anybody who uses it politically in a cynical way is being immoral about it.

I think that memorialisation has changed in the sense that there's this period when every town wants to have its own Holocaust memorial. There certainly is a proliferation – some of which I think is wonderful – that's initiated by a second generation of the survivors. I think it's okay that it's happening, but it's tricky.

Naturally, I have been approached more than once to design these. It's okay that this is happening, but I personally feel that I shouldn't

do it, because after Yad Vashem I thought, for me, 'That's it.'

How was the architecture received at the time of opening?

When we completed the museum, the night of the opening was an emotional evening, obviously, and there were thousands of heads of state. But the architecture was not celebrated. I know when architecture's celebrated. I've opened many projects . . . architecture's in the centre. With Yad Vashem, I sat with the audience.

Why was that? Were they trying to downplay it? It's easily one of the most, if not the most, significant memorials of this century . . .

It was very interesting. Architecture was not celebrated that night. It's not that they don't appreciate it. Maybe they think the architecture gets in the way of the real story of the Holocaust.

Many of those who visit the museum say it is a very emotional journey – some are so overcome by emotion that they have to be carried out.

I know that; I still get amazing and wonderful emails, so the impact of it is very clear to me.

Moshe Safdie (born Israel, 1938) is an internationally renowned architect, theorist and educator whose career spans over 50 years. Certain notable projects include Habitat 67 (his debut project, Montreal, Canada), Marina Bay Sands, the Art Science Museum and Jewel at Changi Airport (Singapore) and Raffles City Chongqing (Chonqing, China).

Moshe Safdie has a long history of designing within Israel, and his work at Yad Vashem, Jersualem, specifically, includes the Yad Vashem Children's and Deportees' Memorials (1987 and 1995) and Yad Vashem Holocaust History Museum (2005).

Notes

Words and Music

1 'Edward Colston Statue: Four Cleared of Criminal Damage', *BBC News*, 5 January 2022, www.bbc.co.uk/news/uk-england-bristol-59727161.

2 'George Floyd Protests Reignite Debate Over Confederate Statues', *New York Times*, 3 June 2020, www.nytimes.com/2020/06/03/us/confederate-statues-george-floyd.html.

3 'Taking Down Statues: France Confronts its Colonial and Slave Trade Past', *Global Voices*, 27 June 2020, https://globalvoices.org/2020/06/27/taking-down-statues-france-confronts-its-colonial-and-slave-trade-past/.

4 David Agren, 'Mexico City to Replace Columbus Statue with pre-Hispanic Sculpture of Woman', *The Guardian*, 12 October 2021, www.theguardian.com/world/2021/oct/12/mexico-city-christopher-columbus-statue-replace.

5 Interview, p.46.

6 Susan Sontag, *Regarding the Pain of Others*, Penguin, London, 2004.

7 Johnny Cash, *Man in Black*, Columbia Records, New York, 1971.

8 Margaret Atwood, *Negotiating with the Dead: A Writer on Writing*, Virago, London, 2003.

Reflections

1 Ludwig Wittgenstein, *Tractatus Logico-Philosophicus*, Proposition 7.

Remembrance Now: Memory and Design in Dialogue

1 Gabriel García Márquez, *Living to Tell the Tale*, Penguin, London, 2005.

2 Charles Fernyhough, *Pieces of Light: The New Science of Memory*, Profile Books, London, 2012.

3 Susan Sontag, *Regarding the Pain of Others*, Penguin, London, 2004.

4 Jean-Paul Curnier, quoted in Rudy Ricciotti, architecte et Passelac & Roques, architectes associés, *Memorial du Camp de Rivesaltes*, Archibooks and Sauterau Editeur, France, 2016.

5 Mémorial du Camp de Rivesaltes, website: https://www.memorialcamprivesaltes.eu/en.

6 Ricciotti, *Memorial du Camp de Rivesaltes*, pp 6–7.

7 Andrei Tarkovsky, excerpt from 'A Poet of the Cinema', YouTube video, 9:46, www.youtube.com/watch?v=gy1DpCOON6Q.

8 Manuel Herz, 'Architect of Memorial Synagogue at Babyn Yar: Bombing "leaves me speechless, numb and powerless"', *Forward*, 2 March 2022, https://forward.com/culture/483314/holocaust-memorial-synagogue-babi-yar-russian-bombing-arhictect-comments/.

9 Bo Yang, *Zhongguo ren shi gang* [History of the Chinese People], Yuanliy chuban, Taipei, 2002.

10 Designboom, 'Kengo Kuma chosen to lead design of Singapore founders' memorial', 23 March 2020, www.designboom.com/architecture/kengo-kuma-singapore-founders-memorial-03-23-2020/.

11 Wahat Al Karama, see www.wahatalkarama.ae/en/index.aspx.

12 EU Mies Van Der Rohe Award, Notre Dame de Lorette, International Memorial: https://www.miesarch.com/work/562.

13 David Adjaye: Making Memory, www.adjaye.com/work/david-adjaye-making-memory/.

14 Quoted in Guadalupe Rosales, 'Collective Healing', *Past Due: Report and Recommendations of the Los Angeles Mayor's Office Civic Memory Working Group*, Huntington USC Institute on California and the West, April 2021.

15 Gavin Stamp, 'London: Royal Artillery Memorial', C20 Society, https://c20society.org.uk/war-memorials/london-royal-artillery-memorial.

16 Hiroshima Peace Memorial (Genbaku Dome), UNESCO World Heritage Convention, https://whc.unesco.org/en/list/775/.

17 'The Three Servicemen' sculpture by Frederick Hart was added in 1984.

18 Maya Lin, www.mayalinstudio.com/memory-works/vietnam-veterans-memorial.

19 Philip Kennicott, 'Fighting a War Over a War Memorial', *Washington Post*, 1 December 2017, www.washingtonpost.com/outlook/fighting-a-war-over-a-war-memorial/2017/12/01/d5b2318a-c639-11e7-84bc-5e285c7f4512_story.html.

20 Professor Erica Doss describes these as 'the creative products of profound personal and public feelings [that help] to mediate the psychic crisis of sudden and often inexplicable loss'. Erica Doss, *Memorial Mania: Public Feeling in America*, University of Chicago Press, Chicago, IL, 2010, pp 68–9.

21 Erica Doss, *Memorial Mania*, pp 68–9.

22 185 White Chairs Earthquake Remembrance Installation – Facebook, www.facebook.com/185-chairs-earthquake-remembrance-art-installation-185356334906566/.

23 Interview between M. Woodger, T. So and Professor Randall Mason of the University of Pennsylvania Stuart Weitzman School of Design, 2020; see also www.design.upenn.edu/historic-preservation/post/twenty-five-years-after-rwandan-genocide-memorials-remember-800000-who.

24 Carl Sandburg, 'Grass', *Cornhuskers*, Henry Holt & Company, New York, 1918.

25 See https://news.artnet.com/art-world/norway-jonas-dahlberg-memorial-1004282.

26 3RW Press Release, 2015.

27 Cymene Howe and Dominic Boyer, 'Death of a Glacier', *Anthropology News*, 22 April 2020, www.anthropology-news.org/articles/death-of-a-glacier/.

28 C.S. Lewis, *A Grief Observed*, HarperCollins, London, 1961.

29 I am indebted to conversations with leading memorial artist Mark Frith who shared these insights with me over multiple conversations and through personal correspondence, 2017.

30 As above.

31 'We're desperately searching for some sense out of the senselessness, and this is one way we can find that.' Kathleen Treanor, whose four-year-old daughter and in-laws were killed in the Oklahoma City bombing (1995), quoted in Jesse Katz, 'Memorial: A Driving Need for Catharsis', *Los Angeles Times*, 19 April 1997, www.latimes.com/archives/la-xpm-1997-04-19-mn-50375-story.html.

32 Max Porter, *Grief Is the Thing with Feathers*, Faber & Faber, London, 2015.

33 Chimamanda Ngozi Adichie, *Notes on Grief*, 4th Estate, London, 2021.

34 Professor Catriona Morrison, 'Memory and the Mind', Inaugural Lecture, Heriot Watt University, 21 March 2014 https://www.youtube.com/watch?v=6hWNP92iGFI (25:03).

35 Fernyhough, *Pieces of Light*.

36 Lisa Feldman Barrett, *How Emotions Are Made*, Pan Macmillan, London, 2017.

37 For some easily accessible starting points, see Gaston Bachelard, *The Poetics of Space*, Presses Universitaires de France, Paris, 1958; Kent C. Bloomer and Charles W. Moore, *Body Memory Architecture*, Yale University Press, New Haven, 1977; Fernyhough, *Pieces of Light*; Anne Sussman and Justin Hollander, *Cognitive Architecture: Design for How We Respond to the Built Environment*, Routledge, London, 2014; Harry Francis Mallgrave, *Architecture and Embodiment: The Implications of the New Sciences and Humanities for Design*, Routledge,

London, 2013; Bessel van der Kolk, *The Body Keeps the Score*, Penguin, Harmondsworth, 2014; Feldman Barrett, *How Emotions Are Made*.

38 Architects specialising in neuroaesthetics include Suchi Reddy of Reddy Made, for example; the Academy of Neuroscience for Architecture (ANFA) is another thought-leader in this area. See also Anjan Chatterjee and Eileen Cardilo (eds), *Brain, Beauty, and Art: Essays Bringing Neuroaesthetics into Focus*, Oxford University Press, Oxford, 2021.

39 'How Long Does One Feel Guilty?', *Spiegel International*, 9 May 2005, www.spiegel.de/international/spiegel-interview-with-holocaust-monument-architect-peter-eisenman-how-long-does-one-feel-guilty-a-355252.html.

40 Interview, p.46; trans. Michèle Woodger, 2022.

41 Joseph Masheck, *Adolf Loos: The Art of Architecture*, Bloomsbury Academic, London, 2013.

1 7 July Memorial

1 Sean O'Hagan, 'How These Men Will Honour the 7 July Dead in this Royal Corner of London', *The Observer*, 31 May 2001, www.theguardian.com/artanddesign/2009/may/31/7-july-bombings-memorial-hyde-park.

2 Interview with Andy Groarke, April 2022, p.34.

Interview with Andy Groarke

1 Antony Gormley, 'Blind Light', 2007, www.antonygormley.com/projects/item-view/id/241.

2 185 Empty White Chairs

1 Philip Matthews, 'Christchurch's 185 White Chairs: Remembering Loss and Thinking Ahead', *Stuff*, 1 July 2017, www.stuff.co.nz/the-press/christchurch-life/art-and-stage/94189382/christchurchs-185-white-chairs-remembering-loss-and-thinking-ahead.

2 ibid.

3 https://www.facebook.com/pages/185-empty-chairs/118948892152345.

4 Christchurch City Plan – Listed Heritage Item and Setting Heritage Assessment no 1290, https://districtplan.ccc.govt.nz/Images/DistrictPlanImages/Statement%20of%20Significance/Central%20City/HID%201290.pdf.

5 185 Chairs Facebook Community, www.facebook.com/185-chairs-earthquake-remembrance-art-installation-185356334906566/?ref=page_internal.

6 Jonny Edwards, 'Peaceful and Landscaped New Home for 185 Empty Chairs', *Stuff*, 6 November 2020, www.stuff.co.nz/the-press/christchurch-life/123317650/peaceful-and-landscaped-new-home-for-185-empty-chairs.

7 Matthews, 'Christchurch's 185 White Chairs'.

8 Official website, https://www.185chairs.co.nz/.

9 Edwards, 'Peaceful and Landscaped New Home'.

3 Anneau de la Mémoire

1 Philippe Prost and Aitor Ortiz, *Mémorial international de Notre-Dame-de-Lorette*, Les édifiantes éditions, Paris, 2014.

Interview with Philippe Prost

1 Interview trans. Michèle Woodger, 2022.

4 Arch for Arch

1 Lindsay Samson, 'Thomas Chapman on the Creation of the Arch for Arch Project', 5 September 2017, Design Indaba, www.designindaba.com/articles/creative-work/thomas-chapman-creation-arch-arch-project.

5 Atocha Station Memorial

1 Hattie Hartman, 'Working Detail: Madrid Memorial by FAM', *Architects' Journal*, 10 January 2008, www.architectsjournal.co.uk/working-detail-madrid-memorial-by-fam/5214000.article.

2 'Atocha Station Memorial, Madrid', RIBA Pix, www.architecture.com/image-library/ribapix/image-information/poster/atocha-station-memorial-madrid/posterid/RIBA114693.html.

3 Graeme Brooker and Sally Stone, *ReReadings II*, RIBA Publishing, London, 2017.

4 Hartman, 'Working Detail'.

6 Babyn Yar Synagogue

1 Tiffany Wertheimer, 'Babyn Yar: Anger as Kyiv's Holocaust Memorial Is Damaged', *BBC News*, 3 March 2022, www.bbc.co.uk/news/world-europe-60588885.

2 Manuel Herz, 'Architect of Memorial Synagogue at Babyn Yar: Bombing "leaves me speechless, numb and powerless"', *Forward*, 2 March 2022, https://forward.com/culture/483314/holocaust-memorial-synagogue-babi-yar-russian-bombing-arhictect-comments/.

3 M. Berenbaum, 'Babi Yar', *Encyclopedia Britannica*, www.britannica.com/place/Babi-Yar-massacre-site-Ukraine.

4 Manuel Herz Architects, Babyn Yar Synagogue, Project Information, www.manuelherz.com/babyn-yar-synagogue.

5 ibid.

8 Camp Barker Memorial

1 'Camp Barker Memorial', After Architecture, https://after-architecture.com/campbarkermemorial.

2 Kyle Schumann, personal communication, May 2022.

3 Katie MacDonald, personal communication, May 2022.

4 After Architecture – Press Release, May 2019.

9 Clamor de Paz

1 The World Bank, 'The World Bank in Honduras', last updated 25 April 2022, www.worldbank.org/en/country/honduras.

2 Cristina Lozano Carbajal, Buildings, 'Clamor de Paz in Honduras by Paul Lukez: What Began with Tragedy Ends with an Inspiring Place', *The Architectural Review*, 8 November 2016, www.architectural-review.com/buildings/clamor-de-paz-in-honduras-by-paul-lukez-what-began-with-tragedy-ends-with-an-inspiring-place.

3 ibid.

10 Dr Kallam Anji Reddy Memorial

1 Spencer Bailey, *In Memory Of: Designing Contemporary Memorials*, Phaidon, 2020, New York, p.74.

2 https://www.drreddys.com/who-we-are#our-founder.

3 Dr Kallam Anji Reddy Memorial, *C3 Special: Remember in Architecture*, Seoul, 2017, pp 68–79.

11 Flowing Paperscapes
of the War Memorial

1 Oscar Chung, 'Second Edition', *Taiwan Review*, vol.69, no.4, July–August 2019.

2 Chien hui-ju and Jonathan Chin, 'Air Raid Survivor Calls for Memorial', *Taipei Times*, 20 August 2016, www.taipeitimes.com/News/taiwan/archives/2016/08/20/2003653494.

3 Janmichael Antoni, personal communication.

12 Gwangju River Reading Room

1 UNESCO, 'Memory of the World', www.unesco.org/new/en/communication-and-information/memory-of-the-world/register/full-list-of-registered-heritage/registered-heritage-page-4/human-rights-documentary-heritage-1980-archives-for-the-may-18th-democratic-uprising-against-military-regime-in-gwangju-republic-of-korea/.

2 Excerpt from documentary film, *David Adjaye – Collaborations*, featuring Taiye Selasi, dir. Oliver Hardt, Signature Films Frankfurt, 2015, https://vimeo.com/117564096.

3 Project Artistic Director: Nikolaus Hirsch; Curators: Philipp Misselwitz and Eui Young Chun.

13 Hegnhuset Memorial and
Learning Centre

1 Henrietta Thompson, 'Fitting Tribute: Blakstad Haffner Architects Unveil Latest Piece in Utøya's Rebuilding', *Wallpaper**, Architecture, 22 August 2016, www.wallpaper.com/architecture/blakstad-haffner-architects-remembers-utoya-massacre-with-new-memorial-and-learning-centre-hegnhuset.

2 ibid.

14 Japanese Immigration Memorial

1 'A little corner of Brazil that is forever Okinawa', *BBC News*, 4 February 2018, www.bbc.co.uk/news/world-latin-america-42859249.

2 'Memorial da Imigração Japonesa', Gustavo Penna Arquiteto e Associados, www.gustavopenna.com.br/memorialdaimigracaojaponesa.

15 Judenplatz Holocaust Memorial

1 Rachel Whiteread/Andrea Rose, 'Interview', in Jon Woods, David Hulks and Alex Potts (eds), *Modern Sculpture Reader*, Henry Moore Institute, Leeds and J. Paul Getty Museum, Los Angeles, 2007, pp 449–62.

16 Katyń Museum

1 'US Hushed Up Soviet Guilt over Katyń', *BBC News*, 11 September 2012, www.bbc.co.uk/news/world-europe-19552745.

17 Levenslicht

1 Daan Roosegaarde, personal communication, 2022.

18 Mausoleum of the Martyrdom of Polish Villages

1 Mirosław Nizio, personal communication, 2022. Translated by Karolina Szmytko.

19 Mémorial du Camp de Rivesaltes

1 Mémorial du Camp de Rivesaltes, 'L'architecture du mémorial', www.memorialcamprivesaltes.eu/larchitecture-du-memorial.

2 Mémorial du Camp de Rivesaltes, 'Découvrir le mémorial', www.memorialcamprivesaltes.eu/decouvrir-le-memorial.

3 Rudy Ricciotti, architecte and Passelac & Roques, architectes associés, *Memorial du Camp de Rivesaltes*, Archibooks & Sautereau éditeur, Paris, 2016, pp 6–7.

20 Memorial Hall For Israel's Fallen

1 Ministry of Defense, Legacy, 'National Memorial Hall', https://english.mod.gov.il/About/Legacy/Pages/National_Remembrance_Hall.aspx.

2 Isabel Kershner, 'In Memorial to War Dead, Israel Avoids Addressing its Conflict', *New York Times*, 16 April 2018, www.nytimes.com/2018/04/16/world/middleeast/israel-national-memorial-hall.html.

3 ibid.

4 Agence France Presse, 'Israel Honours its Fallen with Understated Architectural Gem', 11 January 2018, www.france24.com/en/20180111-israel-honours-its-fallen-with-understated-architectural-gem.

5 Kimmel Eshkolot Architects, Mount Herzl Memorial Hall, www.kimmel.co.il/projects/national-memorial-on-mount-herzl/.

21 Memorial to the Murdered Jews of Europe

1 'Berlin Memorial to the Murdered Jews of Europe', Eisenman Architects, eisenmanarchitects.com/Berlin-Memorial-to-the-Murdered-Jews-of-Europe-2005.

2 ibid.

3 In 2017, the memorial garnered negative attention in the international press when Israeli artist Shahak Shapira used selfies taken from social media accounts and superimposed them on grim archive photographs of prisoners and corpses, which he posted (without permission) on a satirical website, 'Yolocaust' (YOLO being a banal catchphrase meaning 'You Only Live Once'). Shapira received praise in the media for calling out these instances of disrespect, but the architect himself had in fact previously advocated that the memorial should have alternative uses, including picnics and photo shoots (see https://www.bbc.co.uk/news/world-europe-38675835).

4 How Long Does One Feel Guilty?', *Spiegel International*, 9 May 2005, www.spiegel.de/international/spiegel-interview-with-holocaust-monument-architect-peter-eisenman-how-long-does-one-feel-guilty-a-355252.html.

22 Memorial to Victims of Violence in Mexico

1 In 2020, the cost of violent crime to Mexico's economy was 4.71 trillion pesos (£190 billion). Mexico has the ninth highest homicide rate globally, and is home to the five cities with the highest homicide rates in the world: Tijuana, Ciudad Juarez, Uruapan, Irapuato and Ciudad Obregon. See '2021 Mexico Peace Index', www.visionofhumanity.org/mexico-peace-index-2021-peacefulness-improves-after-four-years-of-deterioration/.

2 'Mexican memorial to victims of violence', *BBC News*, 5 April 2013, www.bbc.co.uk/news/av/world-latin-america-22046161.

23 Mitsamiouli Stele

1 'Catastrophe de l'A310: un seul survivant pour l'instant', 30 June 2009, www.lefigaro.fr/international/2009/06/30/01003-20090630ARTFIG00256-un-a-310-de-la-yemenia-air-s-abime-au-large-des-comores-.php.

2 Mahmoud Keldi, personal communication, May 2022 (and all further quotes from him in this piece), trans. Michèle Woodger, 2022.

Interview with Claudio Vekstein

1 Centre for Architectural Structures and Technology (CAST), University of Manitoba, Canada: https://umanitoba.ca/architecture/cast.

2 Ayelén Coccoz, artist's website, www.ayelencoccoz.com/.

3 Ayelén Coccoz, 'Still' and 'El Fantasma Flota': https://ayelencoccoz.com/Still-espanol and https://ayelencoccoz.com/El-fantasma-flota.

25 National 9/11 Memorial – Reflecting Absence

1 9/11 Memorial & Museum, 'About the Memorial', www.911memorial.org/visit/memorial/about-memorial.

26 National 9/11 Museum and Pavilion

1 Snøhetta, 'National September 11 Memorial Museum Pavilion', https://snohetta.com/project/19-national-september-11-memorial-museum-pavilion.

2 Davis Brody Bond, 'National September 11 Memorial Museum, New York', www.davisbrodybond.com/national-september-11-memorial-museum.

28 National Memorial for Peace and Justice

1 National Association for the Advancement of Colored People (NAACP), 'History of Lynching in America', History Explained, https://naacp.org/find-resources/history-explained/history-lynching-america.

2 TED, Michael Murphy, 'Architecture That's Built to Heal', www.ted.com/talks/michael_murphy_architecture_that_s_built_to_heal, conference transcript, 11:38.

3 ibid.

Interview with MASS Design Group

1 The interview with MASS Design Group was conducted with Brianne Nueslein in 2020.

2 See www.ted.com/talks/michael_murphy_architecture_that_s_built_to_heal/transcript?language=en.

29 National War Memorial

1 Yogesh Chandrahasan, personal communication, 2022.

30 Nyamata Church Genocide Memorial

1 Jens Meierhenrich and Martha Lagace, 'Through a Glass Darkly: Genocide Memorials in Rwanda, 1994–Present', Nyamata, 2010, http://maps.cga.harvard.edu/rwanda/nyamata.html.

2 Randall Mason, 'Conserving Rwandan Genocide Memorials', *APT Bulletin: The Journal of Preservation Technology*, vol.50, nos 2/3 (2019), pp 17–26; also conversation between MW, TS and Randall Mason, May 2022.

31 Shoes on the Danube Bank

1 'Arrow Cross Party', Hungarian organization, *Encyclopaedia Britannica*, www.britannica.com/topic/Arrow-Cross-Party.

2 Sheryl Silver Ochayon, 'The Shoes on the Danube Promenade – Commemoration of the Tragedy', Yad Vashem: The World Holocaust Remembrance Centre, www.yadvashem.org/articles/general/shoes-on-the-danube-promenade.html.

32 Singapore Founders' Memorial

1 'About Founders' Memorial', National Heritage Board, www.foundersmemorial.sg/.

2 Singapore National Heritage Board, 'Winner of the Founders' Memorial Design Competition Unveiled', 9 March 2020, www.foundersmemorial.sg/milestones/winner-of-the-founders-memorial-design-competition.

3 C3 Diz, 'Kengo Kuma Wins the Singapore Founders' Memorial Competition with a Living Memorial Plan to Inspire the Present and Future of Singapore', 27 March 2020, www.c3diz.net/singapore-founders-memorial/.

4 Justin Zhuang, 'A New Kind of Monument', Spotlight/Founders' Memorial, *Skyline*, Issue 13, Singapore Urban Redevelopment Authority, www.ura.gov.sg/Corporate/Resources/Publications/Skyline/Skyline-issue13/A-new-kind-of-monument.

5 National Heritage Board, Singapore, 'Share Your Story, Shape Our Memorial', www.foundersmemorial.sg.

33 Son Yang Won Memorial Museum

1 Lee Eunseok, personal communication, 2022.

34 Steilneset Memorial to the Victims of Witch Trials

1 Alexander Zaxarov, 'Steilneset Memorial by Peter Zumthor + Louise Bourgeois', *Thisispaper*, Architecture, 11 August 2020, www.thisispaper.com/mag/steilneset-memorial-peter-zumthor-louise-bourgeois.

35 The Clearing

1 All quotes from the architect taken from 3RW's Project Text.

36 Thunderhead 2SLGBTQI+ National Monument

1 'The Silence Stops Here: LBGT Purge Class Action', https://lgbtpurge.com.

2 Public City, 'Thunderhead. 2SLGBTQI+ National Monument, Ottawa, Ontario', www.publiccityarchitecture.com/thunderhead.

3 ibid.

37 Tiles to the Desaparecidos

1 Wolfgang Kaleck, 'Argentine dictatorship 40 years on', European Centre for Constitutional and Human Rights, 2016, www.ecchr.eu/en/publication/argentine-dictatorship-40-years-on.

2 Sam Harrison, 'In the Streets of Argentina Lie Hidden Memorials to Disappeared People', *Atlas Obscura*, 8 October 2018, www.atlasobscura.com/articles/argentina-dirty-war-tile-memorials.

3 ibid.

38 Tree of Knowledge Memorial

1 Rose Etherington, 'Memorial for Tree of Knowledge by m3architecture and Brian Hooper', 13 November 2009, www.dezeen.com/2009/11/13/memorial-for-tree-of-knowledge-by-m3architecture/.

39 Wahat Al Karama

1 'Wahat Al Karama with Artist Idris Khan', https://bureauproberts.com.au/project/wahat-al-karama/.

2 UAP, 'Idris Khan, Wahat Al Karama, Abu Dhabi, UAE', www.uapcompany.com/projects/wahat-al-karama.

3 UAE Culture Agenda 2031, https://en.unesco.org/creativity/policy-monitoring-platform/uae-culture-agenda-2031.

41 War and Women's Human Rights Museum

1 The War and Women's Human Rights Museum, Seoul, http://wisearchitecture.com/product/detail2.html?product_no=21&cate_no=1&display_group=2.

42 Wenchuan Earthquake Memorial Museum

1 'Sichuan 2008: A Disaster on an Immense Scale', *BBC News*, 9 May 2013, www.bbc.co.uk/news/science-environment-22398684.

2 Testimonies from student survivors makes for heartbreaking reading; see UNICEF, 'Voices of Child Survivors of the Sichuan Earthquake', 18 May 2008, www.unicef.cn/en/stories/voices-child-survivors-sichuan-earthquake.

3 Cai Yongjie, personal communication. Translated by Tszwai So, 2022.

43 Westerbork Camp Commander's House Intervention

1 Herinneringscentrum Kamp Westerbork, 'History', https://kampwesterbork.nl/en/history.

2 United States Holocaust Memorial Museum, Washington, DC, Holocaust Encyclopedia, 'Westerbork', https://encyclopedia.ushmm.org/content/en/article/westerbork.

3 Herinneringscentrum Kamp Westerbork, 'Former camp', https://kampwesterbork.nl/en/to-do-now/camp-grounds.

4 Oving Architekten, 'Overkapping commandantswoning', personal communication, 11 May 2020.

5 John Bezold, 'Oving Caps a House with Glass', *MARK Magazine*, no.56, Frame Publishers, Amsterdam, 2015, pp 30–31, http://johnbezold.com/articles/owing-caps-a-house-with-glass-mark-magazine-no-56/.

44 World Memorial to the Pandemic

1 Reuters COVID-19 Tracker, 21 May 2022, https://graphics.reuters.com/world-coronavirus-tracker-and-maps/countries-and-territories/uruguay/.

2 Martín Gómez Platero, personal communication, 2022.

45 Yad Vashem: The Holocaust History Museum

1 *Yad Vashem: Moshe Safdie – The Architecture of Memory*, Lars Müller Publishers, Switzerland, 2006.

2 ibid.

Index

Note: italic page numbers indicate figures; page numbers followed by n. refer to notes.

Picture Credits

1, 2, 3, 4, 5, 6 Tszwai So; 7 Michèle Woodger; 8, 9 Adobe/Chris Dorney; 10 Adobe/Kira Volkov; 11 Adobe/Joppi; 12 Andia/Alamy Stock Photo; 13 Wilfrid Pisani; 14 Andia/Alamy Stock Photo; 15 Ian G. Dagnall/Alamy Stock Photo; 16 Design Indaba; 17 Adobe/Kar Sol; 18 Adobe/Kapyos; 19 Manuel Herz Architects; 20 Iwan Baan; 21 Manuel Herz Architects; 22, 23 Joakim Boren; 24, 25 Sam Oberter; 26 After Architecture; 27, 28 Paul Lukez Architecture; 29, 30 Mindspace Architects; 31 Sebastian Zachariah (courtesy of the architect); 32, 33 Tsung Wei Yang, Janmichael Antoni; 34, 35 Adjaye Associates; 36, 37 Erlend Blakstad Haffner; 38 Jomar Bragança; 39 Gustavo Penna Architects and Associates; 40 Adobe/Ed Nurg; 41 BBGK Architekci; 42, 43 Julius Sokolowski (courtesy of the architects); 44 BBGK Architekci; 45, 46 Daan Roosegaarde, www.studioroosegaarde. net; 47, 48, 49 Nizio Design International press images, Photo by Marcin Czechowicz; 50, 51 Michèle Woodger; 52 Kévin Dolmaire Photographe; 53 Michèle Woodger; 54, 55 Amit Geron; 56 Kimmel Eshkolot Architects; 57 Adobe/Joy T; 58 Carlos Adampol Galindo/via Wikimedia Commons; 59 REUTERS/Alamy Banque D'Images; 60 Mahmoud Keldi; 61 Federico Cairoli; 62, 63 Claudio Vekstein; 64 Adobe/Francois Roux; 65 Shutterstock/Nick Starichenko; 66, 67 Adobe/ Henk Vrieselaar; 68 Doublespace; 69, 70, 71 MASS Design Group; 72, 73, 74 Maniyarasan; 75 Government of India; 76, 77 Dave Proffer/via Wikimedia Commons; 78 Adobe/Sergii Figurnyi; 79 Adobe/Lunnaya; 80, 81 Kengo Kuma and Associates; 82, 83, 84 Lee Eunseok + Atelier KOMA; 85 Shutterstock/Inger Eriksen; 86 Bjarne Riesto/via Wikimedia Commons; 87, 88 © 3RW, Photo by Martin Slottemo Lyngstad; 89, 90 Public City; 91, 92 Maria Isabel Munczek/via Wikimedia Commons; 93, 94 Jon Linkins and Brian Hooper Architect; 95 Adobe/creativefamily; 96, 97 Wang Ziling © DnA_Design and Architecture; 98 DnA_ Design and Architecture; 99, 100 Kim Doo Ho; 101 WISE Architecture; 102, 103, 104, 105 Cai Yongjie; 106 Susan Schuls; 107 Shutterstock/365 Focus Photography; 108, 109, 110 Gómez Platero Architecture and Urbanism; 111, 112 Moshe Safdie/Safdie Architects; 113 Adobe/Naeblys; 114, 115 Timothy Hursley